"A gorgeous, moving, and deeply important book. The art this book showcases, and the short stories behind each piece, remind us that the complicated, painful, and often invisible experience of infertility is both shared and singular. Highly recommended for scholars of reproductive health and justice and especially for people experiencing the pain of infertility who would like to feel a little less alone."

—JENELL JOHNSON, professor of communication arts, University of Wisconsin–Madison

"This daring collection harnesses the power of the arts to dismantle isolation and stigma, letting the light shine through to reveal hidden layers of the infertility experience. With its diverse voices and vignettes, *Infertilities, A Curation* deepens our understanding of infertility's profound and complex reverberations."

—LAURA SEFTEL, LMHC, ATR-BC, art therapist, author of *Grief Unseen: Healing Pregnancy Loss through the Arts*, and founder of The Secret Club Project: Artists on Pregnancy Loss

"*Infertilities, A Curation* offers a one-of-a-kind contribution about the experience of existing within the liminal space of infertility. It speaks to and with ongoing discussions of health communication, rhetoric, gender, sex, and identity. The editors and contributors do a beautiful job of dimensionalizing infertility, bringing art, affect, theory, literature, and passion to the table in ways that are groundbreaking and heartbreaking all at the same time."

—ROBIN JENSEN, professor of communication, University of Utah

# INFERTILITIES,
## A CURATION

# Infertilities, A Curation

*Edited by Elizabeth Horn, Maria Novotny, and Robin Silbergleid*

WAYNE STATE UNIVERSITY PRESS
DETROIT

ISBN 9780814350652 (hardcover)
ISBN 9780814350669 (e-book)

Library of Congress Control Number: 2023930383

Cover art: Jessie Dietz-Bieske, *Lady in Waiting*, 2013, mixed media, 27"H × 23"W × 4"D, collection of The ART of Infertility

Cover and interior design by Lindsey Cleworth

Grateful acknowledgment is made to the Leonard and Harriette Simons Endowed Family Fund for the generous support of the publication of this volume.

Wayne State University Press rests on Waawiyaataanong, also referred to as Detroit, the ancestral and contemporary homeland of the Three Fires Confederacy. These sovereign lands were granted by the Ojibwe, Odawa, Potawatomi, and Wyandot Nations, in 1807, through the Treaty of Detroit. Wayne State University Press affirms Indigenous sovereignty and honors all tribes with a connection to Detroit. With our Native neighbors, the press works to advance educational equity and promote a better future for the earth and all people.

*Wayne State University Press*
Leonard N. Simons Building
4809 Woodward Avenue
Detroit, Michigan 48201-1309

Visit us online at wsupress.wayne.edu

# CONTENTS

PREFACE | xi
Elizabeth Horn

INTRODUCTION | 1
Maria Novotny, Robin Silbergleid, and Elizabeth Horn

## 1. 9

*Lady in Waiting* | Jessie Dietz-Bieske . . . . . . . . . . . . . . . . . 10

The House | Maria Novotny . . . . . . . . . . . . . . . . . . 12

*Waiting on Wanda* and *Everyone Knows* | Jaimie Peterson . . . . . . 14

*Baby Ladies and Dog Lady II* | Faye Glen . . . . . . . . . . . 18

A Dog Is Not a Baby. Or It Is. | Marjorie Maddox . . . . . . . . 20

*A Game of Twenty Questions* | Christine McDonough . . . . . . . 22

Baby Land | Matt Quarterman . . . . . . . . . . . . . . . . . 23

*Seventy-Two Red Tears: Undeniable Proof* | Maria Novotny . . . . . . 24

*HSG* | Adi Hadar . . . . . . . . . . . . . . . . . . . . . . . 26

Infertility Sestina | Robin Silbergleid . . . . . . . . . . . . . . 28

The Fertility Patient | Robin Silbergleid . . . . . . . . . . . . 30

*Challenger* | Sharon McKellar . . . . . . . . . . . . . . . . . 32

*Infertility Study—Objects* | Lauree Jane (Sundberg) Schloss . . . . 34

Incantations for Fertility | Margaret A. Mason . . . . . . . . . 36

Mother's Day | Carla Rachel Sameth . . . . . . . . . . . . . . 37

*Tainted* | Christine Moffat . . . . . . . . . . . . . . . . . . . 46

*It Is Easier for a Camel to Pass through the Eye of a Needle than for a
     Fertile Woman to Understand Infertility* | Gwenn Seemel . . . . . 48

She's Not My Mother: Fertility, Queerness, and
     Invisibility | Jennifer Berney . . . . . . . . . . . . . . . . . 50

*Collecting Seeds* | Crystal Tursich . . . . . . . . . . . . . . . 62

*One Pill, Two Pill, Red Pill, Blue Pill* | Shannon Novotny . . . . . . 64

Inheritances | Lisa Grunberger . . . . . . . . . . . . . . . . . 66

*Imitor Virgo Fructuarius, Mulieres Offerunt Maternitam,* and *Familia*
    *Adduco Mundum* | Eva Nye . . . . . . . . . . . . . . . . 74
*Two Futures: A Portrait of Infertility* | Cha Gutiérrez . . . . . . . . 78

2.    81

*Stone Womb Fetuses* | Katie Benson . . . . . . . . . . . . . . 82
Poem of the Body | Betty Doyle . . . . . . . . . . . . . . 84
The Mozart Effect | Betty Doyle . . . . . . . . . . . . . 85
On Ovaries | Betty Doyle . . . . . . . . . . . . . . . . 86
*Excision* | Jo C. . . . . . . . . . . . . . . . . . . . . 88
*What the Fibrous Tissue of Your Love Has Created* |
    Montserrat Duran Muntadas . . . . . . . . . . . . . . 90
*The Seeds Were Sown* | Monica Wiesblott . . . . . . . . . . . 94
*Hair Piece II* | Sally Butcher . . . . . . . . . . . . . . . 96
The Miscarriage: A Sunday Funny | Douglas Kearney . . . . . . 98
*Pain Will Not Have the Last Word* | Foz Foster . . . . . . . . . 100
*Anyway, Here's Wonderwall* | Annamarie Torpey Miyasaki . . . . . 102
Grief to the Bone | Yomaira Figueroa-Vásquez . . . . . . . . . 104
*The Loss* and *The Wound* | Ashley MacLure . . . . . . . . . 116
Cycle #2 | Siobhan Lyons . . . . . . . . . . . . . . . . 119
Birth ~~Plan~~ Warning | Siobhan Lyons . . . . . . . . . . . . 121
*A Mother's Embrace* | Poonam Parag . . . . . . . . . . . . 122
*El Camino* (The Journey) | Molina B. Dayal . . . . . . . . . . 124
The Tribe of Broken Plans | Cheryl E. Klein . . . . . . . . . 126
*Connection* | Leanne Schuetz . . . . . . . . . . . . . . . 134
*From Hatred to Hope* | La-Anna Douglas, Sarah Matthews,
    and Cynthia Herrick . . . . . . . . . . . . . . . . . 136
*Box: What Remains Hidden in IVF* | Sarah Clark Davis . . . . . 138
*Staying Mobile* | Kevin Jordan . . . . . . . . . . . . . . 140
Downer | Kate Bradley . . . . . . . . . . . . . . . . . 142
*That Time We Had Fleas* | Kelly Zechmeister-Smith . . . . . . . 148
What IF | Barrie Arliss and Dan Louis Lane . . . . . . . . . . 150

## 3.    153

*In My Heart* | Jamie Kushner Blicher . . . . . . . . . . . . . . . . . .154

*Disbelief* | Roxy Jenkins . . . . . . . . . . . . . . . . . . . . . . .156

A Mother by Any Other Name | Jenny Rough . . . . . . . . . .158

*Bloodlines, Matryoshka* | Raina Cowan . . . . . . . . . . . . . .170

*S/m/othering: Cassatt* | Marissa McClure Sweeny . . . . . . . . . .172

My List of True Facts | Erika Meitner . . . . . . . . . . . . . . . .174

An Open Letter to Our Sperm Donor | Robin Silbergleid . . . .176

*We Have No Room: A Study in the Ritual Practices of Infertility* |
    Amy Traylor . . . . . . . . . . . . . . . . . . . . . . . . . . .178

*Twelve Vessels* | Cole Askevold . . . . . . . . . . . . . . . . . . . .182

Frozen Futures | Krys Malcolm Belc . . . . . . . . . . . . . . . . .185

*Cactus Middle Fingers, on My Way down the Mountain* | Annie Kuo . 190

*Cousins* | Elizabeth Horn . . . . . . . . . . . . . . . . . . . . . . .192

Frozen | Robin Silbergleid . . . . . . . . . . . . . . . . . . . . . . .194

*Round and Round the Merry-Go-Round* | Noah Moskin and
    Maya Grobel . . . . . . . . . . . . . . . . . . . . . . . . . . . . 204

*Until Her Last Breath, This First Breath* | Ryan Ferrante . . . . . 206

Fingerprints | Michele Wolf . . . . . . . . . . . . . . . . . . . . . 208

*Begin* | Carla Davis . . . . . . . . . . . . . . . . . . . . . . . . . . .210

*Sun Showers* | Brit Ellis . . . . . . . . . . . . . . . . . . . . . . . 212

The House—Part II | Maria Novotny . . . . . . . . . . . . . . .214

*Letting Go* | Denise Callen . . . . . . . . . . . . . . . . . . . . . . 216

*Crib with Medication Boxes* | Elizabeth Horn . . . . . . . . . . . .218

APPENDIX I: Thematic Table of Contents | 221
APPENDIX II: Art-Making around Infertility | 229
RESOURCES | 235
ACKNOWLEDGMENTS | 240
CONTRIBUTORS | 242

# PREFACE

*Elizabeth Horn*

In March 2009, I began a journey. My husband and I decided we wanted to expand our family by having a baby. I was not aware of it at the time, but it was not going to be easy. It was going to be a road lined with anger, pain, sadness, frustration, and stress. I was initially reluctant to undergo fertility treatments, and my experiences eventually included intrauterine insemination, in vitro fertilization (IVF), complications from an egg retrieval, a twin miscarriage, divorce, and a disrupted adoption.

It is estimated that 61 percent of women with infertility do not tell even their close family and friends, and, at first, I was no exception.[1] We had been undecided about kids for much of our marriage, and I always figured that when I got pregnant it would be a nice surprise for our family. Unfortunately, when life revolves around doctor appointments, blood draws, and 9:00 p.m. curfews for intramuscular injections, it is hard to keep it quiet. Slowly, we started to let family and friends in on our secret.

In an effort to make sense of my diagnosis and surround myself with people who understood the difficulties of navigating their own, I joined an infertility support group and realized the importance of sharing my experiences. I also began creating artwork representing my infertility. I found ripping up paper for mixed-media collages and feeling my paintbrush gliding across canvas soothing. I took the pieces I created, along with artwork and stories collected from members of my support group, and curated the exhibit *The ART of IF: Navigating the Journey of Infertility*, which debuted at the Ella Sharp Museum in Jackson, Michigan, in March 2014. The exhibit involved a three-part organization that documented the personal story of Ella Sharp's experience with infertility in the late 1800s, showcased portraits and narratives of seven Michiganders who experienced infertility, and featured art created by patients as a way to heal and express their journey.

*ART* has a double meaning, referring both to the artwork created by individuals living with infertility and to assisted reproductive technologies, the medical treatments that help those struggling to become parents. *IF* also has a double meaning. It is not only the acronym for *infertility*. It is also a common

word that infertility patients use as they live the limbo that infertility forces them into, as their schedules are controlled and lives put on hold by fertility treatment. "I'll be late to work on Tuesday IF I need to go in for another ultrasound and blood draw. We'll need to put off treatment another month IF I accept this promotion at work. We won't be able to join our family on vacation IF our frozen embryo transfer works this fall and I'm eight months pregnant by then."

Shortly after this exhibition, I met Maria Novotny at Advocacy Day, an annual event hosted by RESOLVE: The National Infertility Association, which lobbies Congress on access to care and family-building issues important to the infertility community. At the time, both Maria and I were running peer-led infertility support groups in Michigan and spent the day together visiting our representatives on Capitol Hill. We also shared with each other how neither of us was actively trying to build a family. Despite our decision to take a break from conceiving, we were still seeking to create and process our infertility journeys.

After Advocacy Day, Maria sent me some short nonfiction vignettes detailing the everyday struggles of reorienting from the previous expectations she had as a young, newly married woman and, now, infertile wife. In turn, I shared mixed-media art pieces representing the pain, frustration, and isolation of experiencing failed fertility treatments. Sharing our artistic representations of infertility, we noted how central creativity was to grieving and healing. Believing that we were most likely not alone in using art as a form of personal expression, we decided to collaborate and form an arts, oral history, and portraiture project and traveling exhibit. Within months, we began hosting events at fertility clinics, and Robin Silbergleid, who had recently published a memoir about becoming a single mother through ART, joined us to design writing workshops. The ART of Infertility was born.

Our mission to curate and exhibit as a constellation of infertile voices has grown and evolved over the years since first developing this organization. To date, The ART of Infertility has engaged more than thirty-eight local communities through exhibitions, workshops, conference panels, and invited talks, totaling more than eighty-eight events. Maria and Robin work with undergraduate student interns on infertility-related research on their campuses. And today we store our permanent collection in two states and have more than one hundred interviews and oral histories saved on hard drives.

Most of our exhibits showcase thirty-five to forty-five pieces of visual art alongside a label narrating the artistic connection to infertility—just a portion of the nearly two hundred pieces of art in our permanent collection.

As our collection of art has grown, so, too, has our network. As we exhibited in cities across the United States, from Seattle to Philadelphia, to Minneapolis, to Salt Lake City, we found ourselves creating a community whereby art and storytelling offered a new medium for connecting over such an emotionally devastating disease. Our exhibits bring together people from all walks of life, who are infertile and also not, and who have a range of knowledge about the challenges of building a family with an infertility diagnosis. The gallery became a safe place to process, reflect, and even mourn the invisible pain of living with infertility. This book was born out of The ART of Infertility, and we hope that it continues to expand our reach, creating a different type of infertility network.

Over the years much of our curatorial work has required in-person events, but the COVID-19 pandemic halted our ability to offer curated exhibits and programming. While the idea for this book rooted long before the pandemic, it became imperative as Maria, Robin, and I quarantined in our separate homes trying to figure out how to make our organization more accessible to the infertility community. Out of many conversations, texts, emails, and numerous Zoom calls has emerged a portable curated exhibit of patient narratives and art. In assembling this book, we wanted to make these stories public and more permanent, as well as available to audiences that include fertility patients, their families and friends, reproductive endocrinologists, and others. We see this book as not just an innovative capturing of the range of infertility experiences but also a tool to educate and inform others on infertility.

Our hope is that by sharing the stories of our journeys and the journeys of others, we will reach those experiencing infertility and they will know they are not alone. That we will educate their friends and families so they will know how they can support loved ones through their illness. That we will start a dialogue and make it easier for people to discuss this often-private disease.

## NOTE

1   This statistic is widely cited; see, for example, "3 Key Infertility Facts: What Johns Hopkins Fertility Experts Want Women to Know," *John Hopkins Health (Spring 2016): 1,* www.hopkinsmedicine.org/news/publications/johns_hopkins_health/spring_2016/3_key_infertility_facts.

# Introduction

*Maria Novotny, Robin Silbergleid, and Elizabeth Horn*

Art can educate. Art can advocate. Art can
heal. Collectively, art creates community.

Too often conversations concerning the "trouble" of trying to conceive or the sudden miscarriage one experienced last summer are shared only in close confidence with a friend or a close relative. Sometimes these private moments lead to confessions of others who also had trouble getting pregnant and the sharing of tips and advice, such as helpful reading materials, informative websites, and support groups; such intimate conversations can reduce feelings of isolation and stigma. *Infertilities, A Curation* seeks to move these moments of private disclosures into the public sphere. In doing so, we hope to intervene in the larger cultural practices that reinforce the desire to keep these stories confined to whispers. In an effort to break this silence, we have tried to reclaim and rewrite dominant narratives and myths surrounding infertility, including who "counts" as infertile. In fact, the definition generally used by insurance companies and therefore doctors relies on the presence of heterosexual behavior rather than a biomedical condition: the absence of conception after a year of unprotected sex. This narrow understanding of infertility necessarily excludes the experiences of single women and men, LGBTQ+ individuals and couples trying to build their families, and anyone who hasn't yet *tried* to become pregnant through sex even if they have a condition that makes it impossible for them to conceive.

Infertility is a complex condition that defies easy categorization. It is recognized as a disease by the World Health Organization and as a disability by the Americans with Disabilities Act. But it is also a profound lived experience that affects all parts of life, one that remains uncomfortable for many to discuss openly, thereby posing challenges for people to access the physical, emotional, and financial support needed to build one's family. Yet in sharp contrast to the silence surrounding it, statistics indicate the prevalence of infertility and point to its impact. According to the Centers for Disease Control and Prevention,

infertility affects one in eight couples, a number that fails to account for same-sex couples in need of reproductive technology services to build their family, as well as single parents by choice.[1] And while nearly 7.4 million women have needed to rely on fertility-related services to become pregnant, women are not alone in seeking fertility treatment. The American Society for Reproductive Medicine finds that approximately one-third of infertility is female-related, one third male-related, and one-third resulting from either a combination of problems in both partners or otherwise unexplained. And these analyses do not account for the many individuals who are infertile, whether for physiological or social reasons, who do not pursue treatment.[2] Such statistics are amplified further when coupled with facts related to reproductive loss. For instance, one in four pregnancies ends in miscarriage.[3]

The emotional weight of navigating life with an infertility diagnosis is profound and impacts many, yet the experience occurs behind closed doors, often met with silence, stigma, and shame. Stereotypical misconceptions about infertility remain in media representations and casual conversation. For example, male factor infertility continues to be downplayed and stigmatized; common phrases such as "pulling a goalie" jokingly associate masculinity with fertility. And, as we have learned traveling the United States listening to people's stories and witnessing the heartbreaking artistic representations of reproductive loss, the experience of infertility can be overwhelming and its effects life lasting. In fact, a well-cited study conducted by the Domar Center for Mind/Body Health found that the psychological impact of receiving an infertility diagnosis and experiencing recurrent reproductive loss was similar to the emotional stress and anxiety of receiving a cancer diagnosis.[4]

This book tells the human stories of infertility, stories that are far more nuanced than statistics, insurance diagnostic codes, and treatment plans. The diversity of the infertility experience lies at the center of this book and our organization. Infertility does not discriminate, and our curatorial process holds us accountable to represent and amplify untold stories. In this book, we acknowledge and highlight the myriad voices and perspectives of individuals who experience infertility, including women and men, nonbinary and transgender individuals, heterosexual couples, single parents by choice, and lesbian and queer-identified couples who require medical assistance and access to donor egg, sperm, or gestational surrogates in order to conceive. In short, infertility impacts far more than just the older white heterosexual couple.

Rather, against this stereotype, we need to underscore the fact that infertility impacts people of color disproportionately. For instance, current research indicates that married Black women have almost twice the odds of infertility compared to white women, even as they are half as likely to seek treatment.[5] And when they do, they are less likely to have success; among other causes, Black women are more likely to be predisposed to other reproductive factors, like fibroids and other uterine abnormalities, which complicate pregnancy. More broadly, people of color encounter a host of additional medical, social, and economic barriers that may affect their ability to have a family. Asian, Latino/Latina, and Native American individuals undergoing fertility treatment also have decreased pregnancy and live birth rates compared to white women. We share these stark statistics to underscore how sociocultural contexts can further complicate the experience of infertility. That is, while infertility may not discriminate who it touches, its impact can be felt differently because of embedded racial health inequities. We hope this book counters prevailing assumptions about infertility by presenting a range of experiences, voices, and media to showcase the multivalent, intersectional nature of recurrent reproductive loss.

The book is not a simple catalog of the artwork in our collection but a visual and textual performance of the experience of infertility across a large cross section of the population. While some of the contributors to this collection, and to The ART of Infertility project, are professional artists, the majority are not. The work produced is a powerful rendering of the impact of infertility across media and styles. Additionally, the work included here is raw, not sentimental, and resists easy closure with babies conceived after infertility. This choice speaks to the larger narrative our exhibits portray: There can be hope and success with an infertility journey, but it often requires experiencing much pain and developing endurance and a newfound understanding of who we are and why we want to have a family through the process. Infertility is more than a "battle to beat"; it is an identity comprising all the experiences along the way. This book tells those stories—the ones that happen on the journey—no matter how they end.

We have deliberately brought together written and visual text. Visual art communicates the trauma of infertility in a powerful, visceral way. Art allows infertility to be seen. Art is a medium that demands its audiences to see emotional and metaphorical representations of infertility. But it doesn't always

stand alone to educate viewers about infertility as a multifaceted issue with a social as well as personal significance. Written text, by contrast, can provide a personal narrative or reflection, unfolding in time or working through a changing identity, overtly confronting challenges to physical and mental health, gender, identity, spirituality, and the effects of infertility on romantic relationships, friendships, and family. There is no part of identity that infertility does not touch. And we believe in the power of personal narrative to counter misconceptions about infertility and infertile individuals. Too often the story sold to us in mainstream media and popular culture is that infertility is a condition that affects older white women who have put off childbearing, which can be "solved" through expensive treatment like in vitro fertilization (IVF). The truth, as our contributors reveal in their poetry, memoir, and personal essay, is much more complicated, individual, and culturally contingent. Memoirist Melissa Febos argues that "the resistance to memoirs about trauma is always in part—and often for nothing but—a resistance to movements for social justice."[6] By not telling trauma stories we allow oppression, silence, and shame to exist. We hope our approach will make apparent the diverse and, at times, even conflicting experiences and beliefs about infertility, as well as ignite further conversations and uptake of creative, arts-based practices as essential to infertility treatment and the associated traumas of recurrent reproductive loss.

Both the content and the structure of this book reflect how we approach our editing process as curators. Just like many of our gallery exhibits, the artworks in this collection span medium and genre, including painting, portrait, poetry, creative nonfiction, graphic narrative, mixed media, and photographs of sculpture and three-dimensional art. We offer a book that takes the reader through the unpredictable IFs of the infertility experience at various moments in time: the psychological effects of diagnosis; the physical and emotional toll of treatment, miscarriage, and pregnancy loss; the consequences on partnerships and marriages; the decisions of what to do with donor gametes and embryos; the questions surrounding what it means to raise a child who doesn't share your genetics. The book takes the shape of three sections, or rough movements, that convey beginnings, middles, and ends of infertility experiences. These are not singular but multiple. And, as we have found with our own experiences, there are not clear delineations among these movements; rather, the experience of infertility is temporally linear and emotionally recur-

Maria Novotny, Robin Silbergleid, and Elizabeth Horn

sive. Infertility is a diagnosis, a disease, an obstacle to family building, a trau-matic, life-altering experience. It is an invisible identity worn day in and day out, marked by the scars of trying to conceive. The experience of infertility, as so many of our contributors show, is not a linear narrative that ends with bringing home a baby. Rather, readers will find a range of experiences with fer-tility treatment and how individuals define family-building "success." Some of our contributors have undergone infertility treatment; others have not. Some have "take-home" babies; others remain child-free. Some adopt, and some use donor insemination, IVF, third-party reproduction such as gestational surro-gacy, or egg or embryo donation. Some individuals find a resolution quickly, whereas others struggle with infertility for years. Some never recover from or "get over" the experience, whether or not they create the family they desire.

Because the experiences of infertility are both individual and recurring, we have included a thematic appendix that cross-lists key terms associated with infertility and the works of art in this book that touch on them. These terms include common medical conditions and diagnoses, such as uterine fibroids and polycystic ovary syndrome; approaches to treatment, including intrauter-ine insemination (IUI) and IVF; and other significant markers of identity, such as LGBTQ+ or race, that intersect with and complicate the infertility experience. We should note that many pieces touch on miscarriage and repro-ductive loss; although a single miscarriage is not itself an indication of infertil-ity, recurrent miscarriage is, and the experience of pregnancy loss after infer-tility treatment is profoundly devastating. Additionally, many pieces are listed under multiple key terms, which illustrates the complex intersectionality of the infertility experience. We encourage you to read the book from cover to cover to experience the intended emotional arc; if you are seeking out par-ticular types of stories, see the appendix for an alternative, thematic table of contents that is focused around diagnosis or topic.

All the pieces included in this book were created by those who have expe-rienced infertility and testify to the complex experience of recurrent repro-ductive loss. The pieces reflect the emotional impacts of treatment and the effects on gender identity, self-esteem, emotional well-being. Some are darkly humorous; others are angry. Many are deeply sad. Visual artwork is accom-panied by a statement that provides context for the artist's personal narrative and artistic decisions; brief biographies at the end of the book tell more about contributors' family-building and reproductive narratives. Together, these

pieces and statements try to provide a fuller educational and emotional experience of the phenomenon of infertility.

Collecting these stories in book form allows us to bring together the myriad infertility experiences in a way that galleries, constrained by time and space, cannot. Pop-up exhibits and even weeks-long exhibitions are ephemeral. A book can also accommodate longer narratives and written text. While we have often featured framed poetry on a gallery wall, we have not been able to do the same with written pieces that are several thousand words long. On the other side, we note that some of the visual art pieces we've included in these pages cannot fully be appreciated here in their reduced size, and three-dimensional works arguably lose some of their power when you cannot walk completely around them. Although a book can never replicate the embodied experience, it affords the opportunity of expanding access to our work. For those experiencing infertility, we hope this book provides companionship and some solace in the knowledge that they are not alone.

Infertility, for most of us, does not end. Even now, years after our diagnoses, infertility continues to be something we grapple with on a daily basis. For Robin, that happens when her eleven-year-old child from donor egg/sperm watches the Netflix show *Fuller House*, which features an infertility and gestational surrogacy subplot, and asks about his own origin story. For Maria, this happens when she is asked by unpresuming students how many kids she has and if she is planning to have any more. For Elizabeth, it crops up as she struggles to answer the question "Do you have children?" while honoring each of the experiences that have made her a parent.

Beyond our personal situations, reconsideration of infertility has become more urgent in the wake of the US Supreme Court's decision to reverse *Roe v. Wade*. Legislators across the country are introducing new bills that impact access to reproductive care, as well as challenge and question the ability to use ART to build one's family. Infertility is fundamentally connected to pro-family movements, yet it also serves as a reminder that so-called pro-life legislation does not fully account for the complexities that surround family building for those who can't conceive through sex in the privacy of their own home. Additionally, proponents of the reversal of *Roe v. Wade* have dangerously suggested that limiting one's ability to access an abortion will increase options for infertile persons to build their family through fostering and adoption. These

Maria Novotny, Robin Silbergleid, and Elizabeth Horn

arguments fail to consider the complex legal and medical systems that regulate family building and access to reproductive care for all who require it.

That is, assumptions that the reversal of *Roe* is a win for infertile individuals disregards the core tenets of reproductive justice, which the Sister-Song Women of Color Reproductive Justice Collective defines as "the human right to maintain personal bodily autonomy, have children, not have children, and parent the children we have in safe and sustainable communities."[7] Such tenets underscore the issues of reproductive choice at the heart of the infertility experience. We raise these legislative threats and their implications on infertility to underscore the contemporary exigency for this book and to ponder how creativity may be used as a tool to resist continued threats to reproductive health and justice.

No matter how you come to this book—as an individual who identifies as infertile, a health care provider, a family member, ally, or someone who wants to learn more about the experiences of individuals who have experienced reproductive loss—we hope that this collection invites you to consider how creative practices such as art and writing aid in efforts not only to heal individual traumas but also, more broadly, to serve as a means of advocacy. We see this book as an invitation to expand the scope and affective experiences of living with infertility, and it is our hope that readers may leave with a more embodied understanding of the multiple ways infertility continues to shape everyday life.

## NOTES

1  On the prevalence of infertility, see, for example, the National Survey of Family Growth 2015–2019, Centers for Disease Control and Prevention, accessed August 18, 2022, www.cdc.gov/nchs/nsfg/keystatistics.htm.

2  For a more expansive understanding of infertility, including "social infertility," see, for example, Anna Louie Sussman, "The Case for Redefining Infertility," *New Yorker*, June 18, 2019, www.newyorker.com/culture/annals-of-inquiry/the-case-for-social-infertility.

3  Carla Dugas and Valori H. Slane, *Miscarriage* (StatPearls, June 27, 2022), pubmed.ncbi.nlm.nih.gov/30422585/.

4  See A. D. Domar, P. C. Zuttermeister, and R. Friedman, "The Psychological Impact of Infertility: A Comparison with Patients with Other Medical Conditions," *Journal of Psychosomatic Obstetrics and Gynecology* 14 Suppl. (1993): 45–52.

5  A thorough discussion of the connections between race and fertility is well beyond the scope of this introduction. Our understanding relies on several articles, including Tia

Jackson-Bey, Jerrine Morris, Elizabeth Jasper, Digna R. Velez Edwards, Kim Thornton, Gloria Richard-Davis, and Torie Comeaux Plowden, "Systematic Review of Racial and Ethnic Disparities in Reproductive Endocrinology and Infertility: Where Do We Stand Today?," *Fertility & Sterility Reviews* 2, no. 3 (2021): 169–88; David Seifer, Burcin Simsek, Ethan Wantman, and Alexander Kotylar, "Status of Racial Disparities between Black and White Women Undergoing Assisted Reproductive Technology in the US," *Reproductive Biology and Endocrinology* 19, no. 1 (2020). For a specific discussion of Black women's experiences of infertility, see Rosario Ceballo, Erin T. Graham, and Jamie Hart, "Silent and Infertile: An Intersectional Analysis of the Experiences of Socioeconomically Diverse African-American Women with Infertility," *Psychology of Women Quarterly* 39, no. 4 (2015): 497–511. More broadly, for a discussion of experiences of BIPOC (Black, Indigenous, and people of color) individuals undergoing ART, see Dana B. McQueen, Ann Schufreider, Sang Mee Lee, Eve C. Feinberg, and Mieke L. Uhler, "Racial Disparities in In Vitro Fertilization Outcomes," *Fertility and Sterility* 104, no. 2 (2015): 398–402; Leigh A. Humphries, Olivia Chang, Kathryn Humm, Denny Sakkas, and Michele R. Hacker, "Influence of Race and Ethnicity on In Vitro Fertilization Outcomes: Systematic Review," *American Journal of Obstetrics and Gynecology* 214, no. 2 (2016); and LaTasha B. Craig, Elizabeth A. Weedin, William D. Walker, Amanda E. Janitz, Karl R. Hansen, and Jennifer D. Peck, "Racial and Ethnic Differences in Pregnancy Rates Following Intrauterine Insemination with a Focus on American Indians." Finally, for personal accounts, we would also highlight Shannon Gibney and Kao Kalia Yang, ed., *What God Is Honored Here? Writings on Miscarriage and Infant Loss by and for Native Women and Women of Color* (Minneapolis: University of Minnesota Press, 2019).
6   Melissa Febos, *Body Work: The Radical Power of Personal Narrative* (New York: Catapult, 2022), 18.
7   "Reproductive Justice," SisterSong, accessed September 17, 2022, www.sistersong.net/reproductive-justice.

# 1.

Infertility begins slowly, quietly, with questions and uncertainty. Infertility begins with the growing awareness that maybe making a family won't be easy. Won't happen after a month or three or maybe even a year. Infertility begins with the choice to have a child. Infertility begins in the doctor's office, with tests and diagnostic codes. Infertility begins with sex. Infertility begins with asking a friend to donate sperm. Infertility begins with the arrival of blood each month. A new cycle might yield optimism and possibility: a new medication, a first insemination, a first attempt at IVF, the selection of an egg donor or gestational carrier. Each treatment cycle can work . . . or not. The written and visual art in this section presents emotional beginnings, individuals wrestling with diagnoses and what it means to build family in various contexts.

# Lady in Waiting

*Jessie Dietz-Bieske*

*Lady in Waiting* is a representation of these beautiful eggs that just need to descend so that they may find their calling of becoming a child. When you're not on the infertility journey, you don't have to worry about how many you have, how fully developed they are, etc.; it's just so "natural." If only it were that simple! This journey for me has felt very sterile, in more ways than one.

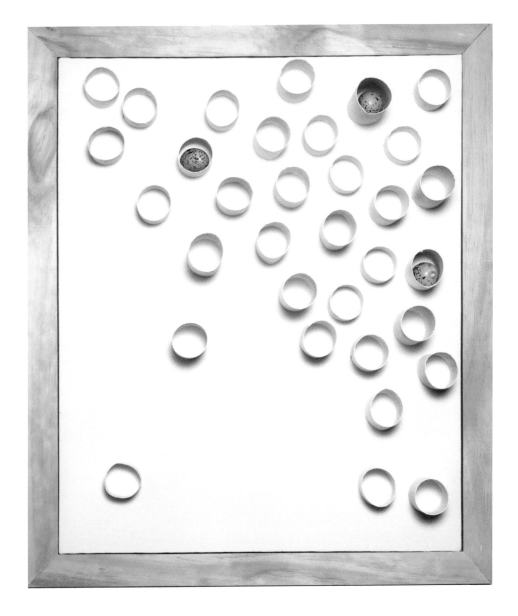

Jessie Dietz-Bieske, *Lady in Waiting*, 2013, mixed media, 27" H × 23" W × 4" D, collection of The ART of Infertility, Ann Arbor, Michigan

# The House

*Maria Novotny*

Right now, I sit in the room that was supposed to be our baby's. We bought a cozy, two-bedroom, two-story house with the intention that the blue room upstairs would be ours; the mauve-colored room across the hall would be repainted because it would be for the baby. I remember talking with my husband and discussing how the blue room was slightly larger than the mauve. Hence, we should sleep in the blue room because a bassinet could comfortably be set up next to our bed. The mauve-colored room, while smaller, had a walk-in closet which could store the baby's port-a-bed, bouncer, and a long-lasting diaper supply.

Two years later, we conceal our hopes for the mauve-colored room. In that room is now a guest bed set up for when friends and parents visit. It has also served as an oasis for each of us at different points in our marriage when the pain of conceiving has pushed us apart, pushed us to two separate beds. We don't like admitting this fact, but that is part of the truth, part of our story.

Next to the bed in the mauve-colored room is a desk where I sit and write and work. Books are stacked on the desk. Not in any order. Just scattered about on the desk. We had planned to put the crib where the desk and bed are now. Now we fill that area with what we think may be our new life. A life filled with professional promise, and a life in which a guest bedroom will always be needed. We will be the future aunt and uncle who can provide a retreat for a niece or nephew.

Coming home to this house, I sometimes remember the thoughts I had when we first purchased it. The room downstairs that now holds bookshelves and dog toys scattered about was supposed to be the baby's playroom. It was attached to the kitchen, allowing me to keep an eye on the baby who would be placed on a play mat in the playroom, as I prepared dinner. I imagine hearing my husband pull into the driveway. I would give the stew in the crockpot a quick stir and then pick up baby Henry or baby Sophia from the play mat in the other room, anchoring the baby to my hip while we wave from the window.

Today those hopes feel more like distant and drifting dreams. The house today symbolizes something different now than when we first purchased it.

The very terms of making and sharing a home together have changed. Now, we often sit in separate rooms of this house. The tension forces a physical distance between us. Our hopes and dreams of one day bringing a baby home, to this house, seem to be out of our reach. We come together only when we hear the dog bark and take her on a walk. Where do we go from here? And how do we fix us? These are two questions that lurk in every corner of every room of the house. No answers yet to those questions. No sense of how to move forward. No baby. Just this house.

# Waiting on Wanda and Everyone Knows

*Jaimie Peterson*

I went through in vitro fertilization (IVF) during the global coronavirus pandemic and isolated from work, family, and friends, which created unique challenges. During this time at home with my husband, I took time to reflect and make art. I made a series of drawings capturing the mundane experiences during my IVF process. These drawings gave me something to focus on and helped me be present in the process. *Waiting on Wanda* illustrates quite literally the time spent on the IVF cycle. My most poignant memory of this series is the drawing *Everyone Knows*. The clinic that I attended was in a busy medical building, and patients had to knock and wait for a nurse to assess them before coming into the office. While I could previously walk in unnoticed, during COVID-19 I had to wait outside for several minutes while many people passed by. I read and reread the signs to distract myself as I felt shame and embarrassment. I shouldn't have felt that way, but the stigma of infertility is tremendous and makes a monumental struggle even more painful. Months later, when I looked at the drawings in the series, my feelings of embarrassment and shame had been replaced with ones of strength and resilience.

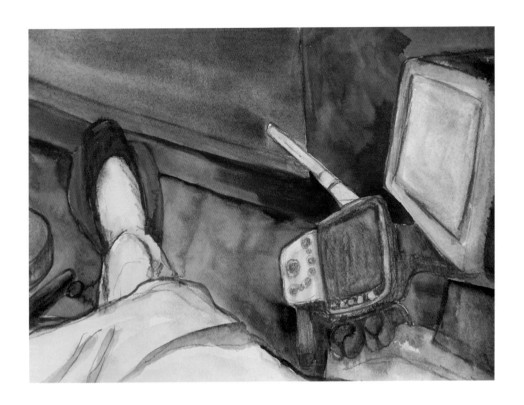

Jaimie Peterson, *Waiting on Wanda*, 2020, graphite and watercolor,
9" H × 12" W, private collection, Hunt, Texas

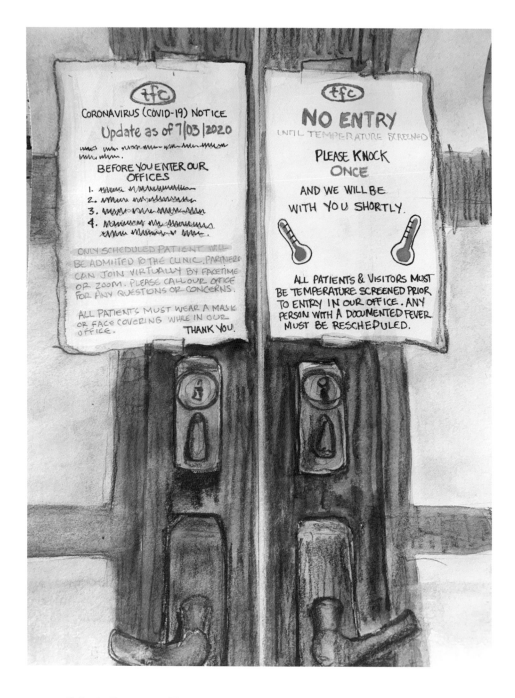

Jaimie Peterson, *Everyone Knows*, 2020, graphite and watercolor,
12″ H × 9″ W, private collection, Hunt, Texas

# Baby Ladies and Dog Lady II

*Faye Glen*

"Do you have children or dogs? If you have, then you will fit in nicely!" This was the question I was asked when I first moved to my village. Thinking of this conversation almost eight years ago inspired this work, which I hope captures the feelings of isolation, a sense of division, and a loss of identity. *Baby Ladies and Dog Lady II* is a version of a previous ink drawing with color added to convey the many feelings of infertility.

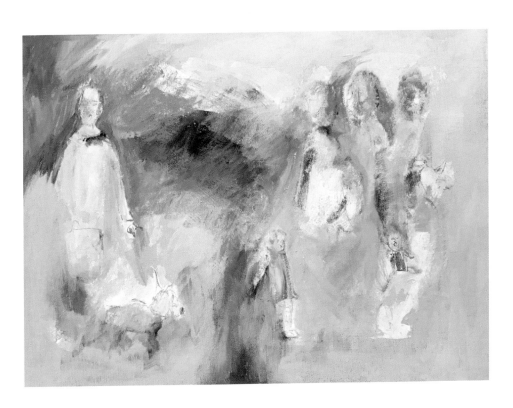

Faye Glen, *Baby Ladies and Dog Lady II*, 2016, print from
transfer with acrylic, 12" H × 16.5" W, private collection

# A Dog Is Not a Baby. Or It Is.

*Marjorie Maddox*

Just yesterday, outside our house,
a woman pushed a terrier in a baby carriage.

Just yesterday, a woman pushed out a baby
in our house. Her terrier is jealous.

I am jealous of your carriage, your baby, your terrier,
your house, your yesterdays, and push you out.

A poem is not an essay. Or it is,
waiting to be pushed outside this house of lines.

Come to me little poem, little terrier.
Inside the house is a warm carriage.

Inside a carriage is a house of yesterdays
pushing you into an essay on babies.

My sister is there with her terrier
waiting outside our house for a child.

Ride the carriage of yesterday with your terrier
into my house of now.

"Just yesterday" is everyday. Waiting.
A dog is not a baby.

# A Game of Twenty Questions

*Christine McDonough*

Christine McDonough, *A Game of Twenty Questions*, 2018, pen and ink,
8" H × 8" W, collection of The ART of Infertility, Ann Arbor, Michigan

# Baby Land

*Matt Quarterman*

It's expensive enough that not everyone
can go. We know the time saved up
we know the long journey
we know returning empty-handed
is hardest. Trade a plastic cup
of tokens for tickets to earn the prize.
There's the ultrasound screen,
there's the wheel of pills,
there's the calendar app, reminders and still
not enough. Not enough can be offered,
report card clean, but no one here judges,
the problem is ours together to create,
to solve. Some get there unexpectedly,
an osprey dives through empty oxygen,
the force of the flower the green fuse drives,
fool's gold, cruise boat, newsreel,
the heat death of everything, passengers waving.
They've run out of options. They hope
for the best at the turnstiles,
the monorail speeding away,
always away. Forget it—it's Baby Land.

# Seventy-Two Red Tears: Undeniable Proof

*Maria Novotny*

I was young, just twenty-four years old, when I first encountered difficulties conceiving. Not ready to face the fact that I may need to undergo fertility treatments if I ever wanted to carry a child on my own, I decided to go to graduate school. It was my escape, where I quietly hoped and prayed (to whomever would listen) that by some magic power I would become pregnant.

*Seventy-Two Red Tears* is a data visualization of the six years, twelve months, and seventy-two periods that serve as undeniable proof of my infertility. During the first few years, when my period began, tears would trickle down my face. I mourned the sadness that yet another month had passed without conception. However, as time passed and as I heard the stories of others who have had to live with infertility, my own strength slowly increased. No longer did every period begin with tears.

I made this piece shortly after I completed my dissertation. It serves as an homage to the ways infertility continues to be present in my professional and personal life.

Maria Novotny, *Seventy-Two Red Tears: Undeniable Proof*,
2017, acrylic on canvas, 24" H × 12" W × 2.25" D, collection
of The ART of Infertility, Ann Arbor, Michigan

# HSG

## Adi Hadar

This painting represents the three hysterosalpingograms (HSGs) I had to do. I had to do three attempts on three consecutive days because the first two times the doctor could not get the dye to successfully push through my fallopian tubes to see if I had any blockages. So when I came in again for the third time, I was very stressed out. I wrote to my doctor before the third time. She was amazing. Although she had another patient at the time, she came down and did the procedure herself to make sure that the HSG would work. The procedure was supposed to take ten minutes, but it ended up taking nearly forty minutes. I was happy because I felt like my doctor was really there for me.

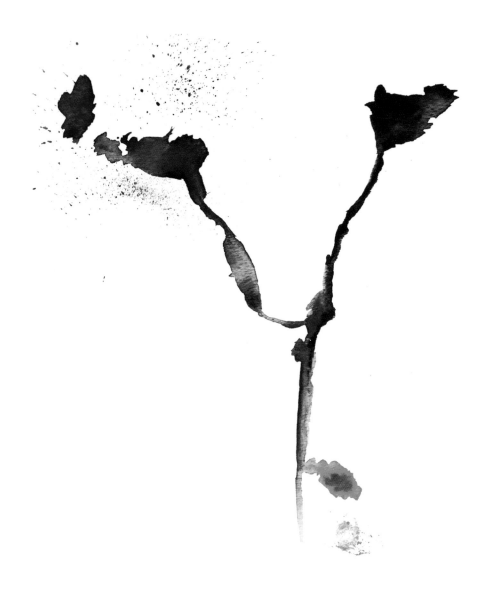

Adi Hadar, *HSG*, 2015, watercolor, 11" H × 8.5" W, private collection

# Infertility Sestina

*Robin Silbergleid*

This is how it goes: Say you want a baby,
say you are twenty-seven & alone,
as in uncoupled, there is no father
in this equation; you read *Taking Charge of Your Fertility*,
keep charts & graphs, cycle days & symptoms. Months
tracking cervical fluid, basal body temperature. Patient,

you wait, you bleed, you write; you are more patient
than you thought possible. Everyone is having babies
but you. You read messages online, every month
someone else gets pregnant; you feel alone,
certain of the diagnosis—628.9 Infertility
(female, unknown)—although you are only lacking a father's

DNA. Your child will have a donor, not a father—
the sample shipped on dry ice to the clinic. Patience,
your doctor says, you could be "Fertile
Myrtle." After the procedure, you go to the Baby
Gap, buy teeny white socks and onesies, a lone
purple cap. You imagine dressing your newborn months

from now. Cycles tick by in prenatals & pills, six months
of progesterone supplements & finally *positive*. "I'm a father!"
the nurse jokes when she draws your blood; she left you alone
with your legs in the air two weeks ago, your patient
checkout form on the counter, and in those quiet moments a baby
started to take shape, simple kiss of egg & sperm & bam—
                                        In the fertility

clinic waiting room you skim pamphlets on male factor infertility
& the magazines that have sat there for months
mocking you, *Working Mother*, *American Baby*,
*Fit Pregnancy*. It is your nurse, not some father-
to-be who sits with you for the sonogram, patiently
searching for the embryo, the heartbeat, & then she leaves you alone

to put on your clothes, to drive home, more lonely
than you have ever been. Not pregnant, your chart says, infertile:
blighted ovum, missed miscarriage, D&C at 11w4d. Patient
will call to schedule follow-up appointment in a month.

This is how it goes. You wanted to be a single mother,
but there is a black hole in your uterus, not a baby.

# The Fertility Patient

*Robin Silbergleid*

628.9 Infertility (unknown)
>>> For six months, numerical codes

628.9 Infertility (unknown)
>>> on insurance forms. The doctor

628.9 Infertility (unknown)
>>> writes in blue ink, her certain

628.9 Infertility (unknown)
>>> hand. She prescribes pills:

628.9 Infertility (unknown)
>>> Serophene, baby aspirin, progesterone.

628.9 Infertility (unknown)
>>> The nurse fills vials with blood—six

V72.4 Pregnancy, unconfirmed
>>> seven, eight. The nurse makes her pee

V72.4 Pregnancy, unconfirmed
>>> on a stick. In a cup. The nurse draws

V72.4 Pregnancy, unconfirmed
>>> another vial. The doctor asks

V22.2 Intrauterine pregnancy
>>> her to open her legs, inserts a catheter,

V22.2 Intrauterine pregnancy
>>> a probe. On the monitor, the sac

V23.9 Prenatal care, high-risk
>>> comes into focus, black, tiny. The doctor says,

V23.9 Prenatal care, high-risk
>>> *We can't rule out an ectopic.* The doctor asks

V23.9 Prenatal care, high-risk
>>> her to open her legs, inserts a probe.

632 Missed abortion

> Says, *The sac is bigger, but there's still nothing*

632 Missed abortion

> *inside.* They offer injections, surgery.

632 Missed abortion

> They offer Kleenex from a cardboard box.

632 Missed abortion

> The fertility patient thinks,

632 Missed abortion

> *This is my life, my blood—*

628.9 Infertility (unknown)

# Challenger

*Sharon McKellar*

I had a miscarriage after years of infertility and found myself sinking into a hole of despair. I have always had a passion for photography and felt at home in a darkroom. I realized that a darkroom just might rescue me. I bought myself a used film camera and went back in time to a place where the smell of chemicals, the feel of the tools in my hands, and the manipulation of images brought me comfort and calmed my anxiety. One of my first creations, while I relearned how to use chemicals, paper, and enlarger, was this photogram that represents my journey up to that point and how I was feeling in that moment.

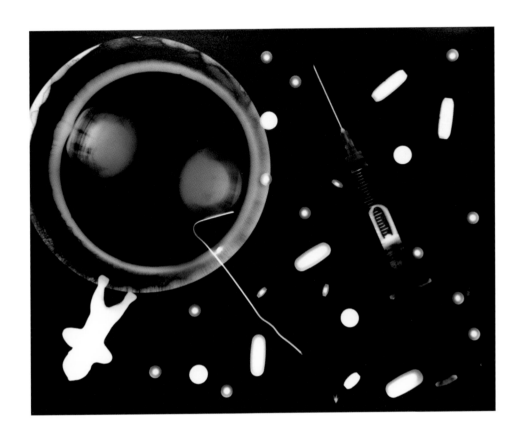

Sharon McKellar, *Challenger*, 2014, photogram, 8" H × 10" W, collection of The ART of Infertility, Ann Arbor, Michigan

# Infertility Study—Objects

*Lauree Jane (Sundberg) Schloss*

My fertility journey started in 2008, after my three-year-old brother was diagnosed, battled, and died from brain cancer in eight short months. I knew life was too short to wait to start a family. I was twenty-seven. I had no idea that trying to have a child would cause so much pain and heartbreak, year after year.

I began to make infertility art in 2012, when I was finally pregnant with our first child, a boy. We achieved that pregnancy from our third embryo transfer after our first IVF. In 2013, we decided to try for a sibling for him. We went through two additional IVFs and a total of five more embryo transfers. Two of those embryo transfers ended in miscarriage, one at ten weeks gestation—devastatingly, even after seeing a healthy heartbeat. Our eighth and final embryo transfer, in 2016, gave us our final miracles: boy/girl twins. This piece uses digital photography and manipulation to express my experiences with IVF and miscarriage.

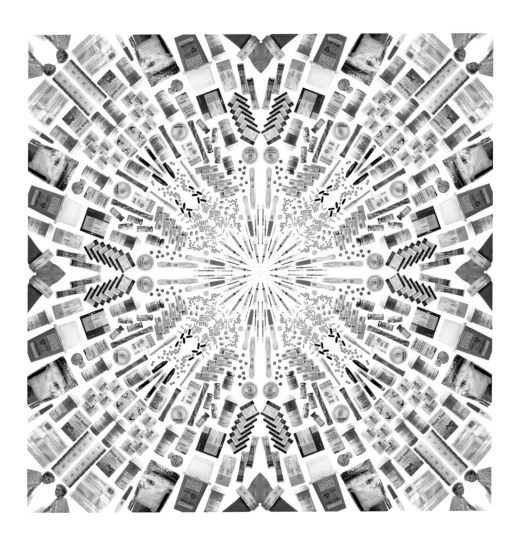

Lauree Jane (Sundberg) Schloss, *Infertility Study—Objects*,
2012, digital photography and manipulation, 20" H × 20" W,
collection of The ART of Infertility, Ann Arbor, Michigan

# Incantations for Fertility

*Margaret A. Mason*

    I.  Every month, watch your body for signs.

   II.  Divine your fortune from your basal body temperature chart.

  III.  Sink your head to the floor for child's pose.

  IV.  Sip muddy teas of Chinese herbs.

   V.  Swallow doses of evening primrose oil.

  VI.  Be still while needles perforate your skin.

 VII.  Gather egg-shaped stones anywhere you find them—the lakeshore, a garden bed, a mountain path, a parking lot.

VIII.  Call up the wish and blow the eyelash off your finger.

  IX.  Slather circles of geranium and clary sage oils on your belly.

   X.  Snug jasper inside your waistband.

  XI.  Secure a red velvet pouch of herbs and charms from your witch sister and sleep with it tucked under your pillow.

 XII.  Place a marker where the rabbit made her nest in the lawn and scare off the neighborhood cats.

XIII.  Plunge your hands in the soil and bury daffodil bulbs. Nibble at the dirt in your nails.

XIV.  Betray nothing when the palm reader fruitlessly searches your hand for child lines.

 XV.  See your growing stack of stones and whisper, *How will I survive this?*

# Mother's Day

*Carla Rachel Sameth*

It was 1995. Mother's Day, the day I'd been dreading. I was not a mother, the thing I desired more than anything in the world. Yet I felt strangely calm. The day before had been one of the bad days. I had yelled at Larry, "I can't take this rage!" while in a rage. Larry, raging, rose up in that way that frightened me, and I cowered, trying to hide under the fireplace ledge. I realized I needed to separate from him. Not just threaten but really do it. We'd been together since April 1993. Our entire time together had been spent focused on trying to make a baby.

*What's happening to me?* I wondered. Was it fear? Hormones? Prednisone? Prednisone was one of the many drugs I was taking for a confluence of auto-immune conditions that was thought to be causing me to lose pregnancy after pregnancy. Prednisone made me hyper, like a Labrador, or a toddler who needs a nap but can't settle down. I didn't know if I was crazier from the drug or from having been pregnant six times with no baby to show for it. Or maybe the insanity stemmed from trying to have a baby with a man I no longer liked—from being married to someone who now disgusted and frightened me.

Each new treatment came with its own warnings, off-label uses, and possible side effects. They were all necessary, according to my reproductive immunologist. In fact, I was told that I needed more treatment, which could cost more than $30,000 a month (impossible for us). All this to have a baby from my own body, with my egg and my husband's sperm. Looking back many years later, I see it seems absurd—this blind adherence to a path that proved so destructive to my health and psyche. Especially when I had always felt that there were many possible paths to motherhood.

When he was thirteen, Larry and his sister were sent away for a weekend trip with extended family. Their mother was ill and stayed behind. When they returned, their mother was dead. Larry and his sister moved in with their father, who was hardworking and stern. He had a job as a night-shift custodian, eventually moving up to supervisor. Larry never learned the cause of his mom's death. She had been a party animal, probably an alcoholic, cycling through a series of abusive relationships, one of which ended with her throw-

ing grits at her boyfriend. Although she'd been a favorite auntie to his cousins, the chaos of constantly moving and changing relationships probably kept her from being the mother Larry needed.

At age thirty, Larry made his way as best he could, eating odd meals at odd times, sleeping in odd places, going to bed with his clothes on. On this day, Larry sat in front of the television and ate leftovers. I had not filled his loss of a mother, nor had I become one. It was Mother's Day, and I had no baby. I longed to feel honored for having the heart and soul of a mother. I wanted the flowers, the card, the brunch, the recognition of my maternal being. Or at least acknowledgment of my unrivaled loss.

It seems that Larry and I should have shared this sorrow, but I hoarded it as my own. When we'd first started dating, Larry won me over with his same driving need to have a baby that I had. His younger cousins were already having children, and he felt too old to be childless. I had listened to his low, sexy voice and seen his shy, silent looks, convinced that perhaps still waters ran deep. I ignored a pattern familiar to me from my dad's explosive temper: the uncontrollable anger followed by remorse and, in my dad's case, consuming guilt. My dad had seemed the antithesis of a violent man, with his antiwar beliefs and strong family loyalty. Larry, too, seemed to be a man committed to social justice and, like me, wanted to create a family. But like my father, Larry was volatile. Their tempers often led to ugly words. Larry's sometimes led to pushing, shoving, once even choking. And to my running, screaming, crying, even picking up a fireplace poker and threatening to fight back.

Looking back at my marriage to Larry, I believe that perhaps he was driven by fear and a traumatic history. Like my dad, he probably wanted to be the best person he could. Like them both, I too have been driven by this need of wanting those closest to me to fix what was missing or broken within me. And I was unable to step away from their brokenness but rather wanted to control it somehow. Yet so much of my life I have found that one person's scars rubbing against another's can produce, to disastrous end, a wound greater than the scars combined.

In reality, the house I shared with Larry was not a home. Our house had no routine, no regular meals. It was a lonely life. We rarely spoke. This was not the landing place, the peaceful hearth. There was no baby. It was not the life I had imagined.

I was attending an abused women's group, and the women there were baf-

Carla Rachel Sameth

fled as to why I would choose to have a baby with a man who hurt me. They were going through custody battles because they had made the same choices in the past. A former expert on violence toward women, I acted as if I facilitated that group. Yet I was unable to tell them why I persisted in my quest to have a baby with Larry. I was determined to believe it was all possible—love, marriage, and baby—even if the danger signs existed before the wedding.

I had seen Larry lose his temper once in a union negotiation, but it wasn't until sometime after my second miscarriage that he got that angry with me. He had disappeared one night and didn't call. When I questioned him, he screamed at me and raised his fist. But after it was over and he told me he would go to counseling, I felt comforted when he sang the song by the Five Stairsteps, "O-o-h Child," telling me that things would get better. This pattern continued, his anger and my fight-or-flight response.

Larry listened to the same music: slow soul, love songs of the seventies by groups like the Delfonics, the Stylistics, the Chi-Lites. These were some of the songs we played at our wedding. We had a Black jazz band that played Jewish music, big-band tunes, jazz, and salsa and a former world music DJ playing all the other songs we wanted. My usually cynical brother-in-law commented about our wedding: "If only all of LA could be like this."

I found it much easier to create a wedding that brought together all the city's diverse (and sometimes warring) communities than to create a peaceful marriage.

A month before that Mother's Day in 1995, Larry and I had gone to see an infertility specialist whom we nicknamed "Dr. Doom." While he moved the vaginal probe in me, he complained about the overabundance of "faggots" at the World Cup, which was currently airing, and commented that Larry looked like Forest Whitaker. Larry stood behind him making gagging gestures. I tried to signal him to say nothing; I didn't want to upset the doctor with the vaginal probe still inside me. If his homophobia and racism weren't jarring enough, Dr. Doom told us that "people like you" should not have children or they might have problems. Who were people like us? People who had recurrent miscarriages? People who had difficult-to-describe natural killer-cell problems? People who . . . We had learned the complicated immunological explanations from Dr. Beer, our reproductive immunologist.

Better to do surrogacy, Dr. Doom told us, as if that were simple. "Get your sister to do it for you," he suggested. The one who gave blood to me for one of

the bizarre treatments, though she hated giving blood, just as she hated morning sickness? No, there was a limit to what one could ask.

After Dr. Doom removed the vaginal probe, he did a breast exam and said, "You have some kind of lump on your breast!"

"Uh, my breasts are cystic anyway," I told him, but we left thinking, *What is this?* I was the same age as Larry's mom was when she died suddenly. Larry looked shell-shocked, as if his life was going through some strange repeating spiral.

We walked out with instructions to get a mammogram and no clear idea of where we were headed. No baby. A marriage built entirely on trying to make a baby. A feeling of being less than desirable parents due to some deficiency of my stuff and his stuff and the intermingling that was causing killer cells.

You might think I was crazy—and I often was—to repeatedly revert to the feeling that I would simply dissolve if I couldn't have a baby. All I know is that with each new lost pregnancy, my level of crazy, the medication, the medical problems, and the debt just kept amping up.

You see, I was like the team of nurses in a critical care unit that tried to force a tube down my dad's throat while he lay squirming beneath them; they barely noticed his wild panic and distress. It's as if they were plumbers with a job to do, get that snake through the tube, their focus interrupted only by my insistence that they stop hurting my father. But they were undeterred.

I was relentless: We would create the perfect "We Are the World" family.

But my tenacity was no longer an asset. My unstoppable desire to have a baby, to grow a family no matter the cost, was destroying my body and my soul. We'd built up a house-size debt over the years of trying to have a baby—with no baby or house to show for it. Where I had once felt capable of having a baby on my own, I was now physically and emotionally depleted.

Walking around on our steep street the day before Mother's Day, I had heard chattering birds and smelled jasmine. I'd smiled at a little boy imitating his father, who was also really just a boy. I had allowed myself to notice these things, to be strangely and gratefully detached from my self-absorbed misery, to let myself feel a rare caress—sunshine.

But now it was Mother's Day, and there was no card, no flowers, no breakfast in bed—no child. I sat in the bedroom feeling sad, knowing I might not see anyone I cared about that day. My sadness bored me. Ennui and self-pity enveloped me. Why would this dreaded Mother's Day be different from any

other day? Like everything else that I insisted I might control through feral and misguided tenacity, I believed that Larry and I should endure this day together. I'd assumed he'd go to the movies with me, but instead he sat in the living room watching television; he didn't want to talk to me or even sit beside me. Where was the husband from our wedding invitation, "My Beloved, My Friend"? The hope, the precious love from almost a year and a half ago seemed far away. I did not ask myself what shame, what wretchedness, Larry wrapped himself in. That his mother was dead and what other meanings Mother's Day might have had for him—his own sense of failure, not being able to produce a baby like all his younger cousins—this is not what I was thinking about. I was able to see only my own suffering.

You might ask why didn't I just get in the car and drive away. I stayed. My internal broken record half whining, half ranting: *Always alone. Always alone.* Then the tears came.

The week before, Larry had shown me a recipe in the paper. "I think I'll make this for you on Mother's Day," he'd said. It was a coconut pie. That picture of the pie he planned to make for me on Mother's Day—it was like he understood. But I never would see that coconut pie.

On Mother's Day, while the sound of the television drifted into the bedroom, I didn't say all the things I was thinking. I thought he should just know. I just wanted to do something. Anything. For Mother's Day.

From outside, I heard families, children. I knew I couldn't live with Larry anymore. I plugged my ears like I'd done since I was little. I didn't want him to hear me crying, but, really, I didn't want me to hear me crying.

I was drowning in my gloom. Why didn't I go somewhere? Anywhere. I thought that maybe I'd go to the library to pick up books. My mantra chained me to my bed, though: *Always alone. Always alone.* Never truly suicidal, I simply wished to feel no more pain. Rather than die, different parts of my body malfunctioned just enough to keep me in constant discomfort. I had gone to more than 365 doctor appointments the year before, and I wasn't a hypochondriac. Somehow it all whirled together into a tornado of malaise: stomach pain, intestinal pain, rectal pain, and even car accidents, at least two of which had been my fault, causing further pain. With each miscarriage, the intertwining medical issues seemed to increase, and it was not clear what had caused what or what had revealed what. Sometime after the second miscarriage, one doctor told me that I might have lupus and that if I had a baby, the baby might

need a pacemaker at birth. When we arrived home, Larry washed my feet in warm, scented water, massaged them, and lovingly tucked me into bed. Later, another doctor explained to me that I was perhaps "at risk for" but not diagnosed with lupus. Two of my doctors—the reproductive immunologist and the gastroenterologist—said they believed that giving birth to a baby would solve many of my problems, though they couldn't truly articulate the medical reasons. Or maybe I just couldn't understand them.

That day. Mother's Day. Me—pregnant six times. Six unborn children clamoring to have been brought to life. I felt of death instead.

My friend María Elena called. At first I didn't hear the phone ring because of my plugged ears and wailing. But she called back, and as my sobbing gained momentum, she said that she was coming to pick me up.

I had met María Elena Fernández when I first moved to Los Angeles and she was living with her parents. We worked together at the International Ladies' Garment Workers' Union, and La Familia Fernández became my adopted family.

María Elena's parents were an immigrant success story, having bought the apartment building where they had raised their kids. They stood in for me as the family that would love me unconditionally. María Elena and I supposedly look alike—at least our most obvious features. Some people ask if we're sisters with our so-called ethnic features—"strong" noses (shorthand for "big"), pale skin, dark hair, prominent cheekbones. She was the friend who taught me the power of décolletage. She had thrown off the vestiges of being an obedient Catholic and discovered sexy.

For years, María Elena had listened to all my tedious despair—my back-and-forth ruminations that went on for days, weeks, months; my unceasing need to turn back the clock on irrevocable decisions—until one day, after seeing me through yet another crying jag of heartbreak, she told me, "*¡Basta!* It's simply too much to be witness to so much pain. I can't be that sponge."

One time before she told me *no más*, she picked me up and drove me about while I cried and she held my hand. For a moment I wished that she was my girlfriend. I wanted someone as smart and as beautiful as her for a soulmate. My dad asked me, after I'd come out as a lesbian, "Why not María Elena? That I could understand!"

"She's like my sister, Dad; that's incest," I said.

But on my motherless Mother's Day, she was still the one I turned to for

Carla Rachel Sameth

consolation when I was inconsolable. Before María Elena and her parents picked me up to go out to eat, I went to a local nursery to look for a present for Señora Fernández, my surrogate mother. All the plants looked like they had been skipped over. I found a section of spindly little cactus plants with tendrils that reminded me of *The Little Engine That Could*. They were sorry-looking. But that whisper of a red flower was endearing.

So much of my experience of Los Angeles was like this—cracked sidewalks with a lone sprig of fragrant purple wildflower fighting its way to the surface. When I first moved to LA in 1988, native-born Angelenos adored hanging out with me because I saw the hidden beauty that many new arrivals didn't. They saw only the ugliness, the tackiness, the smog, the failed dreams. My friends who were born and raised in LA neighborhoods—Silver Lake, East LA, Hollywood, Pico-Union—they had seen their hoods blossom fully, like the fuchsia bougainvillea and the purple jacarandas that arrive joyfully, inspired and reliable, every spring. Now, many years later, I live near a jacaranda tree wrapped up by a brilliant scarlet bougainvillea. I still have that same comfort, that leap of joy—they will always return.

The florist took the best-looking straggly cactus and, with a bright red ribbon, made it into a gift. The best I could do; my eyes were red and swollen with days of tears. No baby this Mother's Day, but I was going to celebrate *mi mamá de Los Angeles*—La Señora Fernández.

"Oh, yes, this will bloom again," the florist told me. *But I won't*, I thought. The cactus might endure, and I knew Señora Fernández would. She'd love this cactus, just as she took in all the worn, the beat-up, and the *acabado*—the wretched of the earth—knowing that someday they might perk up, too, after all, especially with her love, her cooking, and her *ponche* every Navidad.

Señora Fernández knew my struggle to become a mother. When I'd broken up with my fiancé but he wanted to reconcile, she encouraged me to go along with the idea of being back with him and to "just get pregnant." I'm not sure she would have given her own daughter that same advice, but at that point, she knew my spirit was slipping away with longing. She understood my single-minded focus on having a child; she lived for her own children. But now I needed her to bless my decision to give up, to accept my failure at becoming a mom through giving birth.

Three years after starting the journey, I needed to be done with my indomitable attempts to make a baby with Larry. I needed to be done with all the

strange treatments and blood transfusions. Years later, I would not remember the names of the treatments and diagnoses I had become so versed in. But I still remember one involving some kind of reconstituted red blood cells—blood taken from my older sister once and another time from Larry—like potions put together and pumped into me as subcutaneous injections. That one felt like a cigarette being burned on your arm and then having the flu for days. I remember the intravenous immunoglobulin (IVIG) being hooked up to get a blood supply pooled from more than one thousand strangers. I still remember the one doctor's warning that I might someday get some kind of disease from this theoretically screened donor blood.

On that Mother's Day in 1995, I let go into the nurturing arms of my adopted Mexican family. I gave Señora Fernández the spindly little cactus, which she graciously accepted and has nurtured all these years. And I accepted that I could—and would—go on to build my own idea of family, even if it didn't look like the one I had tried to force into existence.

It was time to regroup and find a way to finance adopting a baby, by myself. I would somehow deal with the mountain of debt we had created in the process of trying to make a baby the biological way. No, it wouldn't be as easy as going to the store and picking up a baby. I knew that from the company I was keeping, the various support groups for people who couldn't have babies, who couldn't keep a pregnancy alive, or who gave birth to babies who died soon after.

I felt a huge relief in letting go—in realizing that I could not, by sheer will, make the world conform to my desires. But I could do something to create a family as a single parent, something I'd set about doing before I decided to try with Larry.

But then, three days after Mother's Day, I still hadn't gotten my period, and because it was close to the time I could take a pregnancy test, again my thoughts revolved around the question "Am I pregnant?" And I was frightened because I started to believe that perhaps I was, and I knew it would feel like speeding into a brick wall with no brakes if I weren't. With that came desolation; I could not imagine spending every day for the rest of my life anywhere. Doing anything. I figured once I stopped trying to get pregnant, it would be open season on looking to medicate myself: painkillers, antidepressants, sleeping pills, everything they gave to women who were depressed and in pain

Carla Rachel Sameth

with what life had to offer. Everything I refused to take while I was trying to have a baby.

But it turned out I was pregnant with my son, Raphael, on that Mother's Day in 1995. And the sad little cactus I'd given Señora Fernández was named the Raphael Tree, after this baby with whom I fell undeniably, irrevocably in love.

The Raphael Tree is lanky, like its namesake, but not as tall, not as big as one might imagine it would be after twenty-one years. Its tendrils lean into the light, and these days Senora Fernández decorates it with loudly colored papier mâché birds covered with little feathers. It's sparkly, the Raphael Tree.

I had been trying to have a baby for years. I had been pregnant six times. Though I am able to recall almost a dozen circumstances under which I learned of positive, negative, and failing pregnancies, I am absolutely stripped of any memory of how I found out I was pregnant with the one that would become Raphael. When did I first learn it was going well? That the numbers were going up the way they were supposed to? When did I find out that May 1995 did, in fact, bring me a real Mother's Day? How soon did the famous reproductive immunologist Dr. Beer order the IVIG transfusion and assure me that the Chicago Medical School financial office was making arrangements—a special research grant—so we wouldn't have to pay the $30,000 a month to try to keep this pregnancy intact?

A couple of years ago, I emailed Larry to ask if he remembered when or how we first learned of that pregnancy, "the one that took." He emailed back: "Girl, I can barely remember when I took my last piss. LOL. I'll think on it."

I just remember that, for a moment in time, soon after Mother's Day 1995, we too believed our dreams of family were possible.

We separated eight months after our son was born.

# *Tainted*

## *Christine Moffat*

Infertility is a deeply emotional journey. The darkness in the piece represents the anguish of multiple miscarriages and lost hope through the years of infertility treatments, which left me despondent and cynical. The brightness is the way I wished I could feel about conceiving, but it was tainted by the truth of reality. The bright orbs represent my future hope in conceiving while acknowledging the subpar quality of our embryos. I created *Tainted* to show this dichotomy.

Christine Moffat

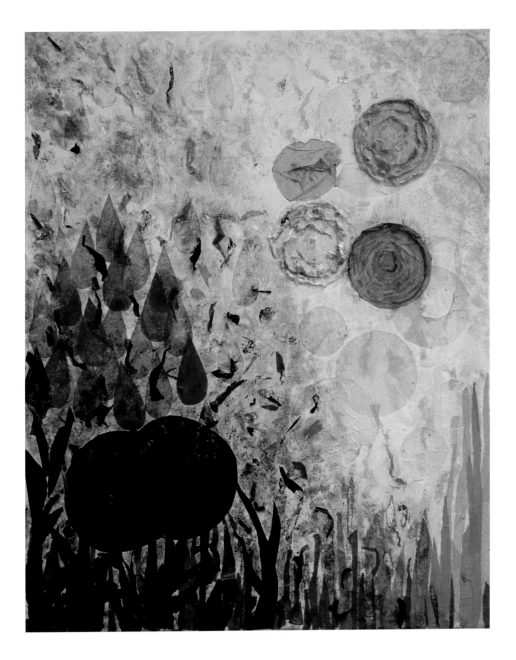

Christine Moffat, *Tainted*, 2017, mixed media, 20" H × 16" W, on loan
to the collection of The ART of Infertility, Ann Arbor, Michigan

# It Is Easier for a Camel to Pass through the Eye of a Needle than for a Fertile Woman to Understand Infertility

*Gwenn Seemel*

I always assumed I'd have children one day. It wasn't something I felt strongly about until I was diagnosed with endometriosis, a disease that often causes infertility. Suddenly the future I hadn't cared much about seemed important. The maybe-never of the diagnosis put me in a "should I even try?" frame of mind.

After being told repeatedly that the urge to reproduce is primordial, I turned to nature to look for the origins of common baby-making assumptions. To begin with, I found only the animal version of "first comes love, then comes marriage, then comes the baby in the baby carriage." But I wasn't convinced. Slowly but surely, I unraveled the mystery of this seemingly universal formula. I started to understand that the scientists who described animal behavior could be as stuck in a nursery rhyme version of normalcy as I was, and I began to find scientists who weren't.

As I researched, I broadened my question. I could see that this wasn't just about baby-making. It was about all the things that we think people have to do and be in order to qualify as "natural."

For all my investigating, I still couldn't control whether or not I could have children, but I could decide to create a children's book instead. The mom and baby shown in this painting are one of fifty-six species featured in my book *Crime against Nature*, because for dromedaries, like for many animals, conception and childbirth are difficult.

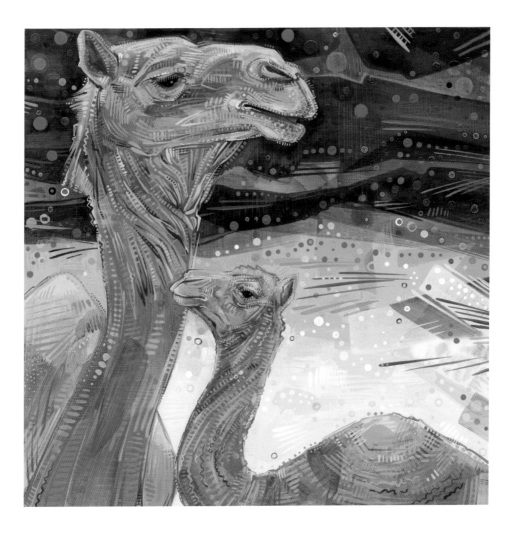

Gwenn Seemel, *It Is Easier for a Camel to Pass through the Eye of a Needle than for a Fertile Woman to Understand Infertility*, 2012, figurative painting, 10" H × 10" W, private collection

# She's Not My Mother
## Fertility, Queerness, and Invisibility

*Jennifer Berney*

"I'm dreading this," my partner, Kellie, warned me. We were on our way to the reproductive clinic, the only fertility specialists in the small town where we lived. It had taken us years to get this far—first there had been months of discussions on whether or not we'd have kids, followed by months of discussions on how we'd source sperm. Then there were the months we spent poring over catalogs and donor questionnaires. I assumed we were done with the hard part. Now we were on our way to an intake meeting—a formality, I thought. The clinic, though we'd never been there, already held the sperm we'd purchased in its cryogenic freezer.

"Relax," I told Kellie. "This is Olympia." We lived in a town that was rumored to have the highest per capita lesbian population in the world. I reassured us both that they must have treated plenty of lesbians.

The waiting room was not what I expected. I had imagined leather couches, warm lighting, and potted plants—the kind of ambience that might suggest to a client that the thousands of dollars they were spending was being directed, at least in part, to their own care and comfort.

Instead, I opened the door to find two rows of uncomfortable chairs, outdated wallpaper, and fake plants frayed at the edges. The reception desk was empty.

Kellie sat anxiously, her face hidden behind her long hair. Normally, she moved through the world with ease. Just a week earlier, she'd amazed me when she met me for happy hour at a bar that I normally went to without her. It was the kind of place where the waitresses are notoriously grumpy—it's part of the decor, and you tip them extra to apologize for being a customer. That day, the waitress and I had a typical curt exchange, but when Kellie arrived she greeted the waitress by name. "Hey, Annie," she said, sliding into the booth.

"How you doing?" the waitress responded. It was the first time I'd seen her face bear any expression other than a scowl. They bantered for a moment before Kellie ordered a beer.

"You know her?" I asked Kellie, awestruck.

"Not really," she said. "We've just both been around for a while."

It would never occur to Kellie to fear a grumpy waitress. It was a rare situation, such as being in a clinic like this one, that made Kellie feel she had to hide.

Eventually, a nurse called my name and led us down a corridor to deposit us in a room with a giant desk. "Dr. Lu will see you in a moment," she explained. "And then you'll consult with Dr. Norman."

We sat in silence for several more minutes. Kellie marked time by tapping her foot.

Dr. Lu entered through a door at the back of the room, and we rose to shake his hand. He was a middle-aged Korean man, broad-shouldered and lean.

"Who's this?" he asked, nodding at Kellie. "Your mother?"

My heart dropped. A bank clerk once, years ago, had made the same assumption. "Is this your daughter?" she asked Kellie as she collected the forms we'd just filled out. We were opening our first joint account together. Kellie shook her head and said, "Nope. Definitely not my daughter." I'd stood there wide-eyed, waiting for Kellie to finish the correction, but she never did. If she had, we would have had to field the clerk's embarrassed reaction. Instead, the clerk gave a strained laugh and disappeared with our papers. Though it was a fleeting moment, I'd never forgotten it—the shame of being unable say aloud who we were to each other, the icky sinking feeling of having your lover confused for your parent.

"My partner," I said now. I watched Dr. Lu's face to see if he noticed or cared about his error, but his expression did not change.

"Okay, fine," he said, and looked at me. "You'll carry?"

"Yes."

He took out his clipboard. "How old are you?" he asked.

"Twenty-eight."

"How many times have you been pregnant?"

"Zero."

"You've never been pregnant."

"No."

"Are you sure?" he asked.

Was I sure? I was sitting next to my lesbian partner, the second of only

two lovers I'd had in my life. I could not even begin to explain to him how sure I was. Dr. Lu stared at me, waiting for my answer. I looked to Kellie to see if her eyes would mirror my rage. In my mind, the worst-case scenario had never been this dramatic. I'd imagined an office that felt like the real-world incarnation of all those brochures and websites I'd looked at. I imagined doctors who were welcoming, who smiled at us and treated us like regular patients but who quietly signaled their disapproval. I imagined they might avoid making eye contact with Kellie or that they'd give us endless forms that asked for the husband's name and information, but I never imagined they'd ask if Kellie was my mother or question my own body's history.

"Yeah, I'm sure," I told Dr. Lu. "I've never been pregnant."

His eyes returned to his clipboard. He kept rattling off questions, and I kept answering them; my entire body was tense as if I were waiting for the right moment to flee. I could feel the same tension in Kellie's body. It was like we were one animal.

The questions ended. Dr. Lu didn't waste any time with small talk. "Dr. Norman will come soon," he informed us while rising with his clipboard. This left Kellie and me alone in the office once again.

"I want to walk out of here," she whispered.

"Do you think we should?" I asked. My heart raced. I knew she was right. We should have flown out of there, hand in hand; we should have torn through the parking lot and driven home. But I felt frozen to my chair.

"I will if you want to," I said. But I stayed put.

This was the one fertility clinic in our town. This place had a file with my name on it. They were already storing our sperm for us—I'd arranged it over the phone. Their rates were surprisingly reasonable. I didn't want to wait another month. And besides that, I couldn't imagine walking out mid-appointment. What would we tell the receptionist? I straightened my back in the chair and told myself it didn't really matter where or how we conceived our baby. Sure, this clinic sucked. But did this process really have to be magical?

"Maybe this next doctor will be better," I said.

Dr. Norman entered the room in his white lab coat and shiny brown loafers. He introduced himself with a soft voice; his hand, when I shook it, was dry and cold. He resembled Mister Rogers, only taller, stooped, and aloof. He did seem like an improvement on Dr. Lu, if only because he wasn't barking questions at me.

"So," he said, looking over the clipboard that Dr. Lu must have handed to him, "we want to have a baby, and we've agreed that the younger one of you will carry."

Kellie and I nodded. He looked up. "I'm going to write in your chart 'male factor infertility.'" Kellie and I laughed together, assuming he was making a joke. Male factor infertility, as in: my partner did not produce adequate sperm. My partner, of course, did not produce any sperm. The male factor was simply missing from our equation. But Dr. Norman didn't laugh with us. He lifted his pen and proceeded to scrawl exactly that. *Male factor infertility.*

There was a long pause that followed, a pause that seemed to hold the distance between us like a puzzle. We were amused; he was serious. Months later, as I lay awake in bed one night, I would finally understand: Dr. Norman had no medical template for us. For him to treat us, for him to send us through his system, he had to document us as if we were straight, to offer us a diagnosis. It didn't matter that we were undiagnosable, that, as far as we knew, our bodies functioned exactly as they were designed to. We were coming to him for a service, not a cure. There was no place in his chart for him to simply write *lesbians.*

As it turns out, there's no place on anyone's chart to write *lesbians.* There wasn't then and there still isn't. Male factor infertility remains the standard diagnosis for all lesbian couples seeking intrauterine inseminations. It's a term that inserts a man in the equation, when there is none. There is no infertile man; there is simply a need for sperm. The distinction may strike some as unimportant, but it reveals the medical industry's insistence on viewing the world through a heterosexual frame. To say that Kellie and I suffered from male factor infertility was to lie a little or to dance around the issue. The refusal of the system to name what is—the refusal to use language that acknowledges queerness—is an action familiar to all kinds of queers who so often hear our partners referred to as "roommates" or "friends," who are regularly misgendered or dead-named, who move through life with many old friends or family members who know our identities but refuse to ever say them out loud.

Kellie and I left the office that day with instructions to call their office once I approached ovulation. During the car ride home, Kellie and I barely spoke. Instead, we looked straight ahead at the road, the crosswalks, the traffic lights; we replayed the uncomfortable moments on a loop in our minds, privately, as if by not speaking them aloud we could erase them.

———

Though Kellie and I could have chosen to never return that day, we went back and kept going back. I saw Dr. Norman every month, and every month I hoped it was the last time I'd ever have to see him. I hoped, of course, that I would easily become pregnant and that Dr. Norman would blur into one of many less-than-amazing doctors I'd seen over the course of my lifetime.

But I didn't get pregnant easily. Failure took on a familiar shape in my house. It began in the bathroom, where, as I approached my period's due date, I pulled down my pants with trepidation, afraid of what evidence I'd find. Sometimes I wore black underwear, half hoping that if I couldn't see the blood, then it didn't exist. But the blood came anyway. It revealed itself at first in streaks of pink on a wad of toilet paper. I tried to convince myself that maybe this wasn't a period. Maybe this was implantation spotting—a sign that an embryo was making a home in my uterine wall. Maybe, I told myself. Maybe this little spot would be the only blood I'd see for months. I willed my brain to imagine this: month after month of clean underwear. It seemed inconceivable—like a feat I'd have to achieve through sheer will. But later, inevitably, my period came in bright red torrents that could not be denied.

As I bled, I waited for my next chance.

I suspected that something was wrong. I felt certain that we were success-fully conceiving, that every month sperm penetrated egg, creating a zygote whose cells divided and grew. But there was a failure in my body; that zygote couldn't find a place to dwell. It would not implant. My mind carried an image I'd found in my research: that of a blastocyst burrowing into a uterine wall. It looked messy, like it was digging up soft and fertile earth. I wondered what my own terrain looked like: Was it rocky, pocked, and hard? Was there a reason that no embryo could make a home in me?

"I think there's something wrong with me," I told Kellie after every failure.

"These things take time," she answered.

On our third insemination visit, I asked Dr. Norman at what point we should worry, as if worrying weren't already at the center of everything I did. His face registered nothing, and at first I thought he hadn't heard me. I pre-pared myself to ask the question again. Then he put a hand above my hip and pinched at my flesh. I squealed involuntarily—I was ticklish and surprised.

"You may not have enough chub," he told me. "Go to Baskin-Robbins."

54                                                          Jennifer Berney

I said nothing. I was not underweight. I had plenty of chub. But apparently, that advice was all he had for me.

It makes sense to me now. I had made the mistake of assuming that medicine in general, and fertility medicine in particular, would be flexible—that they yielded to the needs of each individual patient, that Dr. Norman—or anyone—would respond to my particular situation. But fertility diagnosis is intractable, and it's based on an assumption of heterosexuality. A couple begins treatment for infertility after a full year of unsuccessful trying. For the average straight couple, this simply means a year of unprotected sex. But a year of heterosexual intercourse—sometimes casual and always free—was different from my situation, my months of charts and ovulation predictor kits, the sperm that had been examined for motility each month under a microscope, the thousands of dollars we had already spent. Every try so far had been expensive and precisely timed. It seemed like a waste to just keep trying for a year, when I already suspected my body might have a specific and treatable problem.

I would later learn that if I had lived in San Francisco, and if I had gone for inseminations at our sperm bank where the majority of their clients were lesbians, they would have steered me toward fertility testing after four unsuccessful tries. They had developed this protocol because they saw and understood their patients.

But Dr. Norman didn't see or understand me. To him, I was an oddity, a patient who didn't fit in his mold. Instead of adapting his protocols, he more or less ignored me.

To this day, there still aren't any widespread protocols specific to lesbians and other queer folks and single women who are trying to conceive with donor sperm. We show up at sperm banks or fertility clinics and are treated like anomalies in spite of the fact that we are our own demographic with specific needs, needs that might be easily studied, assessed, and responded to. It would be so easy, I believed then and still believe, to simply decide that for people who are tracking their cycles and precisely timing their inseminations, four months can replace the standard one-year guideline.

A full year after we'd begun trying to conceive, I left Dr. Norman a voicemail. We had used up our last vial of sperm, and now my period had arrived. I wondered if he had any advice.

It was true that so far he hadn't been kind or useful. But now, I realized, we had been trying for so long that we had passed the one-year mark. Maybe he would finally have protocols for us, the same ones they applied to straight couples who'd spent a year having unprotected sex, and maybe those protocols would diagnose my problem. Maybe he could fix me. And so, though it was a Sunday afternoon, I picked up the phone and asked him in a voicemail. We had been trying for a while now, I reminded him. Now we were out of sperm. Should I be taking some tests? Were there treatments I should consider?

His answer was waiting on my answering machine when I returned from work the next day. I could picture Dr. Norman at his desk with his reading glasses on, examining our file with pen in hand. "We normally recommend in vitro after six failed inseminations." He spoke slowly. "As you said, you've had ten of those. So that would be my recommendation. In vitro fertilization."

My stomach dropped. I knew about IVF. It was the thing I had told myself I'd never do. For one thing: the money. So far we'd been spending hundreds of dollars each month on our attempts, and those hundreds had added to thousands over time. But in vitro required an investment of $13,000 for a single try. It wasn't just that I didn't want to spend that kind of money; I imagined how I would feel that month, in those two weeks leading up to my period's due date. Wouldn't it feel like standing at the blackjack table, having put $13K on an arbitrary number? Wouldn't it feel like watching that wheel turn and turn and turn, not for a minute but for fourteen long days?

Months and months ago, before we'd ever started trying, it had been easy for me to declare that I would never subject myself to this. I believed then that I was fertile. But now here we were. The option was on the table. I was looking at it.

I had always imagined that there would be a series of steps in between inseminations and in vitro. I had imagined that before they took my tens of thousands of dollars, they'd at least draw my blood and give me an ultrasound. I wondered now if my orientation was once again the issue, if fertility protocols were so rigid, if doctors were so inflexible, that I had no chance of getting the care I needed.

When straight couples entered Dr. Norman's clinic, they paid the same $200 consultation fee that I did. In our case, that fee had paid for a simple male factor infertility diagnosis, while for straight couples it launched a series

of investigative tests. Men provided samples for semen analysis. Women had blood draws, urine analysis, and ultrasounds.

Dr. Norman had skipped this step for Kellie and me, which was reasonable. We had no semen to analyze, and at the time I had no concerns about my own fertility. But I had trusted Dr. Norman to manage my case accordingly, to decide at some point that it made sense to give me the same workup he gave to any straight, married woman who came into his office after trying for a year.

Instead, it seemed like we had skipped that square in the board game, and going back was inconceivable to him. He'd given us our diagnosis. Male factor infertility. We'd already exhausted the limits of his curiosity.

When I told Kellie that Dr. Norman had recommended IVF, she laughed. "We're not there yet," she said. "It will happen when it's meant to happen."

"You don't know that," I said. I no longer believed in the inevitability of happy endings.

"Yeah," she insisted. "I do. We're just going to take a month or two off. We're going to hike in the desert, come home, and figure this out."

Some weeks earlier, on one of winter's dreariest days, Kellie had convinced me to buy tickets to New Mexico so we could walk under a different sky for a while. We charged it to the credit card. It wasn't much compared to what we'd been paying for sperm. I knew it was a good idea, and as I stared at ticket fares, I couldn't say out loud the reason I was hesitant: What if I was pregnant by then? Would I enjoy the vacation? Would I want to leave home? I imagined that any pregnancy once achieved would feel tenuous and that airplane travel, hiking, sleeping in an unfamiliar bed might feed my anxiety. Instead of looking out to the sky, I'd be checking my underwear for traces of blood. But now, it turned out, the trip was well timed. We would leave in a week. My period would be over by then. Because we'd be skipping the next cycle, my longing would carry less urgency. In New Mexico, I would simply pretend that I lacked nothing. I would be a woman in the world, whole in my body.

"Okay," I told Kellie, and I filled my mind with landscape, with red dirt and sagebrush instead of eggs and tubes and motile sperm.

The Sunday before our departure, my bed was covered with piles of clothes, my suitcase on the floor as I tried to decide what I would pack. So far, I'd packed two pairs of jeans, one pair of shorts, and five T-shirts. I was happy to leave behind the paraphernalia that had been ruling my life for the past months: the basal thermometer and the ovulation predictor kits, the san-

itary pads and the tampons. But just as I was stuffing a rolled-up pair of socks into my hiking shoes, I felt an inexplicable drip between my legs—inexplicable because my period had ended days ago and I was still a week away from ovulating.

In the bathroom I discovered a small spot of blood, the kind of spot that would have been normal if my period had just arrived. To bleed twice in a month was unprecedented, and so I did something equally absurd: I took a pregnancy test. I had a stockpile of them in the bathroom cupboard because they helped me spread out the disappointment of my period. Some months, when the anticipation of my due date was unbearable, I would take a test. When the result came back negative, I knew to expect blood. But this time, for the first time, I could make out a clear double line that indicated a pregnancy.

I wondered if there was any way that I might actually be pregnant. I wondered if some people had periods during the first months of pregnancy or if some stray ball of living cells might have survived the flush of menstruation and had just now decided to make a home in me. Google confirmed that vaginal bleeding during pregnancy was not unheard of.

I tried to believe that I might be hosting some kind of miracle, while another part of me hovered in judgment. *That's pathetic*, I told myself. *You are having a miscarriage. Not even a real one.*

I added a package of sanitary pads to my travel bag and decided that the next two days would reveal the truth. If I continued to spot and not bleed, then maybe I was growing a baby. But if I began to bleed in full, there would be no reason to hope. I did not disclose my crazy hope to Kellie. I simply complained that our vacation would include the inconvenience of my blood.

Madrid, New Mexico, was a kind of alternate universe, a small town with red hills and a wide blue sky. A two-lane highway ran through the town's center, which included a collection of coffee shops, a pizza place, art galleries, and a tavern called the Mineshaft. Madrid was originally a mining town, and in the hundred or so years since the mines had closed, both everything and nothing had changed. Everything had changed in that the miners had left forever. Nothing had changed in that, when the hippies and artists moved in, they didn't tear anything down or build anything up. Instead, they reshingled the mining cabins, installed indoor plumbing, and hung Tibetan prayer flags on the porches. There were no billboards anywhere, no buildings higher than an average house, and if you wanted to make a phone call, you either had to

use the pay phone outside of the pizza place or tilt your cell phone toward the sky and hope for reception.

I bled in Madrid, bright red blood that came steadily. I waited for the flow to taper as it would have with a normal period, but instead it persisted. On the fourth evening of our trip, Kellie and I walked along a trail that cut into the desert hillside. The trail had once been a railway, but the coal cars had long ago stopped running along the tracks, and now it allowed us to walk the length of the town at dusk, to look out over the cluster of roofs as the sky changed and the air cooled. These were the moments when my body let go of expectation. It was enough to feel the air against my bare arms.

But as we neared the end of the trail and descended into town, I felt a new gush of blood. By the time we hit Main Street, that blood had spread well beyond my underwear. I could feel it against my thighs and in the fabric of my shorts. Town was quiet except for a few couples sitting outside at cafe tables.

"I can't believe how much I'm bleeding," I whispered to Kellie. All afternoon as we'd hiked in the Cerillos desert, I'd ducked behind shrubs or abandoned mines to change my pad and stashed the rolled-up wad of trash in my front pocket. I had packed four pads in my purse and assumed that two of these were overkill, but now I was completely out.

"Are you worried?" Kellie asked. A flash of concern crossed her face.

"A little," I admitted. I imagined myself waking in the middle of the night to a literal puddle of blood spreading far beyond the width of my body. We were far from home, and I had no idea where a hospital was.

"Maybe you should call the clinic," Kellie suggested.

"Dr. Norman won't care."

"We pay him to care," Kellie pointed out. She shook her head. Her worry for me quickly metabolized into disdain for Dr. Norman.

I didn't want to call from the town center, so Kellie and I walked the half mile to the casita where we were staying and I scrambled up the desert hill, tracking the bars on my phone. The sun had gone down, and the sky was now a dimming purple-gray. I found a reliable spot next to a large prickly pear cluster, and I crouched beside it to dial. The recorded voice instructed me that in case of an urgent concern, I should leave a message and wait for Dr. Norman to return my call. I described my bleeding into the receiver, hung up, and waited. The flow of blood had paused, but I still hadn't dealt with the spill now settling into the fabric of my shorts. Sweat from earlier in the day had

dried on me, and I was beginning to feel cold. I wanted a shower. I wanted to wash it all away.

I wondered how long I would wait here. In the casita below me, Kellie had turned on the light and was likely opening a bottle of wine and starting a pot of water as I'd asked her to do.

My phone rang, and I answered it. Dr. Norman announced himself. "You're having a miscarriage," he told me. I'd known this for days, and yet I felt relief in hearing it spoken by a doctor. But Dr. Norman didn't pause for my reaction. Instead, he instructed me to seek medical care if I bled through a pad or tampon every half hour. *Pad or tampon.* Though he'd assessed the tilt of my uterus with his gloved hand, and though he'd prodded at my cervix with the tip of a syringe, it surprised me to hear him mention these intimate objects.

"I'm in New Mexico," I said. In my message, I had explained I was on vacation, but I wanted to make sure he understood. "So I should find an ER if I start bleeding that much?"

"Every half hour is the guideline," he repeated. "Otherwise you're fine."

I hesitated before hanging up, as if he might offer something more. Instead, I heard a click.

I hated him. Or maybe I just hated that I was dependent on him—an uncaring stranger—to help me realize my dream of a future family.

I tucked my phone in my pocket and looked out at the sky. The first stars had appeared. Dr. Norman had said I was "fine," and though I resented his indifference, his assessment—from what I could tell now—seemed accurate enough. My bleeding had peaked with the heat of the day and with the motion of hiking. But the gushing had ended. It wouldn't return.

On our last morning in New Mexico, I sat outside again with my coffee. The morning air was cool, but the sunlight warmed me. The wasted hills were familiar to me by now. As I looked out at them, my future spread before me: blank. In that blankness, for the first time in a long time, I found comfort rather than despair. The feeling surprised me.

I assessed the things I knew for sure: I knew I didn't want to see Dr. Norman anymore. I knew that I didn't want to pay money for sperm from men I'd never met. I knew that I still wanted to have a baby.

I assessed the things I didn't know: I didn't know what was wrong with my body, why it rejected, month after month, the cluster of cells that might

have grown into a child. I didn't know where our sperm would come from if not from a catalog. I didn't know for sure that I would get the thing I wanted.

For once in my life, for that morning at least, I was okay with not knowing. Maybe I didn't believe in fate anymore, but I found myself nurturing an impulse to move forward, to let go of the things that didn't serve me, to create room for the things that would.

That morning, in my mind, I finally fled Dr. Norman's office the way I should have on the day of our initial appointment. I never said goodbye, and I never went back. Because our vials of sperm were all used up, they were storing nothing for us and we owed them nothing.

We were free now, and starting again from scratch.

# Collecting Seeds

*Crystal Tursich*

After suffering a miscarriage in 2018, I turned to my camera to sort through my emotions. Each image was carefully constructed, incorporating personal mementos and symbols as well as images of myself. The resulting series serves as a collection of artifacts, creating a visual archive of my experience.

*Collecting Seeds* was created after my partner and I began to seek infertility treatments in 2020. Nearly two years after my miscarriage, the overwhelming weight of months of trying to conceive with no success was daunting. In this image, the bountiful pomegranate, an ancient symbol of fertility, is being ripped apart by my own hands; deep red juice from broken seed sacs splashes onto my fingers, and a glass dish collects fallen seeds. The action depicted represents the frustration of infertility.

Crystal Tursich, *Collecting Seeds*, 2020, digital photography,
20" H × 16" W, collection of the artist, Columbus, Ohio

# *One Pill, Two Pill, Red Pill, Blue Pill*

*Shannon Novotny*

This watercolor visually lays out the daily pill routine my husband and I performed, punctuated by messy, blood red splotches that represent the disappointments of secondary infertility and loss. Initially, the colorful pills in different shapes and sizes seemed distinct and memorable, but after weeks and months and years of intake they assumed a uniformity that corresponds to the numb and hopeless feelings of recurrent loss. Yet the unremarkable repetition of the process carries within it a semblance of hope that the cycle will end, that popping the pills will someday lead to a successful pregnancy.

Shannon Novotny

Shannon Novotny, *One Pill, Two Pill, Red Pill, Blue Pill*,
2017, watercolor on paper, 16" H × 20" W, collection of
The ART of Infertility, Ann Arbor, Michigan

# Inheritances

*Lisa Grunberger*

## 1954, NYC. THE AMERICAN DREAM: WITHOUT A UTERUS

By the time my parents came to America, in 1954, from the new state of Israel—my father, thirty-four years old, a Holocaust survivor who had arrived in British Mandate Palestine with nothing but my Omama's sister's name, Tante Gisela Weiss, and my mother, twenty-nine years old, the eldest of three children—they were, I imagine, tired. One day, climbing the subway on the way to work, my mother fainted, a pool of blood around her.

She woke up without a uterus. She was thirty years old, and although married since she was just eighteen, she and my father were still childless. Two years later, they made the unlikely move for immigrants of that generation—all due to my moxie mother's *sekhel*—and built a house in a "new development" on the southern tip of Long Island, a sleepy fishing town, about forty minutes from Queens.

My parents settled into this little hamlet of the American dream and into a life without children. "That's what life dealt me," my mother would say to her new friends, as they played mah-jongg on Tuesday nights. She had a stoic disposition but was joyous and witty; had she had a formal education beyond high school in Israel, she would have been a Ruth Bader Ginsberg, a Golda Meir, a Dr. Ruth Westheimer. There was nothing she couldn't do, and if she didn't know how to do it, she was fearless in figuring it out. Solving problems was her specialty. In later years, she would put on her granny glasses, which dangled off a chain around her neck, and read the instructions, throw them down, read a recipe, throw it down, and purse her lips in such a way that meant, *Show me what you got, I'm ready*. Very Israeli.

Mom became the aunt to many of the children on the block. And then, when she was about thirty-seven, she decided to adopt a baby. Just like that, she thought, why shouldn't I become a mother? The first adoption, for which they sent out engraved baby announcements, failed. They went to Miami to pick up baby David Lawrence, and the birth mother changed her mind. I imagine it was devastating. She never talked about it with me.

Given their separate beds, I thought: *No wonder why you didn't have your own biological kids.* I might have even said it to her once, while she was stirring soup, mending clothes, or reading the Improve Your Vocabulary column in *Reader's Digest*. And had I said it snarkily and provocatively, she would have sat me down and explained about how she and Deddy, for she pronounced *a* like an *e*, had wanted to have children before they adopted me, but it just didn't happen. I don't recall a conversation in which I probed her further.

Nothing like: Did you go to infertility doctors in Israel during the war? It was understood, of course, that the "war" was World War II just as "the city" was always New York. Wars and cities. She had grown up in a small town outside of Tel Aviv called Holon to a cross-eyed, eccentric German mother and an observant Polish father, who went to synagogue every morning before he climbed atop houses and laid roofs. She spoke German and Hebrew and a little Arabic. As the first born, she was responsible, methodical, and mature beyond her years. When her mother would go out to get milk and eggs and potatoes, she would come home with chocolate and no eggs, and my mother's father would never complain or let the children complain about their eccentric mother. He would fix it and stand by the stove and cook whatever they had. My mother, like her father, was resourceful.

I didn't ask her about infertility clinics, for this was British Mandate Palestine, and it was 1943. I wear their gold wedding ring, engraved in delicate cursive by one of the boys who came over on the illegal ship my father took from Romania to Jaffa. *To Rachel Grunberger, 1943. Love, Robert.* I wear it in front of one of the diamond rings she never took off, a diamond set in the middle like a flower with small diamonds around it.

## SCARS

I am nine and my mother is forty-nine. We are in the pink-tiled tub in the bathroom that connects to her bedroom. My mother's hysterectomy scar is a long ugly vertical line with short horizontal staples running across it from navel to pubis. Her belly is jelly, and her large breasts droop down to her belly. Can I touch your scar? She takes my hands and lets me trace the outline of the scar. I am fascinated by it. And that's why I couldn't come out of you? Because the doctor removed your uterus? Tell me again how old you were. And how you bled on the subway. And how you were on your way to work in the garment district on the Lower East Side. And how you would stop at Horn and Hardart

for lunch, for a sandwich from the machine. And then at Gimbels. And how you worked on the looms. And you were left-handed and faster than all the other workers. And head of the union. Tell me.

I am my mother's wound. And my presence was my mother's un-wounding. She couldn't bear children. Then me. A wound is a gift. I was her chosen gift.

## CHOSEN

I imagine my parents on a movie set. At the airport they rent a mint-green Cadillac. They travel in style, my mother in a pale blue polyester pants suit she sewed herself, my father sports a hat and leather shoes. They arrive early for my birth, just as they paid all their bills early. They are immigrants; their resourcefulness comes out of a fear of being exiled. Their rage to arrange time comes out of Hitler's rage for order.

In a Florsheim shoe box filled with old Amoco bills and tax receipts from the late twentieth century, I find the parking garage receipts to the Miami Beach hotel where my parents stayed when they came to pick me up from Mount Sinai Hospital in Dade County, Florida, April 1966.

They stop at a diner for breakfast where my mother asks my father, "How can you eat?" as she finishes her plate of blueberry pancakes and black coffee. They press the elevator button to, say, the sixth floor; in the hotel room, there await diapers, plastic bottles, and blankets that were all packed back in their new Long Island home. My mother tells a miniskirted receptionist, who wears a peace pin on her blouse, who they are, but the girl can't understand, my mother's Israeli accent thick as Turkish coffee.

They are escorted to a waiting room where my clockmaker father steps up close to the grandfather clock as though it were an anxious father-to-be. It's 7:23 a.m. I won't be born until tomorrow's breakfast. Patiently they wait, hands folded in their laps.

It was an underground parking garage. I imagine when it begins to rain at 5:00 p.m. my father is relieved that the car is protected. It is safe, my mother is safe, and I too will always be safe, with a roof over my head, dinner at six, boots and a warm winter coat, a proper breakfast. When I am sick, there will be hot tea and rice pudding, Vicks VapoRub and flannel pajamas.

When the doctor comes out of the operating room with his head hanging down, my mother whispers in Yiddish, *Oy, etvas ist eppes nicht gut*. She doesn't

take my father's hand but steps right up to the doctor's body where she meets his chest. The doctor says, "The baby's mitral valve may be damaged." My mother says, "We'll take her just as she is. What nonsense is this? She's our child. You don't return a child like a piece of clothing because it's damaged!"

When she first came to America, my mother did piecework in the garment district in the 1950s. She sorted through damaged clothes to see what could be salvaged and sold. Pull a loose thread through a loop—and *azoy!* Good as new. She was a master at saving sweaters, I heard, made magic with her hands, even without the proper tools.

When my mother tells *her* version of this story, she ends by leaning into the table covered with fruit salad and borscht, chopped liver and blintzes; in a low voice, she says, "You know what? It wasn't even true. Your heart was perfect. You were so beautiful, the doctor wanted to keep you all for himself."

When I was a teenager, I cringed at this part, rolled my eyes as far up in my head as they would go, as though this couldn't possibly be true. I didn't feel anything close to beautiful.

If ritual is an attempt to set things right, so the fire, the dance, the drum beat, the kiss, are all just right, like the stars in the sky, that ancient ritual of night's order, then ritual gives hope to life's messy imperfection, its roughshod disorder. If done just right, ritual has the power to reverse life's smelly accidents and irreversible spills. If you believe in its spell.

In ritual retellings called stories, we fix things so they perfectly align. The storyteller is the director of the action, chooses the details, like the mint-green Cadillac, the blueberry pancakes, the blintzes.

In the Hebrew Bible, the calf is sacrificed, bled a certain way, prayers are said. The Levite priests were nothing if not obsessive compulsive. Experts at making this unholy life holy. My parents too. They could turn lemons into gold, survivors to the core. They are gone. In the blanks, I continue to weave their story. I place the parking receipt in a frame, hang it in the hallway, next to my dad's favorite grandfather clock, the one he called Sam.

I feel holy and beautiful, forever chosen, and woven. They were my prayer and my answer, and they waited, sat vigil, always prepared.

They saved everything, including me.

## APRIL 26, 2013: MY BIRTHDAY

So many exiles and displacements live inside me. Yet I am whole through them. I belong to the dead, who are here today, the day of my birth, two pink camouflaged kites—one from Vienna, one from Israel, caught in the branches of the flowering cherry blossoms. My father was born in Vienna, my mother born in Israel. Today, forty-five years ago, I was born to an unwed teenage woman in Mount Sinai Hospital in Dade County, Florida. When I am nervous or too full of longing to know what to do with my body, my left hand reaches for my Israeli mother's wedding ring, which circles the middle finger of my right hand. I am perpetually wed to them. I long for two pink lines to appear on the pregnancy test stick when I dip it into my urine, pray for a child to grow inside me.

I turn the gold ring round and round, winding clockwise, unwinding it counterclockwise; it guards the diamond flower in front of it, farther from the knuckle. Inside the ring, the numbers are engraved: *1943*. In 1943, my parents were married on Nachmani Street in Tel Aviv.

I touch the ring to soothe myself from being alive without them. And without she who I know remembers me crowning between her bloody legs on this day, an April day of newborns, dogwoods, and palm trees, forty-five years ago. I trace faded letters and numbers. Over and over I turn the parking receipt from the hotel where my parents stayed during their wait, try to rub it into me, a child tattooing herself with evidence of her arrival.

## BLOODY

I am driving to the fertility clinic. I have given blood and been entered a thousand times—the nurses my lovers now, feet up in stirrups, white hospital paper draped over my thighs. I haven't shaved my legs in months since the injections started, four in the morning to be repeated at night at the same time in the abdomen below the belly or in the thigh, someplace fleshy.

On the radio, Isabel Allende is talking. About translation. About writing. About the death of her daughter. When her daughter died, she wrapped her granddaughter in her arms, wound the premature child in and through her body, and this baby became life pulsing, became hope. Allende talks about how she writes to her mother every day and at the end of the year her mother sends her letters back, which helps her to remember so she doesn't have to invent and lie so much.

Lisa Grunberger

I wish my own mother were alive. Oh, Rachel, how did it feel to wake up without a uterus? Did you grieve the loss? Did you cry, Mom? The only time I saw you cry was when you learned your own mother had died in Israel.

At the clinic, my favorite nurse, Charlotte, who could be from everywhere—Iran, Puerto Rico, Israel—speaks slowly, enunciates every word as though she were in a class recital, her kinky mocha hair in a loose braid. The doctor says for mature eggs I am doing very well.

*Mature* means "old" in this building.

One must learn to translate like a pro, a grifter, a genius. And spontaneously, Dr. Something hugs me, me without panties or mascara, me, forty and scared, me who misses her mother gone for almost twenty years.

I write her letters in the car. Letters in the park. Wait for the letters to come back so she can help me remember. Dear Mom, I am wearing your wedding ring, the one Daddy had engraved in Israel in 1943. Mom, I have already named my daughter Rachel. I know it's premature, but I did it, and I want it to be prophecy. I can't bear more disappointment, more needles, more loss, more miscarriages, more of the universe telling me no. I want a yes, a fuck-you to Hitler, to war. I want to give life to a Jewish baby named Rachel, my revenge child, your grandchild; even if you are not alive, she will be yours as I am yours for eternity, as long as I can breathe. One child named Rachel. Is that too much to ask for? Dear Mom: Tell me a secret you died with; tell me what you looked like on your wedding day in 1943; tell me how to live another day without a child to call my own.

Dear Mom: I am trying to remember everything about being infertile: the yellow walls of the clinic, the plastic plants in the waiting room, the parking lot that echoes with my footsteps, the receptionist who looks tired and bored, an unframed photo of her baby son taped to her computer, the shape of the bruise on my belly, the last time I made love and took pleasure in it.

You let me trace the outline of your scar. And that's why I couldn't come out of you? Because the doctor removed your uterus? Tell me again how old you were. Tell me how you bled on the subway. How you almost died. I do not want to drive down this road again.

Allende says in accented English, "Language is bloody," and I nod, yes, yes. Words beget blood, beget wombs, beget worlds. Mom, your body connects me to all the generations of women before me, and all who will come after me, if there will be an after. Maybe I should adopt a baby, stop putting my body

through all this poking and prodding. I will be the mother, like you are my mother. Why this need to give birth, to carry, to get fat with a child?

Mom, tell me why this impulse to hold a child, to be a mother? Did you go to the doctor in Israel when you did not conceive? Did you believe in fate? Did you ever have a miscarriage? Dear Mom, Rachel is my future memory, she will be your namesake. I am the infertile prophet. This must happen, I must be called Mother. When was the first time I called you Mother? Make something happen, Mom, give me your bloody blessing.

Mom, fix things so they will perfectly align. Make this be the last time I have to drive this route, traverse this road to the fertility clinic. Let this be the last parking receipt from the bloody garage where I get lost, forget the car.

This is damaging me, Mom, this traffic in my head, child, no child, stop, start, mother, no mother, one more cycle of IVF, adopt, don't adopt, should I take life as it is, or should I keep driving to this damn clinic, Mom, try one more time. Look into the Book of Life: Am I fated to be a mother?

# Imitor Virgo Fructuarius, Mulieres Offerunt Maternitam, and Familia Adduco Mundum

*Eva Nye*

After two miscarriages, five surgeries, and numerous infertility treatments, I was about to start the shots for yet another round of in vitro fertilization (IVF). I looked at the needles, syringes, and packaging and knew there was a way to make something beautiful from this long and painful journey. Madonna and child seemed like the perfect image to create, and so *Imitor Virgo Fructuarius* (I imitate the fertile virgin) was born. This title relates both to an infertile woman going through IVF, as well as the fact that virgins today can and have become pregnant and given birth through reproductive technology.

One of the best things I did for my own self-care was to join a support group of women who also struggled with infertility. There I finally felt understood, and my eyes and heart were opened to other ways of creating a family, including using donor eggs. For my second piece, *Mulieres Offerunt Maternitam* (Women offer motherhood), I used material from my own treatment as well as women in my support group. The woman on the right hands over the golden egg, representing nature, and the doctor on the left provides the nurture needed for the embryo to be created. These components grow together inside the uterus of the middle woman. Had the same embryo implanted in another woman's uterus, different parts of the genetic makeup would have been stimulated and the baby born with different character traits. All three women (three muses) are needed to create this new life.

My third piece, *Familia Adduco Mundum* (I bring the world into my family), depicts one couple who finally became parents through medical treatments. My hope with these pieces is to open up the discussion of infertility and assisted reproductive technology.

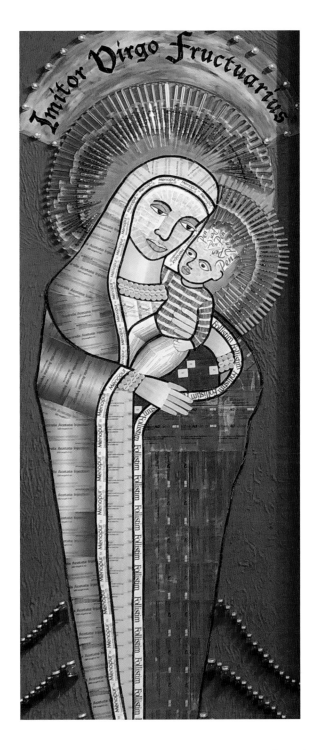

Eva Nye, *Imitor Virgo Fructuarius*, 2014, mixed media,
84" H × 34" W × 4" D, collection of the artist, Batavia, Illinois

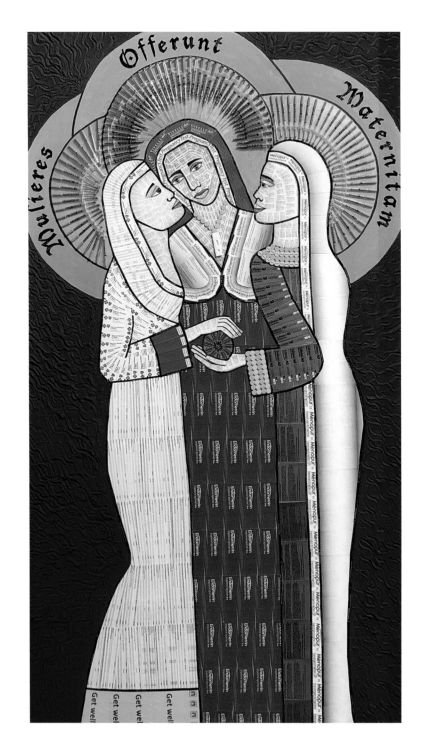

Eva Nye, *Mulieres Offerunt Maternitam*, 2015, mixed media,
84" H × 48" W × 4" D, collection of the artist, Batavia, Illinois

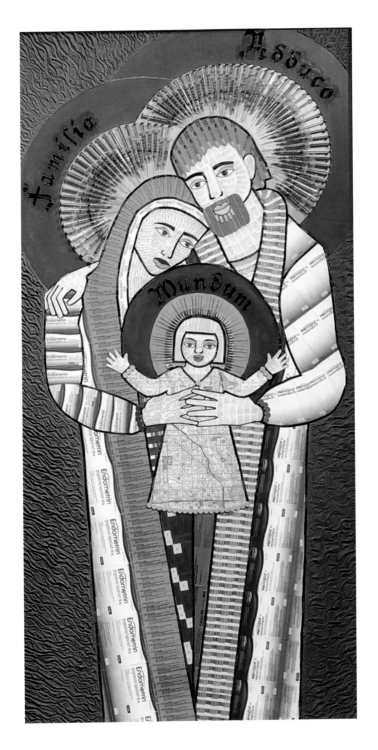

Eva Nye, *Familia Adduco Mundum*, 2015, mixed media,
84" H × 41" W × 4" D, collection of the artist, Batavia, Illinois

# Two Futures: A Portrait of Infertility

*Cha Gutiérrez*

My husband and I had struggled with getting pregnant for five years, during which we experienced a miscarriage, saw many doctors, and shed many tears. I resented my body, imagined it cracked and broken: a complete betrayal. Throughout my struggle with infertility, I became obsessed with imagery of plant life and nature in my work. I tended to my own garden at home, determined to help something grow and thrive even if I couldn't grow a life inside me. I also strived to make a deeper connection with my body's cycle and its relationship to the cycles of the moon. All these themes manifest themselves in *Two Futures: A Portrait of Infertility*, which is influenced by the work of Frida Kahlo. The piece depicts the struggles and sadness I endured throughout my journey with infertility, as well as the imagined possibilities that I desperately wanted. "If I paint it, it will come true" was something that came to mind often as I completed this work. The piece also incorporates imagery and symbolism from tarot, further illustrating the themes of possibility and some kind of fortune-telling that I wanted to sway my way.

Cha Gutiérrez, *Two Futures: A Portrait of Infertility*, oil and acrylic,
30" H × 40" W, The Sagrado Gallery, Phoenix, Arizona

# 2.

Sometimes it feels like it will go on forever. Month after month of negative tests at home or at the doctor's office. Infertility takes over your life. You try everything. Acupuncture, yoga, new diets, new medications, new treatments. You go to new doctors, get new diagnoses. Two pink lines on the pregnancy test end in blood a few weeks later. Adoption proceedings fall through. Medications have side effects, bloating, headaches; procedures require more procedures. Infertility takes over your life, affects your marriage, your friendships, changes your identity. Everyone around you seems to get pregnant, stay pregnant. You don't talk about it. Maybe you make some art, go to a peer-led support group, see a therapist. Before work, you head to the clinic for blood draws and ultrasounds, to drop off a specimen. You watch your bank account dwindle. Infertility pushes you further than you ever thought possible. You say you'll never use donor sperm. You do. You say you'll never do in vitro. You do. How long do you stay in this murky middle trying?

# Stone Womb Fetuses

*Katie Benson*

Having been diagnosed with polycystic ovary syndrome (PCOS) while in my thirties, before having had the opportunity to try to have children, the concern of fertility and childbearing weighs heavily on my mind. I wonder if my womb will ever be used to carry children. I worry, if and when that time comes, will I be able to overcome the effects of the PCOS, and what will I have to endure because of it?

This piece is made of alabaster stone and bronze, both very solid and unyielding media. Set in contrast to the subject of a growing, changing fetus, the piece explores my beliefs regarding family formation. With my diagnosis of PCOS, as well as having watched family members face challenges of infertility, I wonder, *What good is it to have a womb that may not fulfill its purpose? What challenges will I face when the time comes to try? Will I be strong enough?* Like the growing fetus, my questioning and pondering has evolved gradually to reaffirm my belief in having children and my fortitude to face whatever is necessary on this journey to bear them.

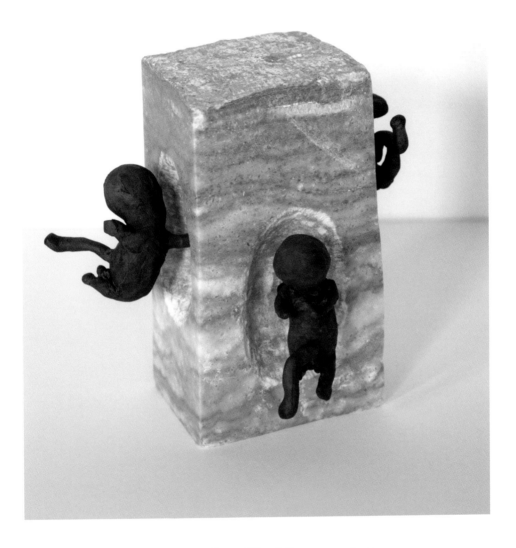

Katie Benson, *Stone Womb Fetuses*, 2016, stone
and bronze, 6.5" H × 3.25" W × 3" D, collection of
The ART of Infertility, Ann Arbor, Michigan

# Poem of the Body

*Betty Doyle*

I have felt
the clammy undersides
of my thighs chafe and weep,
the loose flesh mottled
and wet from the effort,
indecently pink.

I have felt
my gut curdle and retract,
cramp and release.
I have felt the small pink pill
stick at the back of my throat
as it closes up, clamps shut.

Yet I am still not sure
what this is, what this means.

The coarse black hairs
appearing across my chin, my top lip.
The brittle black hairs
suffocating the shower drain.
The hot copper stink
as I leak through bed sheets
every two weeks.

# The Mozart Effect

*Betty Doyle*

My period came at a poetry reading.
I watched as a damp patch darkly advanced
at the V of my pants, wine-shaded.
And I thought, *Shame—the poetry*
*would have made you sincere;*
*as stark as the moon, yet delicate*
*like her light.*

My period came at an easel.
I left my brush muddying water, rushed
to press my searing hips against cool bathroom tiles.
And I thought, *Shame—the art*
*would have made you hungry for color,*
*eyes flickering between fern, forest, mint, moss.*

My period came in Religious Studies:
teacher preaching symbolism of Magdalene, Eve,
the whores and their curses, our centuries of aches.
And I thought, *Shame—womanhood*
*would have made you tough,*
*the beat in my thumb's pulse*
*passed down through countless grandmothers,*
*their secrets of living.*

My period came at eleven.
Every month for thirteen years,
156 yous unloosing themselves
from me, those daydreams.
And I thought, *Shame,*
in the phlebotomy waiting room,
*that it was a waste, all in vain.*

# On Ovaries

*Betty Doyle*

after Kim Moore

That we are born with all the eggs
that we will ever have—in fact,
those eggs are in us when we are an egg
in our mother, and her eggs are in her
when she is an egg within her mother,
so we have all existed in our grandmothers.
That is my favorite fact.
That birds only have one functioning ovary.
That the ovaries hold around two million eggs.
That this can all be for nothing.
That I have laid on the floor of public toilets,
desperate for the cool of the piss-rank tiles
to soothe my groaning hips, burning cheeks.
That male clownfish can develop ovaries
if the alpha female dies. That if you google *ovary*,
the first result is about cancer.
That the nurse said my cervix had a nice shape,
a good color, correct position, healthy cells.
That the nurse said my blood contained
heightened levels of testosterone.
That I started bleeding at eleven—I had to
skip swimming lessons; I sat high above
the yells and surface iridescence,
smug in my supposed womanhood.

# Excision

*Jo C.*

In *Excision*, I explore my experience of having bilateral dermoid cysts, aka mature teratomas, surgically removed from my ovaries. I jokingly referred to the dermoids as "My Little Mutants" to mask my intense fear about the surgery. Our reproductive endocrinologist bluntly told me I needed them to be removed for my general health, but doing so risked losing ovarian tissue and possibly my ovaries entirely. As I was already having a hard time integrating my diminished ovarian reserve diagnosis following my husband's initial male factor infertility diagnosis, the possibility of losing more of my precious eggs was overwhelming. I also feared that they'd find yet another infertility issue, such as endometriosis, during surgery. I delayed the surgery for months.

Once it became evident that the dermoids may have been a factor in my consistently poor response to ovarian stimulation medication, we went ahead with surgery. By that point, my left ovary measured 8 cm and the right 5 cm. Both dermoids contained hair, cartilage, sebaceous glands, and other tissue. What was meant to be a two-hour outpatient surgery ended up being over four hours under general anesthesia. It took a month to become fully mobile again, and the surgery took a lot out of me. It was by far the hardest procedure in all my fertility treatments.

For this painting I wanted to show how unclear it was whether the surgery would be a success or not. No one really knew what the dermoids contained until I went under the knife. For this reason, I used many layers of colors across the canvas, covered them with an opaque white and eggshell palette reminiscent of bandages, and then scraped away to let the underlayers of pink, red, and yellow show through. I used thread to depict the texture of the clumps of hair within each dermoid. While there are many unknowns in infertility, there is always the excision of earlier dreams of conceiving with ease, announcing a pregnancy, and building a family without medical intervention or debt. Infertility removes our expectations of a happy family as swiftly as a surgeon's knife.

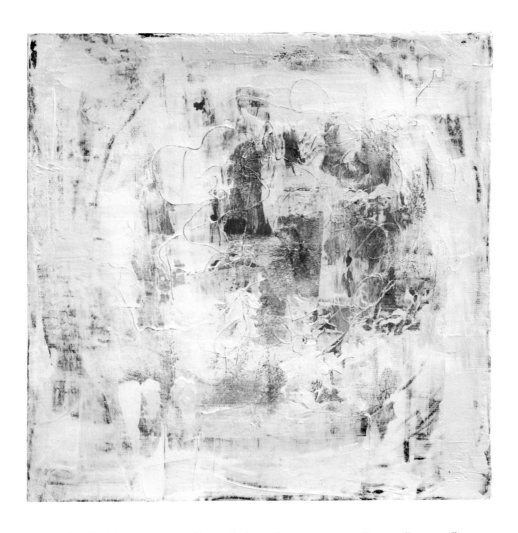

Jo C., *Excision*, 2015, acrylic and thread on canvas, 10" H × 10" W × 1.5" D, collection of The ART of Infertility, Ann Arbor, Michigan

# What the Fibrous Tissue of Your Love Has Created

*Montserrat Duran Muntadas*

At the age of thirteen, I was diagnosed with a uterine malformation that endangered my fertility. As years passed, I developed polycystic ovaries along with a fibroid mass above the uterus.

*What the Fibrous Tissue of Your Love Has Created* is an art installation consisting of various interpretations of uterine fibroids. It is part of a more elaborate project titled *My Beautiful Children and Other Anomalies*, which explores maternity, infertility, and physical anomalies, alongside the assumption that femininity is often associated with fertility.

To accept and describe one's imperfection, to show its beauty, to create from the inability of procreating—these were the challenges I encountered while assembling the blown glass pieces of this intimate yet public installation. The outcome resulted in deformed pieces that seem ornamental, where the inner space notions and the visceral art became literal. The presented pieces are themselves a sign of an artistic change, uniting glass and textile, which by their transparency and textures reciprocally transform themselves. This piece thus focuses on fecundity and freedom to define oneself in a constrictive world.

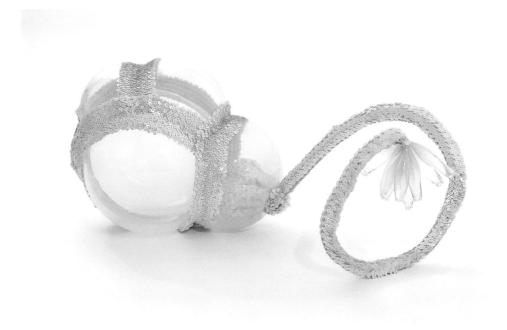

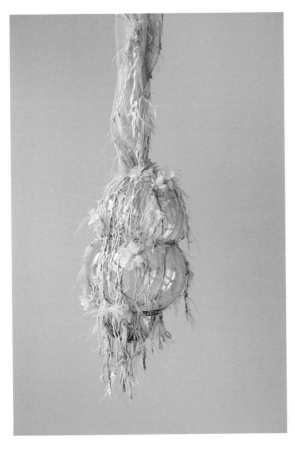

Montserrat Duran Muntadas,
*What the Fibrous Tissue of
Your Love Has Created*, 2020,
fiber, glass, collection of
the artist, Québec, Canada
(continued on next page)

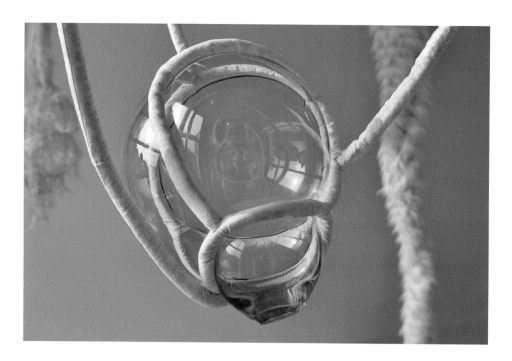

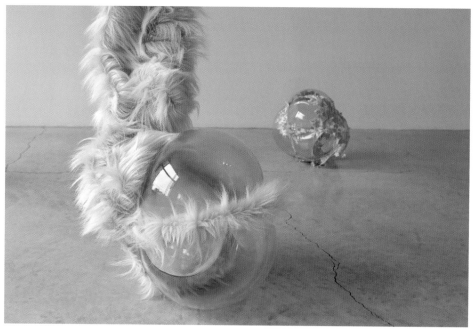

Muntadas, *What the Fibrous Tissue of Your Love Has Created* (continued)

Montserrat Duran Muntadas

# The Seeds Were Sown

*Monica Wiesblott*

From the start of our tribulations with infertility, I knew deep within myself that something was wrong. I went to multiple doctor and ER visits where I was dismissed or prescribed pain medication to numb my experience. Time and time again, I was subjected to blood tests, x-rays, and manual exams. I was stripped of my modesty, dignity, and self-worth. Doctors were quick to claim that the next exam or procedure would net us a family. It started to feel like we were paying snake oil salespeople, who claimed that if I drank this or allowed the next procedure, I would instantly grow a baby with no problem.

When an ovarian growth had changed rapidly, I went in for surgery to save my ovary, during which I was diagnosed with stage 4 endometriosis, with fibroids and cysts on my bicornuate uterus. Everything was stuck together and twisted with scar tissue. The reason for all my pregnancy losses became clear; it took ten years for the answer to be delivered. My etching *The Seeds Were Sown* envisions what was happening in my uterus: I had a wild pea plant that had sprouted, twisted, burrowed, and taken over the womb my baby was supposed to be grown in.

Monica Wiesblott, *The Seeds Were Sown*, 2010, photopolymer etching,
10" H × 8" W, collection of the artist, Ventura, California

# Hair Piece II

## Sally Butcher

My infertility journey lasted around eight years, with four in vitro fertilization procedures, two wonderful babies, and one miscarriage. Although I am a professional artist, I didn't intentionally make art about my experience. With infertility taking over every other part of my life, I couldn't let it invade my space of sanctuary, my only place to escape and forget.

However, I have always made work about female subjectivity, and some of the pieces made during this time linked to embodiment, with potential connections to infertility. I worked a lot with my own hair, which, possibly due to the stress I was experiencing, was rapidly falling out. These pieces take direct imprints through print and digital means, exploring the physical qualities of the material itself. I was very interested in its abject nature: a substance that grows from inside the body, transgresses our rigid borders, links cleanliness and dirt, beauty and horror, life and death. Hair is merchandise in the global marketplace, a material that can be miraculously full of body and vitality, yet mine was lifeless, disconnected and discarded. These pieces were often reminiscent of female reproductive organs, but now I see more readily the layers of entrapment alongside fragility, representative of my own embodied vulnerability at the time.

Sally Butcher, *Hair Piece II*, 2014, collagraph with
human hair, 16.5" H × 11.4" W, private collection

# The Miscarriage: A Sunday Funny

*Douglas Kearney*

# Pain Will Not Have the Last Word

*Foz Foster*

This artwork celebrates the lives of the three children my wife and I lost through miscarriage within one year after previously having two successful pregnancies.

The artwork shown is a detail taken from a very large piece, *Pain Will Not Have the Last Word,* a 2-foot by 75-foot by 4-inch mixed media on moon paper scroll painting that explores the everyday experiences and joys of being a dad.

Through a sequential narrative I capture the imagined experiences of my three dead children. Together, these brothers and sisters celebrate the joys of the everyday, which they never had the opportunity to experience.

The piece initially explores the birth of the protagonists and the dark veneer of the perfect world. It then progresses to a joyous narrative that includes looking for Easter eggs, going to the fair, playing hide-and-seek, playground fun, receiving presents at Christmas, sledding in the snow, and going on holiday.

As a man, I was devastated by what had happened and also by the social and cultural lack of awareness that individuals of all genders are affected by miscarriage.

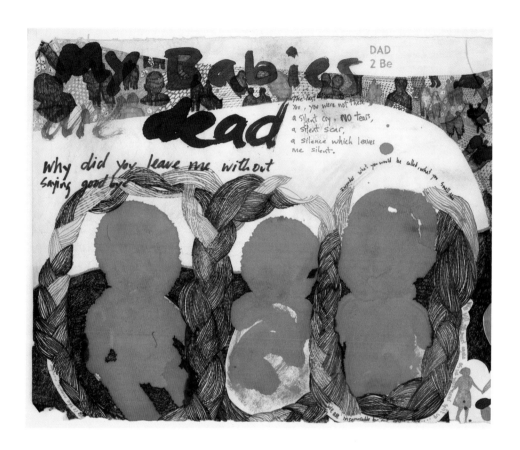

Foz Foster, *Pain Will Not Have the Last Word*, 2012–14,
mixed media, section from full scroll painting
24" H × 33" W, collection of the artist, London, England

# Anyway, Here's Wonderwall

### Annamarie Torpey Miyasaki

I didn't want to make art about infertility. Although I often make art as a way of processing and healing trauma, and I work in self-portraiture to recenter myself in these experiences, I didn't know how to do that with infertility. Everything about this process felt like a loss of control and identity; it is an ongoing trauma rather than one I can reflect on and make sense of in hindsight.

I started a painting of pomegranates about a month after my first reproductive endocrinology appointment. Ironically, while pomegranates are a common symbol of fertility, I chose them for their connection to death and underworld journeys, specifically the Greek myth of Persephone and Demeter. And then I spent a year fighting with it. I finally shoved the painting into a closet in our supposed-to-be-a-nursery spare room.

I didn't want to make art about infertility. I was too heartbroken and exhausted by it. But it is deeply, sacredly important to me to fight shame and stigma. It was a betrayal of my values to stay silent about infertility and pregnancy loss. So I dragged the pomegranates back out, these symbols of fertility and of death—so important to a story about seasons, motherhood, and grief—and almost instantly the entire collage fell together.

I didn't want to make art about infertility. I thought it would be about alienation from myself, sorrow, rage, loneliness, and physical pain. And it is. But it's also about resurrection and rebirth, cycles and choices, little girls and witches, gender and faith. It's about a fat brown cat and my in-laws. It's about trauma and reclaiming power. It's the unlikeliest self-portrait I've ever made.

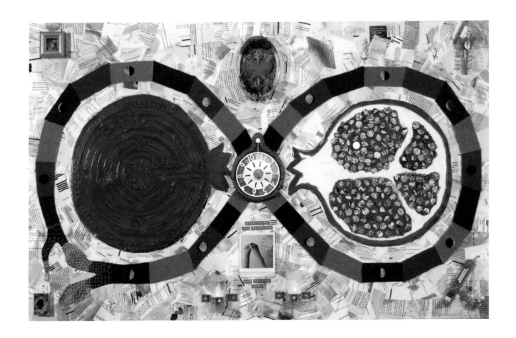

Annamarie Torpey Miyasaki, *Anyway, Here's Wonderwall*, 2020–21, mixed media, 30" H × 48" W, collection of the artist, Union City, California

# Grief to the Bone

*Yomaira Figueroa-Vásquez*

## BEGINNING

We lost our first baby in 2013. I woke up one August morning with sharp pains coming in quick succession. Bleeding profusely and confused, I fell off the bed and crawled on my knees down the hall to the bathroom. I didn't know what was happening, and not wanting to wake up my husband, I kept my moans to a low treble. Eventually, I limped to the couch and cried as the pains swelled across my body over and over again. I remember thinking, *If this is what childbirth is like, I don't want it.*

Later that morning we tried to figure out what was happening: Food poisoning? A bad period? A cyst? A physiological reaction to the blowout fight I'd had with my brother the afternoon before? After a few hours I was able to withstand the cramping and decided to keep my plans to visit a friend who was home with her six-month-old baby. When I arrived at her house, I told her about the pain that morning; she asked if I was pregnant. I told her that there was no way, but in my heart I knew. I drove back home later that evening clenching my teeth as the waves of pain hit me. When I got home, I dusted off an old pregnancy test box and held my breath as I waited for the verdict: pregnant.

I walked out of the bathroom, told my husband the news, and cried. We were both in our final year of graduate school, living in New Jersey—clear across the country from our university in California and making regular trips to check in with our advisers. We were teaching full-time at a nearby university, and I was also holding a part-time job at a clothing shop. Just a few months earlier I had resolved to finally finish my dissertation and start working on applications for the academic job market. This pregnancy was an unexpected interruption to our plans and, like the shtick of a romantic comedy, we needed more proof. Very quickly we were on our way to the pharmacy to pick up another box of pregnancy tests. On the way to CVS and back, I listened and mouthed the words to Hurray for the Riff Raff's "Go Out on the Road" on repeat. We'd just returned from a three-week cross-country road trip, we'd been married for six months, we'd been together for six years, but it felt like

we were just getting started. This felt like a fantastic kind of failure. This would end our hopes to move forward and would mean a whole new future. I was thrilled and terrified.

One positive test after another led to a doctor's visit where a blood test showed that I was indeed pregnant—about five or six weeks, maybe more. The doctor gave me a script for prenatal vitamins and booked me for a follow-up in a week. There was no ultrasound, no discussion of my ongoing pain and symptoms, just a script, a shrug, and a perfunctory "congratulations."

That week my friend, the owner of the clothing shop where I worked on the weekends, was taking the staff on a weekend trip to Puerto Rico. As nervous as I was to be pregnant, I was also superstitiously hoping to see my grandmother—mother to eighteen children and grandmother to more than a hundred—to get her blessing for my baby who was sure to be one of her last bisnietos (as I was one of her last grandchildren to have a baby and she was well into the double digits on tataranietos). When I went to see my grandmother in Caguas I held her hands tightly and stared deeply into her cataract-fogged eyes, saying nothing about my baby as she gave me her bendición: Que santa clara te acompañe.

The morning we were due to leave the island, I snuck away at sunrise to take a solo bath in the salt waters of the Atlantic. I thought of my ancestors bathing and rejoicing in those waters, my ancestors carried violently across the sea and worshipping in those waters, and my ancestors who brought their hunger, greed, and despair to those waters. I meditated on my child and summoned up their emotional, ancestral, and ephemeral inheritance to those waters.

Upon return, my second blood test showed that I was miscarrying or had miscarried. My HCG, or human chorionic gonadotropin, numbers were plummeting, and without much explanation, the doctor said the reason was inconclusive—perhaps a blighted ovum or more likely a chromosomal issue with the embryo. These things happen. Whatever the case, I was told that the pregnancy was not viable and was sent on my way. I felt numb. Had I miscarried that August morning back in the apartment, or had that been implantation bleeding? Had I miscarried in Puerto Rico, or would I miscarry in a few days? Still bleeding a week later, I was left with so many questions that I wouldn't have answers to for years to come. I know now that I had begun miscarrying that August morning, that the doctors didn't listen to my symptoms, that

they treated me as pregnant when in fact I was losing my baby right in front of them.

The rates of mortality for Black women and infants are twice that of white women in the United States, and one of the highest of any "developed" nation. We know too well the stories of Black women who were dismissed or ignored, to death. My own mother's stories of miscarriage and infant death are likewise a documentation of the disregard for Puerto Rican women and their babies in the 1970s. Her first miscarriage led her to hemorrhage on the train from the Bronx hospital where she was refused help, to Hoboken, New Jersey, where she was rushed into surgery. Her second loss came after being misdiagnosed and medicated for not having enough amniotic fluid. Unbeknownst to her, she gave birth prematurely to twin daughters. Only one survived. When I talk about miscarriage and infant loss to my extended kin and community, I am met with a flurry and fury of stories: infinite loss, infuriating care, and often the simple reality of the unknown.

When we lost our first baby, I remember that I was consoled only by the thought that perhaps we weren't ready to be parents just yet. We were wrong.

## MATH

I was diagnosed with dyscalculia in 2007, a few months before my college graduation. I felt freed knowing that my visceral reactions to my university math classes were not just a mix of stubbornness and stupidity but rather a diagnosed disability. I transpose numbers and mix-up equations, I jumble addresses, phone numbers, and codes. My relationship to math has always been as strange and as strong as my transfixing love of words. For many people these worlds are not separate. For me, the use of words and numbers are universes apart.

Over the last three years, the struggle to grow our family has caused me anxieties like I have never known before. The kinds of mental math I make are illogical, absurd, painful, and relentless. There is the equation of deficit— where I calculate where I fall in my family's fertility matrix:

Abuela Santo: 22 pregnancies, 18 children
Abuela Catalina: 6 pregnancies (?), 6 children, 2 murdered after her own mysterious death
Mami: 5 pregnancies (1 set of twins with 1 surviving), 4 children

Papi: 1 child, 5 stepchildren
Sibling: 1 child
Sibling: 1 child
Sibling: 1 child
Me: 0

In this fucked-up equation the number of children decrease with me reasonably getting none.

There is the equation of scarcity, a zero-sum game, where I calculate how many children are in my kinship and family networks and frantically attempt to decipher the "chances" that I will have children:

5 couples with twins
2 couples with triplets
7 people on baby no. 1
12 people on baby nos. 2 or 3
3 close friends pregnant now
700 acquaintances pregnant now
0 babies for me

In this equation every baby born and every baby announcement make the chances of me having a baby go down and down and down. Zero.

Equations like this . . .
Grief the size of a lemon seed
Root into a tree,
A sapling taking hold in the root of you in your womb
A blooming halo
Blocking all light and possibility
Offering instead a sobering truth
You are not like the others
You are like many that are not like the others

Your future children, ojala, may bring you joy
but you know what it is to lose
and the fear of loss consumes you

eats your dreams, invades your days
It reaches inside you and scoops and
scrapes away at the hope you've been hiding

## THE ROAD

We started trying to grow our family in 2016. We had just bought our first home and were so thrilled to be first-generation homeowners and in our first jobs after graduate school. It was a quiet pursuit, our child, and we felt that sharing our desire to become parents would dash our hopes. *Keep your head down, nena, and quietly try for a baby.* I started taking prenatal vitamins, and a few months later we spent the summer in Spain and Morocco, hoping to come back home pregnant. Months passed and my visits to the ob-gyn were inconclusive. My doctor, a white woman, told me to lose ten pounds, then fifteen. My polycystic ovary syndrome (PCOS) and weight were the problem she suggested. Every test returned clear. I started taking medicine to help with the insulin resistance that PCOS can cause, medicine that made me extremely sick. Every visit to the doctor ended with an increase of that medication; every visit was a painful reminder that I had to keep waiting for our baby to come. I dropped fifteen pounds and then twenty pounds by cutting calories, exercising, practicing yoga, and going to acupuncture. But returning to the doctor with those results were not enough—she would not recommend me for fertility treatments. I know now that I could have gone to a fertility specialist without a referral, but at that point I was uncritically following whatever the doctor advised even as she withheld our possibilities.

In 2017, I went to my primary care physician and told her about my fertility struggles. She recommended some blood work, and when the results came back she gravely informed me that she thought I was entering perimenopause. My estrogen levels were low, she said, and this was cause for concern. I was then sent for a mammogram. I made an appointment with my ob-gyn and waited one week for the appointment. During that week I was alternatively catatonic and then inconsolable. I remember crying quietly through an entire work out at the gym. I remember my husband helping me to my feet in the Target parking lot. Stepping out of the car, I had collapsed to the ground in a fit of tears, unable to walk or talk for the pain of the potential diagnosis. At my appointment the nurse on call calmly and lovingly informed me that estrogen is a fluctuating hormone and can only be used to determine fertility in

context. *You are fine. You are perfectly healthy. You can have babies.* I was relieved and enraged at my primary care physician for a potentially devastating diagnosis for which she knew nothing about. I needed a specialist but was still so scared of what that step would mean.

## LEY 116

I come from the most sterilized nation in the world. Over the course of twenty-five years, law 116 saw to it that over 34 percent of Puerto Rican women were coerced into sterilization as a form of permanent birth control or, rather, population control across the island. It was the sole method of contraception available at first (besides the male vasectomy), and Puerto Rican women were often sterilized without their knowledge or without knowing that the procedure was irreversible. Since winning it as a prize of war in 1898, the colony of Puerto Rico has represented both a problem and wealth of biopolitical resources for the United States. The film *La Operación* interviews women and confirms that there was no orientación, no guidance. Puerto Rican women were also used as laboratory subjects to test the nascent birth control pill, which, strikingly, was ten times more potent than what was eventually made available to women in the United States.

The aim to sterilize this population of nonwhite peoples did not stay on the island but instead migrated in the same pattern as the population. Efforts to sterilize Black, Puerto Rican, and working-poor women in the Bronx's Lincoln Hospital were met with mass protests.

I touch my empty womb. I rage against histories of corporeal dispossession.

## LO QUE ESTA PA' TI

Fifteen days before we found out that our baby's heart had stopped beating, we were driving from Michigan to Baltimore for a postholiday family gathering. As night fell over Pennsylvania, I remember being entranced by the moon in its waning gibbous phase. It looked to me like a gorgeous pregnant belly sticking out of the sky. I fantasized about our baby traveling worlds, making its way from the sky to my belly to places beyond my imagination. Just two days before that drive, on Christmas Eve day, we'd seen our baby's little heart flicker for the second time across the screen—135 beats per minute. We were elated. This was our baby. The baby we'd wanted so badly and loved so much already. My mami had said some months earlier to quit with the bad mathematics: *Lo que esta pa'*

*ti, nadie te lo quita*. And that was a balm and a spell that lifted the burden of my miscalculations and the fears that arrested my every move.

Because we'd experienced that early loss five years before, I was caught between excitement and terror. The minor discomforts of my pregnancy symptoms were a relief and my fertility specialist, quietly acknowledging my fears, decided to "graduate" me to a regular obstetrician a few weeks later than scheduled. At that appointment her every move was calming and her words so soothing that I decided against telling her my one thousand concerns. We'd gotten pregnant relatively quickly, just three rounds of some not-too-invasive procedures. She'd gasped at our first visit when she heard how my former gynecologist had treated me. Now, at this appointment, she discussed my previous labs and was thrilled with the progress of my weekly ultrasounds. Our baby had been growing right on target. This is why I went into total shock when the doctor could not find a heartbeat. *I'm so sorry. So sorry. So sorry.*

My husband held his face in his hands and cried. Seeing his instant reaction unmoored me. I had no voice, I could not feel. I failed to think of ways to make it better for him. My loving and distraught partner who'd been the cheer to my worry, who'd written our baby little poems and told us little stories about all the things we'd do together, he too was undone. A few minutes later in her office as I listened to her explain the next steps, my nose started to bleed profusely, and this continued for days.

It was the first week of classes at the university, and I had to teach just a few hours after that appointment. I hardly remember getting to campus, to my office, or to the classroom. I do remember that I quietly cried throughout my entire lecture on Césaire's *Discourse on Colonialism*. My freshmen students asked if I needed a hug. I said no, thank you, even though I'm sure I needed a hug from every single one of them. As I grow older and my students stay the same age, I think of them in new ways: Each of them is a beautiful miracle, someone's baby, someone's whole world.

## DILATION AND CURETTAGE

After a few days of waiting to miscarry naturally, I called my doctor in a panic. The process could take six weeks and I could not handle the thought of having my baby just shrink away inside me. I remembered so vividly miscarrying at home all those years before and was terrified of going through that pain again. In order to get a D&C I had to go in for another ultrasound to confirm

that my baby had indeed lost its heartbeat. I looked away from the screen and squeezed my partner's hand, unable to face the loss. I secretly prayed for the sounds that we loved so much to emerge.

Later that week I was admitted into surgery. My doctor was so kind, answering all our questions, and brought me tissues as I wept in my surgery getup. The big hat and little socks and the odd gown and really just the whole thing would be comical if it weren't so terrible.

A cheerful anesthesiologist came in to introduce himself. He read my name on the chart and with a quizzical look on his face asked: *What is your first language?* I gave my spouse a knowing side-eye as the anesthesiologist explained that when coming back to consciousness after being put under general anesthesia, patients usually respond fastest to their first language. Spanish, I replied. My first language is Spanish. I perked up to ask him where he learned to speak such good Spanish (in a Caribbean accent at that!), and he laughingly told me that some Puerto Rican friends had taught him growing up. He quickly added that he knew that *Puerto Rican Spanish was not professional*, so he didn't use it much. Suddenly he wasn't so funny anymore. A sea of rage rose in me even as I knew this was not the time to tell him about his racism, classism, and linguistic imperialism.

As they rolled me into surgery, I cried in fear and misery. I was in the deepest grief I had known since the death of my father in 2010, and I could not see beyond that fog. The last thing I remember are big blue lights.

In the ether, I heard a woman's voice call my name. My first words when I awoke: ¿Se murió mi bebé?

## DIAGNOSIS

Uterine contents:
Chorionic villi are identified.
Received fresh
labeled "products of conception,
genetic testing, karyotyping"
multiple fragments of pink-tan to brown-purple,
soft, spongy, fibromembranous tissue
Fragments aggregating to
9.5 × 7.0 × 2.3 cm
weighs 59 g

The dear and beloved 59 g extracted from my body turned our world upside down. I could not stop crying. I was lost in a grief so deep that I could see no way out. I worried about ever feeling joy again in my life. Would I ever laugh? My husband held our world together despite his grief. The few people in our community who knew about our loss held us in their care. I hid from all my pregnant friends and avoided eye contact with all pregnant people in public. I could handle the sight of babies, but the sight of a pregnant belly would send me into the deepest well of anger and resentment.

The trauma of being in surgery engulfed me. I felt violated. The idea of being under sedation while they opened my legs, dilated my cervix, and scraped away my almost-child was more than I could handle. Plus, the idea that I would never have a regular (read: happy, fear-free) pregnancy, that I would be wracked with anxiety if we were ever to conceive again, kept me awake all night for weeks.

It was my mami's cries that most tore me apart. She mourned for my loss and for her own. She'd pinned a hope on this baby and had made her own secret plans to move to Michigan to care for our little family. I found myself comforting her as she cried, No me lo esperaba.

Yo tampoco, Mami.

Even as I was undone in every way, I had the privilege of being a Black Puerto Rican woman with health coverage and a job where my colleagues and mentors supported and in fact demanded that I take a medical leave (thank you). I stole away at home where I found solace in nothing but the comfort of my grieving spouse and the sealed mother-of-pearl box with our baby's ultrasound prints and tiny belongings. The surgeon who performed my D&C became my new gynecologist and seeing how depressed and shattered I had been at the hospital and at my post-op checkup, she began to schedule me for biweekly visits to check in with me. I never once had to undress in her office for a physical. These were mental health visits until she could get me into a therapist's office. She sat and talked with me for an hour every two weeks for over three months. My gynecologist showed me every ounce of respect, generosity, and tenderness that I had never experienced in a doctor's office in my entire life. Even now, I don't know where to place my gratitude for her care.

Yomaira Figueroa-Vásquez

## EVERY CELL

One evening in February, the mother and grandmother of a friend unexpect-
edly circled around me, held me, and let me cry for what seemed like hours.
It was cathartic and necessary. *Every cell in her body is grieving*, the mother said.
And I wept uncontrollably in that room for every loss, for every moment of
indignity, for every fear. I left there having been given a simple task: *Do not
cry for the future*.

> Feb. 18, 2019
> She said every cell in my body was grief
> or covered in it
> Last night I dreamt of grief as a garment
> I wore cotton pajamas tight to my body
> covered from my wrists to my ankles in a soft
> chartreuse shroud
> I moved through the dreams in different scenarios
> but each time I became aware of myself I looked down
> and was dressed in radiant green-yellow grief,
> and what is this if not a rotting?
> An oozing pain like I've seldom known.
> or a hope, or a light,
> or the realization that I am consumed by this loss
>
> I'd write poetry for you, my love,
> I write in your memory now,
> thinking of the minor discomforts of your presence
> and the joy we felt in seeing you flicker,
> the loneliness in seeing you fade
> I'd wished for you and begged for you and wanted you
> for longer than I've ever admitted
> If you come to us again, I'd like to keep you
> and write you poems

I waited three months for my body to release all the pregnancy hormones, three months for my blood and my body to say goodbye. It took more time for me to find my balance again.

## CEREMONY

In Puerto Rico this summer I did a ceremony. My shadow fed, a cleansing, a despojo, and a calabaza as big as the moon was tossed into the sea for me.

I was bathed and doted on and called nena, and I cried for the care. I made new family. I made relations larger than the universe. Dressed in white and crowned with rum, I was sainted in the presence of kin.

I came back new. Painting and writing and sewing and gardening and moving my heart in every which direction.

## DUE DATE

It had been on my mind, but I had not fixated on our due date. I was secretly hoping it would pass and I would be too busy living anew to notice.

But we have bodies that remember.

At around 2 a.m. in the early hours of my due date I woke up to an incredible pain in my lower back and cramps that seized me up. Alone in bed and tangled in a sea of blue sheets, I struggled to breathe. The pain came in sudden jolts all night. I don't remember when I finally fell asleep again, but I awoke hours later in a pool of sweat. I cannot explain this. I won't bother trying to understand. I know that this body remembers even that which it tries to forget.

Mi nena, I won't forget you. Te lo prometo.

Yomaira Figueroa-Vásquez

# *The Loss* and *The Wound*

*Ashley MacLure*

The first piece, *The Loss*, shows me in the midst of my miscarriage. I look on in shame during immense emotional and physical pain. Miraculously, after this experience, I was finally able to conceive without any intervention. I gave birth to my daughter in August 2018. The second piece, *The Wound*, illustrates my birth experience. Throughout my pregnancy, I was riddled with fear and anxiety. I had learned to distrust my body. After my water broke, I was in labor for twenty-four hours and pushed for seven. My doctors decided to perform a cesarean section soon after. I will never forget how the doctors made me feel: worthless and unheard. I was unable to hold my daughter because I was shaking so uncontrollably from shock. I will forever remember hearing her tiny cry for the first time. I created this piece to be used on a decorative throw pillow, a domestic object that confounds the viewer. I've considered mailing it to the doctors who delivered my daughter as a reminder that mothers are human.

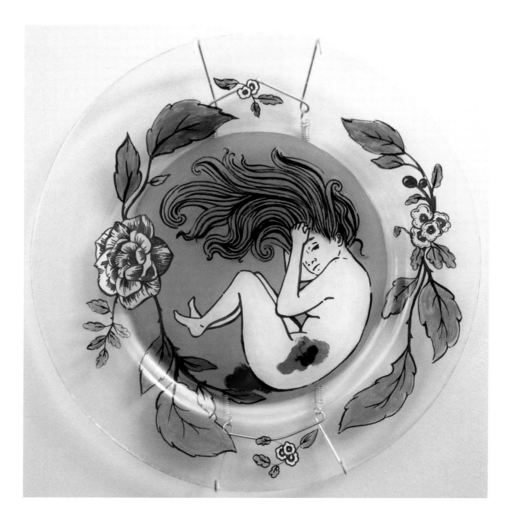

Ashley MacLure, *The Loss*, 2017, Lumocolor and enamel
paint on glass, 6" H × 6" W, private collection

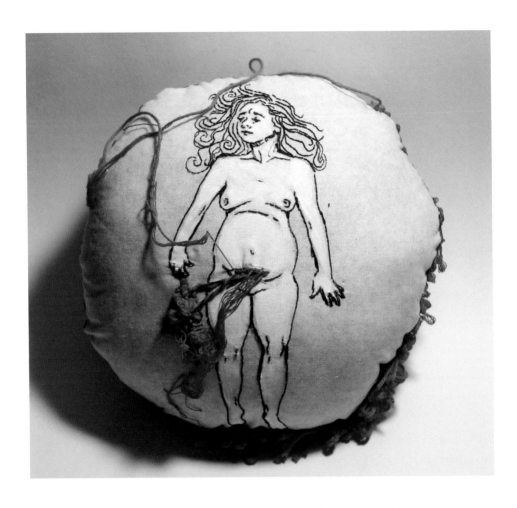

Ashley MacLure, *The Wound*, 2021, fiber, 6″ ʜ × 6″ ᴡ,
private collection, Boston, Massachusetts

# Cycle #2
### *Siobhan Lyons*

I dialed the (pronounce the *the* here like *thee*) number. The ob-gyn. I was finally pecking the ob-gyn's number, a number I dreamed of dialing for the last couple of years. I was doing it! I was calling to make a prenatal appointment. It had to be Sparrow because she was high risk, the only high-risk doctor on all three islands. The best, Harvard-trained. Harvard clinicals. The best. And you deserved the best.

But before I even met her, you turned like the Nile.

I was in class on a Thursday night when we lost you. Home on the zebra couch, happy because the pee test just confirmed, for the twenty-third time, you were a double line. And I had a prenatal appointment on Monday because you were real. My name was given, my phone number was given, your age was given—four weeks old. I, or we, were officially Dr. Sparrow's patient(s). She'd help me, help you, help us. Us, and her Harvard diplomas would smile in their wide frames every visit.

Daddy and I were goofy with excitement. While I was supposed to be in class, online class, with my camera and microphone on over there, on top of our zebra couch, we were livestock live-wire love. We were giddy. Lovebugs catapulted back into honeymoon. We had had teenage sex a couple of hours before, and now when we walked across the floor's tile we swam. Everything was hilarious. Look at the lone laptop on the striped couch with no one there. Hear the PhD candidate voices talking about creativity. We were tricksters! Bonnie and Clyde. And then, excuse me, babe, I had to pee.

What Bible river turns red? Turns. What plague was that? Why, when I held you to the lightbulb you were the most perfect ruby? I wanted to eat you back into my belly, to hold you inside a little longer. I wasn't ready to not have twin hearts. Blood clot. Bumble clot. Mother stink cunt. More perfect than a cookie cutter. A heart-shaped bumble clot. I held you to the light, a heavenly host. This is my body . . . Do this in remembrance of me.

Then the tile was ice. Then we buckled. We were unable. Are unable.

To carry the weight. The wait. Unable to carry our bodies. You. Our bodies without you.

I studied the *Brady Bunch* face tiles of Zoom. I smiled. I shut up. I wanted to birth-moan all my hilarious anguish, but, son, I am a coward.

I tooth-smiled. No one knew, as if you were no one and Daddy were no one. No one knew what prefixes (hom and sue) tugged at my dress. Only my face. A smiling face. Smile face.

Siobhan Lyons

# Birth ~~Plan~~ Warning

*Siobhan Lyons*

I need you to know this story, most experienced technicians of magic:

1. He before you (will be before you) has arrived after three failed IVF cycles, which I squeezed out of the heat of writing a PhD on creativity.
2. He before you has been here before in the following forms:
   A. Fragmented and delirious twins
   B. A singleton who made it to double lines, then morphed, poetically, into a blood clot the shape of a kindergarten-drawn heart
   C. A singleton alongside an intrusive (as it had seemed to him) sperm donor sibling
3. As far as ingredients go, half of three-quarters of him was ejaculated into urine collection containers (twice at home and once in a public bathroom near the airport).
4. His daddy is an illegal alien.
5. He was conceived through raspberry Smirnoff, weed, and acupuncture.
6. If this plan fails, I know intellectually that I at least have this book baby: cathartic, blue, and painful. Jacked edges, dog-ear pages, pushed through a pink and hopeless canal. The second-best ending.
7. I like stories.

But now that I know he is here, seven months established, I beg you to help me cross this large body of water, wide as the water between St. Thomas and Puerto Rico. I've become spoiled, I know. I am desperate for one very specific ending, my son, wanted with no *or*. Only alive.

To the esteemed staff of scrubbed saviors (I am not being funny), who straddle daily the line between planet earth science and the ineffable, please know, when it is all said and done, the only plan that I have is to do what you say. Bring him to me unscathed.

# A Mother's Embrace

*Poonam Parag*

*A Mother's Embrace* is an art piece that represents the sacred space and unique bond between a mother and her child. We had made the decision to start a family when I was in my late twenties. After seven miscarriages, my world was in turmoil, and my only escape was art and meditation. I was mad at myself; I felt like my body had failed me. I was mad at God. And I was mad at society. My younger sister, my cousins, and close friends were all starting their families and bonding over it. I would avoid birthday parties, parks, and meeting friends. Mother's Day would stir up feelings of grief, sadness, and depression.

I was introduced to the Mandala art form at a retreat; the connection was instantaneous and allowed me to express my inner feelings in profound ways. This piece is a visualization of the spiritual world, where mother and baby are united and inseparable. Even though I lost my children, they will be forever in my arms through this art. While still waiting for my miracle baby, this painting gives me comfort and peace.

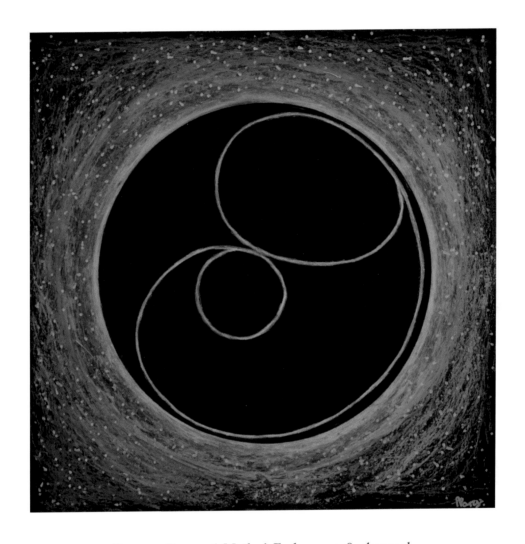

Poonam Parag, *A Mother's Embrace*, 2018, charcoal,
pastels on chalkboard paper, 12" H × 12" W, collection of
The ART of Infertility, Ann Arbor, Michigan

# El Camino (The Journey)

*Molina B. Dayal*

This triptych depicts a dynamic portion of an egg's journey through the fallopian tube. All ovulated eggs start the same way, but not all enter the fallopian tube where fertilization happens. This egg is pulsing with hopeful energy but remains protected by its zona pellucida (neon green and red halo) and surrounding cumulus cells (irregular dark blue halo), gently floating through the fallopian tube. If all goes well, it will be fertilized into a competent embryo that implants, survives, and fulfills the dream of a family.

That's how I felt when I started my fertility journey—full of energy, hope, and potential. It was effortless for me to get pregnant, but the pregnancies never lasted. In fact, my miscarriages were occurring earlier and earlier, after which I wasn't able to get pregnant at all. We decided to try in vitro fertilization (IVF), but after three unsuccessful embryo transfers I began to question what the universe had in store for me. We pursued adoption, which was the best decision of our lives. We knew that the journey wouldn't be easy and there would be hiccups and hurdles to overcome. And while we weren't conventional in our approach, the end of our journey more than fulfilled our dream of family.

I have been practicing reproductive medicine for more than twenty years. Despite being in the field for so long, every day I am humbled by patients and their journeys, as well as by the magic of what happens in the IVF laboratory. To me, the egg is where it starts. I am awed by the potential that every egg possesses. The egg, once fertilized, has the machinery and the ability to become a living being.

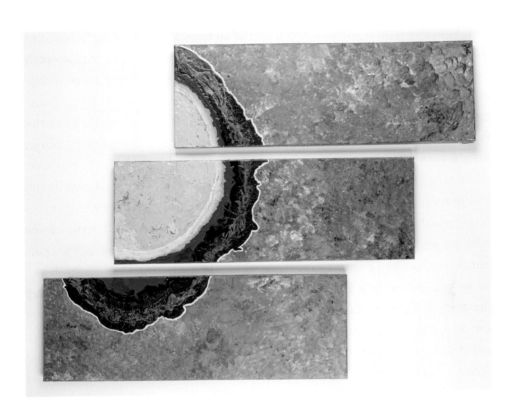

Molina B. Dayal, *El Camino* (The Journey), acrylic,
40" H × 48" W × 1.5" D, STL Fertility, Creve Coeur, Missouri

# The Tribe of Broken Plans

*Cheryl E. Klein*

On New Year's Eve, Justine and Sam showed up at our door with two tote bags and an infant seat full of Ruthie. She'd been born November 9, the day I'd been shuffled into an exam room to discuss a couple of calcifications that had appeared on my mammogram.

In the ensuing weeks, Ruthie had learned to gurgle and smile. The dark fuzz on her head had thinned. She'd announced herself as a fussy, colicky baby. Justine's C-section scars were beginning to heal, though she still carried a ring of fat and skin around her middle, which was usually soccer-player skinny.

During this time, I'd been diagnosed with stage 2 breast cancer and the BRCA-2 gene mutation, which, in retrospect, was the likely cause of the ovarian cancer that had killed my mom ten years before. I'd gotten a bilateral mastectomy, ditching my DD boobs for reconstructed B cups. And oh, by the way, my doctors had said, you should really get your ovaries removed when you're finished with treatment. I hadn't planned to get pregnant since miscarrying twins a year and a half earlier, but there was, I was discovering, a distinct difference between deciding not to pursue something and having all possibility surgically removed from your body.

On New Year's Eve, though, I was feeling lithe and light, the postmastectomy pain diminishing daily. I'd never been crazy about my boobs; they'd never been a big part of my sex life, and they made dress shopping a pain. My partner, C.C., was trying to get pregnant now, and we were in the two-week wait phase. It seemed like 2013 might be a good year, if not an easy one.

Sam held up the tote bags. "We're going to make butternut squash pizza. We brought the pizza stone."

C.C. helped him set up in the kitchen, and I thought about the mess they would leave, which I wouldn't be able to clean up because I wasn't supposed to lift anything heavier than three pounds for another two weeks.

Justine scooped up Ruthie and sat in the armchair. It was a stately looking piece of furniture, upholstered with black-and-white vines. The front was wild with stray threads that had been plucked by cat claws, but it was still our nic-

est piece of furniture. I almost never sat there before surgery, because usually we kept it covered with a sheet. But during the past two weeks, it had been my throne when guests visited.

Now I sat on the loveseat, which we'd bought on Craigslist for $50. Justine lifted her maternity shirt and black sports bra and pressed Ruthie to her pink nipple. Her exposed breast was white, full (compared to the A cups she was usually so proud of), innocent, functional. There were no scars or gummy surgical tape or Sharpie marks where a plastic surgeon had sketched out his plan. Justine's was a breast living out its little breast dream.

"Ruthie *loooves* to eat," Justine cooed, looking into Ruthie's eyes, still newborn-gray. "It's the one thing Sam can't help with, unfortunately."

Sam had gotten his own double mastectomy a couple of years before I met him. He'd been born Samantha and had previously commiserated with me about the world of triple-clasp bras. Now he was dad to a sperm donor baby, and he changed all the diapers in lieu of breastfeeding.

After my miscarriage, I'd had what, in the old days, would have been called a nervous breakdown. I'd despised my body for turning on me, for not providing proper housing for our identical twin boys (we'd learned their sex from a genetic test only after the fact). For months, I'd suffered from tremors and insomnia, fixating on floaters in my vision, certain the walls looked blurry and alive. A sort of slow-motion panic attack. I became convinced I had multiple sclerosis or lupus or (oh, irony) breast cancer—*something* written in the code of me that ensured I wasn't cut out for motherhood.

I supposed that if C.C. were pregnant right now, I would be on diaper duty.

C.C. and Sam clanged around in the kitchen while I tried to make conversation with Justine. She barked directions to Sam: what pan to use to roast the squash, where to roll out the dough. Why couldn't they just bring premade soup and stay for an hour like everyone else? It took our oven an hour just to preheat.

"Excuse me a minute," I said, and went to the bathroom for a long time. Let Justine think I was emptying the four grenade-shaped drains that extended like tentacles from my rib cage, filling with light red fluid, my body's visible grieving process.

Then I made a dash for my phone and shut myself in the laundry room, where I texted my sister. *Justine is sitting in our living room breastfeeding ruthie &*

*telling sam she wishes he could help with that part. FML. i'm hiding like a coward. they must think i'm such a sad sack.*

When the pizza was ready, I wiped my face, took a few breaths, and went to the kitchen. Justine—who'd once thrown away a gift subscription to *Gourmet* magazine because the recipes were too simple—was a great cook, even by proxy.

"This is delicious," I gushed.

C.C. asked about Ruthie's sleep schedule and the closet they were remodeling in their master bedroom. Sam and Justine were the only couple we knew who'd purchased a house in LA without any help from their parents. It was all hardwood floors and carefully curated art. I'd always admired their patient, deliberate approach. They spent years looking for a new couch; now there was another Justine liked at a fancy furniture store in Culver City.

C.C. had done a valiant job keeping our house clean during my convalescence, but even on the best days there were piles of books and shabby IKEA furniture and cardboard boxes designated for C.C.'s computer cables. There were holes in the curtains from the time the cats brawled in front of the window.

The thing that crushed me—more than the breastfeeding, more than the baby—was that Justine and Sam were living proof of plan A working out perfectly. MBA and law school, respectively, followed by house, wedding, sperm donor contract, baby. They were perfect new-millennium power queers. I'd been raised to believe in hard work and planning ahead, and so C.C. and I had done our own nonprofit workers' version of this upwardly mobile life plan. We'd started trying for a kid when I was thirty-three—two whole years before the much-talked-about fertility dip—and even in the depths of my postmiscarriage despair, we'd filled out adoption paperwork. But our relationship had cracked under the stress, and we'd spent months apart last summer, reuniting just in time for one fun vacation, and cancer.

Sam poured beer for himself and Justine, who'd drunk lightly and defiantly throughout her pregnancy.

"So, do you pump?" C.C. asked her. "Or are you going to wait till you go back to work?"

C.C. still lived in the world where breastfeeding was something she might do someday. Maybe someday soon, I hoped. But this information was as irrelevant to me as a recipe in *Gourmet* magazine. I didn't even have nipples any-

more. The chasm that had developed between us last year cracked open again, for a minute.

"I'm kind of tired," I said. "I'm going to go lie down."

I went to our bedroom and cried some more. I emailed Haley, my most rabid breastfeeder friend, for some validation, because she also happened to be long on empathy. The truth was, Justine and I had never had much in common. Once, she told C.C. that she didn't understand why anyone would commit suicide or even want to. "But homicide," she'd said, "that I can understand."

"Justine looks out for Justine," C.C. had said more than once, and not unkindly. Now Ruthie was an extension of Justine.

Eventually I heard dishes being cleared and murmured goodbyes. C.C. came to the bedroom. She had dark straight hair, Indigenous cheekbones, a boyish gait and girlish nervousness. I was never not glad to see her, even—especially—after all we'd been through.

"I should have thought about it," she said. "It didn't even occur to me. I just don't think of these things—"

"Stop," I said. "Don't make this about your failure, because I know what will happen next. You'll resent me because you didn't make me totally happy."

That was what happened with the miscarriage, on a much grander scale, and I felt the weight of it. The possibility of it all happening again, of C.C. turning her anger at herself into anger at me.

"Those things—breastfeeding and things like that—just don't set me off," she said.

"Of course they don't, because no one cut your boobs off." And then I was sobbing for our babies all over again. "I wanted to breastfeed them. I would have done it. I would have been a good mom. I would have taken such good care of them."

C.C. was probably flashing back to the time when I'd sobbed like that every day. She probably felt a little mad at me. I felt a little mad at her for not thinking there might be something wrong with Justine whipping out her tits and talking about Sam's lack of breasts. As if getting them cut off had been a minor, humorously rude act, like blocking someone's car in the driveway. Because what if there *was* nothing wrong with Justine's behavior that night? Then I was just an oversensitive girl who was perpetually Having a Hard Time.

There was a time in my life, in my lonely postcollege years, when the idea of having a tight-knit clique of queer friends—not to mention a cute girl-friend whom I'd Canadian-married—would have thrilled me. But progress, to me, meant perpetual dissatisfaction with the status quo. So now our friends seemed like scheming yuppies. I knew they would talk in pitying tones about their unlucky friend who was Having a Hard Time. I existed, I was sure, only to flesh out their narratives, to add the touch of sadness that makes beautiful people more so. They would stick to plan A while I spiraled toward plan Z.

The truth was, I liked C.C. and myself better than I liked any of them. We were interesting and introspective! We believed in God and the Arts, in a god that could be found in a good book. We knew melancholy. We knew change. I liked our hard-won, scarred *now*. But I wanted *them*—all those people living out the fantasy lives of my superego—to understand that our failures were also our triumph.

They would never understand. Or maybe I would never kick my superego's ass. Same thing.

C.C. would not understand what it meant to have your body turn on you in a half-dozen ways, to confirm the worst dark thoughts you'd had about your-self. But she put her head gently on my sore shoulder.

"Ow." I shifted carefully. Waking up from surgery had felt like wearing a very tight sports bra the day after doing a thousand pushups. Not a terrible genre of pain but a high level.

"Sorry." C.C. relocated her head to one of the two specialized pillows she'd gotten for my recovery. It made her feel good to go on runs for antibacterial hand lotion and dry shampoo and long-handled back brushes.

"Justine made Sam clean up," C.C. said. "I could tell she felt bad."

"That was nice. I guess she knows me well."

"Do we need to go out somewhere?" she asked. "To wash this taste out of our mouths?"

Her solution often involved getting out of the house. The fact that she'd cheerfully endured almost two weeks of not doing so was a testament to her love for me and her willpower, and maybe her own exhaustion. I wanted to say yes, because I knew it would be good for both of us, but I couldn't imagine showing up at the bar around the corner with my unwashed hair and a hoodie stuffed with drains, resembling a newly and oddly pregnant woman.

So we did what our couples' therapist was always telling us to: We entwined

our bodies without totally understanding each other. We lay there in the stew of our respective selves and held hands across the bed.

On New Year's Day, when C.C.'s family drove up from Santa Ana to make potato tacos, I told C.C.'s sister, Elena, about Justine. As an alpha female with a fierce temper, Elena had a bit of Justine in her, but she'd been through a tough divorce a few years ago, and I counted her among my tribe, the Tribe of Broken Plans.

C.C.'s mom sautéed potatoes, and her dad brought in a case of bottled water from the car. Beverages were his thing, his practical and economic form of generosity, like C.C. with her lotion and pillows.

Elena perched on the loveseat. I was back in the armchair.

"I just hope that when I have kids, if I have kids, I won't turn into an ass- hole," she said. "When Hasan and I got divorced, people kept saying, 'At least you don't have kids,' like that was this big consolation. And it broke my heart because we'd really tried to have kids, and that whole timeline of my life was completely thrown off."

I hadn't known that. I'd known they'd tried, but I hadn't known that put- ting off kids was part of her heartbreak. But of course it was.

"I have another friend who went through a divorce," Elena continued. "She was like, 'Being there for my daughter really got me through the day for a while.' And I understand that. But I had to be there for myself. I had to get up every day and try to be strong, not because it was this heroic act for my kids, but because it was what I had to do, all alone."

Elena was only a year and a half older than C.C., but the combination of her strong will and their parents' timidity had made her a sort of de facto par- ent figure. When C.C. was having trouble in kindergarten, it was six-year-old Elena who got called to the principal's office. What had the principal been thinking? Had he assumed that C.C.'s parents didn't speak English? Alice and Don had both been born in the United States, but a certain deferential immi- grant attitude lived on in Mexican Santa Ana.

C.C. had often been on the bad end of Elena's bossiness, but in this moment I saw Elena as a tough six-year-old with skinned brown knees, yarn ribbons around her pigtails, taking notes on how to help her little sister. She'd learned young how to take care of herself, and relearned along the way.

In a more charitable moment, I might understand that Justine had done

the same—Justine who'd grown up with a single mom in rural Georgia, who'd lost her favorite aunt to cancer a few years ago, and who maybe wanted to protect her daughter from the jagged edges of the world for as long as she could. It wasn't her fault I was one big, jagged edge these days.

I wouldn't hear from Justine or Sam for months, despite sending a couple of conciliatory emails explaining my feelings with lots of "I" statements, explaining that I understood that hungry babies needed to eat and new parents had full plates. At first, I assumed they were just marinating on the proper response, and we'd be back to dinner parties soon. But Justine told C.C. she "didn't think the time was right," and the time stayed not right, until it was clear I would never get to show them how okay I really was.

Elena reached for her mom's pico de gallo in the green plastic bowl and spooned chopped tomatoes, onions, and cilantro onto her tacos. I did the same, happy to have Canadian-married into a family with such tasty traditions. C.C. and Elena's biological grandmother had died shortly after giving birth to their mom; baby Alice had been bumped back and forth between Santa Ana and Mexico before settling with different family friends. Alice had loved her adoptive mom deeply, and spoke of her fondly, but she would also mention—in passing, with laughter—how she had more chores to do than the other kids in the family, how she'd make stacks and stacks of tortillas that hungry uncles would steal, leaving her with the blame and more work.

Maybe Alice *wouldn't* have known exactly how a mother was supposed to behave when called to the principal's office about her shy kindergartner. But she was doing her best, for herself and by herself. With help and without. We all were.

Cheryl E. Klein

# Connection

## *Leanne Schuetz*

This piece is a tribute to the dear infertility friends I have made throughout my journey. Women who never told me that I had to cheer up or relax but allowed me to feel my disappointments and heartbreak and said, "Me too, you are not alone."

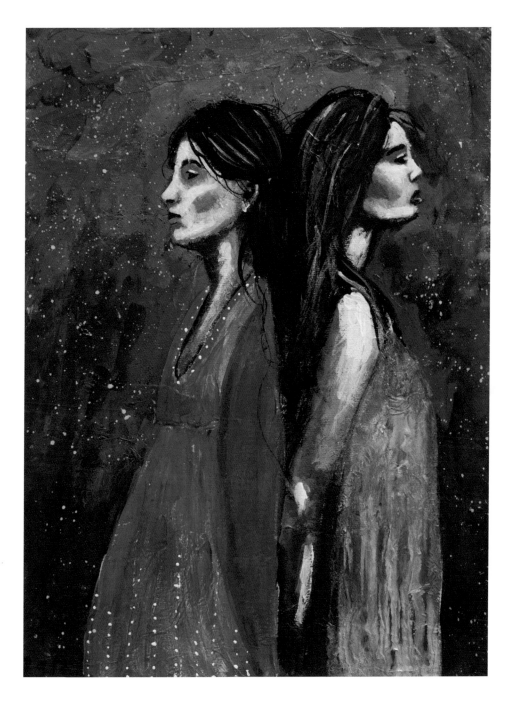

Leanne Schuetz, *Connection*, 2017, mixed media, 12″ H × 9″ W,
collection of The ART of Infertility, Ann Arbor, Michigan

# From Hatred to Hope

## *La-Anna Douglas, Sarah Matthews, and Cynthia Herrick*

This piece is a visual conversation between sisters, La-Anna and Sarah, going through the experiences of infertility and pregnancy; one sister has offered to be a gestational carrier for the other. Inspired by our careers (Sarah, a printmaker and book artist, and La-Anna, a fashion model), we hired photographer Cynthia Herrick to capture intimate portraits of us for this mixed-media piece. The piece explores the complicated emotions surrounding this gift for both of us, particularly as Sarah finds herself unexpectedly pregnant while La-Anna still struggles to conceive after a failed in vitro fertilization (IVF). Together we confront our individual sense of failure; for La-Anna to conceive and for Sarah to carry a baby to term during a high-risk pregnancy, requiring six months of bedrest. We felt like we were stepping on eggshells to communicate without hurting each other. Finally understanding "I am enough!" La-Anna finds herself pregnant after eight years of treatment, three surgeries, fertility drugs, and a failed IVF. Sarah feels relief finally holding her sister's baby in the neonatal intensive care unit. Beyond telling our own story, we created this dialogue to help other sisters navigate the experience of gestational surrogacy.

La-Anna Douglas, Sarah Matthews, and Cynthia Herrick,
*From Hatred to Hope*, 2020, photography, printmaking,
12.5" H × 9.25" W × .25" D, collection of the artists, Columbia, Maryland

# Box: What Remains Hidden in IVF

## Sarah Clark Davis

This repurposed wooden cigar box is part of a larger series I created during my years of trying to have a baby. I loved the idea that the exterior could be one message, as in this box, where the color is cheerful, the bird hopeful, and the quote optimistic, and yet the inside is what really is going on for me emotionally. This particular box both comforted and surprised me when I made it. The quote, from Michael J. Fox, refers to his Parkinson's disease, but it also speaks so well to how to live with infertility. I kept this box on my bureau for a long time to serve as a reminder not to let infertility take over my whole life. Then, the inside of the box came to me, in an angry rage. There is a needle for all the injections and a medicine cap for all the drugs. There are two stacks of dollar bills, representing the stress and anger I felt that none of my treatments were covered by insurance and the strain the financial costs took on my family. The flames and the smoke refer to how out of control my life felt at that point, how my dreams were not matching up to my reality, how I felt when each in vitro cycle failed. I had to keep a lid on these feelings, just like the lid stays on the box. What's inside is hard to name and hard to see.

Sarah Clark Davis, *Box: What Remains Hidden in IVF*, 2012,
wooden cigar box with collage materials, 4.5" H × 8.5" W × 2" D,
collection of The ART of Infertility, Ann Arbor, Michigan

# Staying Mobile

*Kevin Jordan*

As my wife and I delved into our infertility journey about five years ago, one element that came to the forefront is health. Suddenly, we were critical of so many of our lifestyle choices: what we ate, how often we exercised. Were we not respecting our bodies?

One avenue I explored, and still require in my routine, is running. I run off my stress. When we first confronted infertility, I just started running. I ran two half-marathons and a marathon in one year. It might have been obsessive, but it worked. I still use running for my mental and physical strength.

The shoes in the mobile play homage to my personal grappling with infertility. When I was in the thick of not knowing how or if we would have children, my mom shared with me how she found my first pair of baby shoes. I incorporated them into this mobile as a play on the baby mobiles often found suspended over cribs and bassinets. The mobile also symbolizes the spinning in circles that is often experienced as a man living with infertility. Not knowing how to help my wife. Not feeling seen or recognized as someone equally impacted by infertility. Running helped me break free. I have always found it crucial to stay mobile in life.

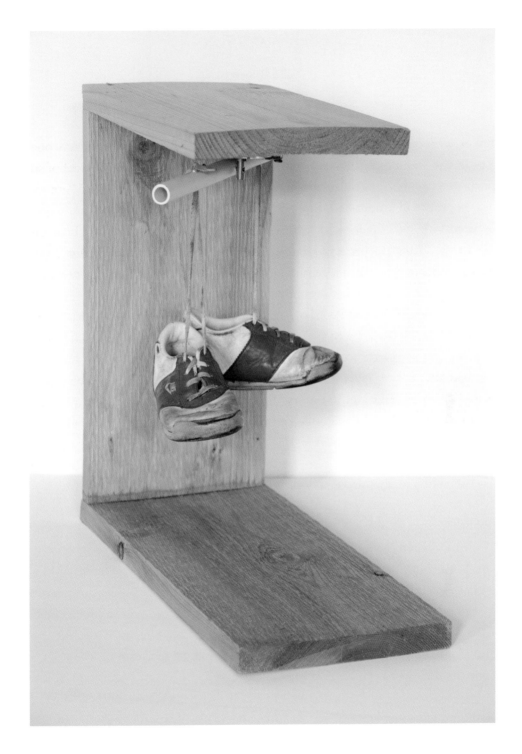

Kevin Jordan, *Staying Mobile*, 2017, mixed media, 16" H × 7.25" W × 12" D,
collection of The ART of Infertility, Ann Arbor, Michigan

# Downer

*Kate Bradley*

I'm waiting outside Helen's classroom for my first parent-teacher conference. Up on the wall are self-portraits the three-year-olds have done. Helen's has purple hair and bright blue eyes.

Another kid's mom is ending her conference. "I'd love to come in and do a little science with the kids," I hear her tell the teacher.

I sigh. Other people seem to have more hours in their days. The teacher, Tracey, calls me in. She's got a button-down shirt, collar popped, under a pastel pink sweater. She looks like a gracefully aging Barbie.

"Welcome," Tracey says. "So glad you could come. We're just loving getting to know Helen."

"So," she says after some perfunctory chitchat. "It's funny about Helen. In the beginning she was quite rigid and almost unfriendly with the others. She would do things like remind a kid to not talk with his mouth full. So much so that some of them were coming to me feeling that she was kind of . . ." She pauses. "A downer."

I give a weak smile.

"But she's really started to loosen up," she says.

I think I've lost my voice. I feel my eyes well up and bite the inside of my lip, hard.

"She's becoming more comfortable speaking to the others," Tracey continues. "As I think I mentioned to you before, she's the only 'only.' The other kids all have siblings. Which is fine! But it might explain."

I nod. On the wall, a group of paintings the kids did with a blue theme. Blue swirls, scribbles, a blue sunrise. Tracey moves on. She takes a folder out and begins showing me results from some basic tests she's run on the kids. I tune out, one word echoing: *downer.*

At home I read an email from my old in vitro fertilization (IVF) doctor and send an email to my new one: *I have decided to forgo the laparoscopy per my previous doctor, who said that performing laparoscopies on pts with suspected endometriomas the*

*size of mine is not recommended and has no effect on pregnancy outcomes. I would, how-ever, like to keep the option of going through with the upcoming IVF cycle open. Please let me know if this will work.*

I keep picturing the doctor at home in her pajamas at her kitchen island, reading the email to her doctor husband. *Can you believe this woman?!* she's saying, sipping her red wine. *Does she want a baby or not?*

When I tell Phil about my emails, he congratulates me. "You're doing it on your own terms," he says. "That's good."

"'On your own terms' is one of those meaningless phrases," I say. "I'm pretty sure these aren't the terms I would choose."

"I know," he says, hugging me. He's babying me and I love it, until I hate it.

After Phil falls asleep, I look up jobs. That's what I'll do. I'll get a real job—no more shitty one-night-stand adjuncting. But then if I get pregnant . . . The baby could go to day care. And then we'd have a sitter pick up Helen from preschool.

Hard to find sitters when your kid is a downer.

I almost won't admit the truth. I am a woman who does not need to work for financial reasons. My life teaching when Helen was a baby was easier than my life now, trying to be a writer during the five weekly hours she's in pre-school. Being, in the perspective of the wider world, a stay-at-home mom. I want to be more, but I also want to be the one to take care of my children. Feminism says I can do what I want. What it doesn't say, but what I know, is that I'm not supposed to want home.

Maybe what happened to Helen has turned me into the hovering sort of mother I never thought I'd be. Or that mother was always inside me. Now that I see how Helen has grown, how she's become a person independent of me, a part of me mourns all the time I missed.

My life is crowded. I can't do more now. I shut my eyes and hear the utter silence of our house at night. *To whom much is given, much is expected*, the lone remaining nun at my high school used to say.

6:15 a.m. at the IVF clinic. A mother next to me death-grips her preschool-age son. "You can't stop licking your bottom lip. Now it's gonna be destroyed. Don't do that. You look like a clown."

I look over. He doesn't look quite like a clown, but his lower lip is bleed-

ing. Why would I want to start this process over, now that Helen has her shit together enough that she's no longer like this boy, helplessly making his own lip bleed?

The nurse who comes to get me is genteel, Southern. Though I have done all of it before, I must listen to everything again. The timeline, the symptoms, the medications.

"Your protocol is really easy," she says. "I wish everybody had this protocol. You're taking two Clomid pills and one Gonal-f injection in the stomach nightly. We will bring you in for bloods and ultrasound every other day. We'll be looking for at least six follicles, preferably more, of eighteen to twenty-two millimeters each. When you're at that point, you'll take your trigger shot to induce ovulation. Approximately two weeks from now, given good follicular growth, you'll come in for your retrieval. At that point you'll be sedated as the doctor removes the eggs and hands them off to the embryologist for fertilization with your husband's fresh or frozen sperm."

She goes over the calendar printout she's made for me. I take it all in easily, not like the first time.

"Someone will go over your after-retrieval calendar after the retrieval," she says. "You'll be on estrogen and progesterone shots if you do get pregnant—those are the fun ones." And I know she means that those are the ones that have to be injected intramuscularly into your ass.

Who was I before I did IVF? I hardly remember that girl. A scene flashes in my head—me in stirrups, the first intrauterine insemination, wondering if that was really a condom wrapper I saw littering the floor of the exam room. Then the first round of IVF—shocked by our diagnoses, terrified, raging. Then the last frozen embryo. "It got to the right spot," the doctor said nonchalantly after the transfer procedure. "We'll see."

After he left, tears fell sideways down my cheeks as I lay reclined on the exam table. Then the acupuncturist arrived, tapping his tiny needles into my ears. A pressure point, he said. The zing when the needles broke the skin and banded together to form a tiny song that meant it was working, that I translated to mean: This will work. I will be a mom.

The nurse pulls a needle from her case. "We're going to practice," she says, pulling a fleshy, skin-colored square from a drawer. I'm writing her story in my head, that she had six siblings growing up in South Carolina, that she always

wanted a big family. She was a patient at the clinic first. What she does gives her life meaning.

Simply being in the same room as the hormones is making me mean already. Or maybe it's me. Judgmental, even when people are just trying to help. A downer, like my daughter.

"Inject without hesitation, like you're throwing a dart," she says.

I quiet my mind, take the needle and plunge it into the faux skin.

When I've convinced the nurse I know what I'm doing, she releases me. "Don't forget your goody bag," she says, and hands me a bag with EMD Serono written on the side. The drug manufacturer, of course.

When I was younger, at a family party an uncle snarled at me, "Don't *you* look like a miserable bitch." Wine sloshed from his glass. My family wasn't generally mean, but there could be a nasty undercurrent.

For no reason at all, I laughed. "Maybe I am," I said, and turned away quickly, to shield him from seeing my shame.

The preschool's Quakerism doesn't seem to be having the intended effect on Helen. When she gets frustrated because she's having trouble with her socks, she glares at me, throws the socks. "If you want *me* to be peace," she yells, "*you have to be peace!*"

In Helen's Richard Scarry book, there are pictures of workers all over town. The poet is in the attic, dreaming away. The teacher is in the schoolhouse with a pointer. The mother is making pancakes and cleaning the kitchen. Kids hang off of her apron. She kisses the father and he heads off to work. Everyone has a job, and everyone's job is equally important, the book says.

Later, I banish the book. I put it in the trunk of my car to donate.

An old friend from New England emailed a few weeks ago. I updated her on Helen, told her I was back at IVF. She wrote back, pleading with me. *My father was a doctor. He always told me to never let them make me a guinea pig. Please, reconsider. They don't know the effects of all this yet. I would hate to see Helen have a prematurely sick mother someday, or worse.*

I send the email to the trash bin. Who does she think she is?

———

While Phil's brushing his teeth one night, I show him the bag of sample medications they gave me at the clinic. "Are you ready for all this?"

"Not really," he says. But I know, as I always have, that he is in fact ready. He wants another baby. He's a great dad. A world where he doesn't want this, where I am in fact the driving force behind this, is impossible for me to believe in. That's the world my mother inhabited, one I was going to settle far away from.

I tell him about the parent-teacher conference. He tells me the teacher is out of line to call a kid a downer, no matter what she thinks. Says that there's no way Helen is a downer. When I tell him that she believes it's all because she's an only child, I choke up.

"Because she's an only child? That's ridiculous."

I nod.

"Have you started the hormones yet?" he asks. "You've been crying a lot."

I look at him and dump the contents of the goody bag all over the bathroom counter, filling up every inch of it.

I leave him alone in the bathroom to clean it up. I haven't started the hormones. I don't even know if I should. We are already a family. So what if Helen can't get along with the other three-year-olds? Three-year-olds are assholes, everybody knows this. *I* wouldn't willingly befriend a three-year-old. If we stay three, my life will only get better: more time alone while she's at school, time to write, to remember who I am.

But then she'll never have a sister or brother, that love. I'm doing it, I already know that. I open the parenting book on my nightstand. How to listen empathetically or some shit like that. Three-hundred-plus pages of tips and tricks. Whoever said there was no handbook for parenting didn't live in 2021.

I'm not in the mood. I toss the book back onto my nightstand and turn off the light.

"It's not the hormones, it's *me*," I scream into the darkness.

# That Time We Had Fleas

*Kelly Zechmeister-Smith*

*That Time We Had Fleas* engages in a convergence of events that happened in a little over a week, including the beginning of a pregnancy loss. First came the unexpected positive test and the (hesitant) celebration that followed. Then the discovery that the cat was host to what seemed like a million fleas. And then the start of the end of a tiny life. I made this drawing inspired by the beloved search-and-find books of my childhood. I kept searching the contents of what came out of me for something to say goodbye to—I would pace the house to try to find answers as to why it happened. All I could find were fleas.

Kelly Zechmeister-Smith, *That Time We Had Fleas*, April 2020, ink on paper, 9" H × 9" W, collection of the artist, Ann Arbor, Michigan

# What IF

## *Barrie Arliss and Dan Louis Lane*

# 3.

It ends, but it doesn't end. You have a baby from intrauterine insemination, from in vitro fertilization, from donor egg or sperm. You decide to adopt. You try again for a second child. You get pregnant, unplanned, after adopting. You have a baby, but you're still infertile, have posttraumatic stress disorder, postpartum depression. You decide to stop treatment because it's been long enough, your relationships have been destroyed, your self. You say you are "child-free," but it's not exactly by choice. Sometimes what we want most doesn't happen; we live in the aftermath. What does the end of infertility look like? Sometimes it looks like a family photo, a thank-you note sent to a doctor when a baby is finally born. Sometimes it is a letter from the cryobank reminding you to pay to keep your future literally on ice. Will you try again? Will you have another child? Will you donate leftover embryos? Sometimes the end of infertility is a work of art hung on a gallery wall, a story shaped like a question mark.

# In My Heart

*Jamie Kushner Blicher*

*In My Heart* honors the many years of treatments and losses I went through to have my children. After our second procedure failed, I was looking for a specific brush in my toolbox and saw that I had thrown some unused needles in there, so I put paint in a syringe and loved how it looked on my canvas: forcing something beautiful to come out of this object that brought me such pain and frustration. The metallic detailing represents the silver linings along the way, including the incredible in vitro fertilization virtual community.

I started sharing my paintings on social media and knew that I wanted to help change the conversation about infertility by speaking about it publicly. I received texts and phone calls from old friends, coworkers, and friends' parents about their stories. I met countless others who have found discussing their fertility challenges to be therapeutic.

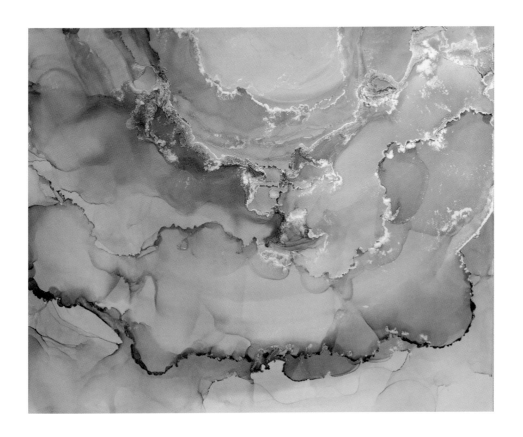

Jamie Kushner Blicher, *In My Heart*, 2016, mixed media,
26" H × 40" W, private collection, Minnetonka, Minnesota

# Disbelief

## *Roxy Jenkins*

For the past eleven years, my husband and I have endured countless medicated cycles, intrauterine inseminations, in vitro fertilization (IVF) cycles, and a twin miscarriage before our dear daughter finally made her way into the world. The arduous journey of secondary infertility has been just as traumatic. It has added three miscarriages, an ectopic pregnancy, a salpingectomy, and a new diagnosis of endometriosis to our list of experiences.

Infertility has made me feel alone, damaged, like a failure. It has turned me into a very closed-off person. It has tested our marriage, our faith, and the belief that anything would come easily to us in life if we worked for it. I want to believe there isn't a breaking point for me. Yet there is no sign that our future will be different, and our past record is less than exemplary. But there also isn't any sign that it couldn't end up different. So we hold on to hope.

I decided to make that pain of infertility work for me. Knowing how special our daughter's embryo picture was to us, I wanted to make it stand out more from the gray tones. So I painted her embryo in rainbow colors a few times, and it turned out better than I imagined. I offered to do the same for my friends who had gone through IVF. They sent me their embryo pictures and I got to work. And Dear Coco Design, named after our daughter, was born. People from all over the world send me their embryo pictures online and I watercolor-paint a reproduction in the colors of their choosing. Throughout the past three years, I have painted and sent more than two thousand different embryos to all fifty states and eighteen different countries. Each embryo painting makes me feel less alone while my husband and I navigate our own infertility journey. Every story people share of how their embryo came into existence is as unique as the embryo itself.

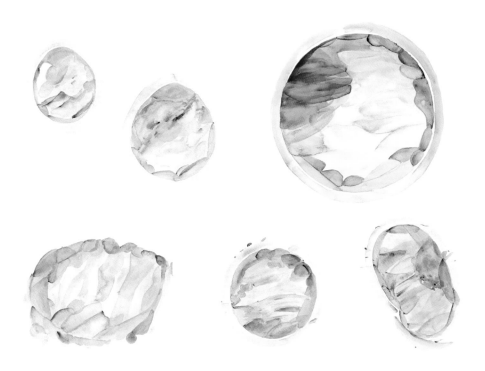

Roxy Jenkins, *Disbelief*, 2021, watercolor, 22" H × 30" W, collection
of The ART of Infertility, Ann Arbor, Michigan

# A Mother by Any Other Name

*Jenny Rough*

At an Ayurveda center in India, I relaxed on a massage table and closed my eyes. Manju, the therapist, dipped her hands into a vat of warm oil and twirled a small section of my hair with her fingers.

I had traveled halfway around the world with the hope that this ancient form of medicine would make me fertile. My husband and I had been trying to have a baby for three years, eight months, and twelve days (not that I was obsessively counting).

My first treatment at the center was called *abhyanga*, a therapy similar to massage, in which my body would be saturated with oil from head to toe. I'd been told it would begin the process of softening the toxins lodged inside my body. As Manju continued to massage my head, I took in a deep breath and exhaled slowly. *Ahh.* So comfortable, so calm, so—

"Ow!" I cried.

Manju had yanked my hair. Hard.

She tiled over to peer at my expression. Manju had beautiful brown skin and looked young, perhaps twenty. She wore a green sari and lots of gold— gold bangles, gold earrings, a gold necklace. She spoke Malayalam, Kerala's native language, and she searched for the correct words in English.

"Is . . . pain?" she asked.

"Yes," I said. "That hurt."

Manju smiled sympathetically and stroked my head. It felt nice, and I thought her comforting touch was an apology. But then she yanked my hair again, just as hard.

"Is pain! Is pain!" I reminded her.

I sat up and took in my surroundings. Above me, a thatched roof of coconut leaves rustled in the tropical breeze. The air was so hot and steamy I could practically see it. I would later learn that energetic hair pulling was part of the treatment, but in that moment I clutched my hair to keep it away from Manju, and I wondered, *What in the world am I doing here?*

When my husband and I decided to have a baby, I thought I'd get pregnant right away. Nothing happened. We followed a few recommendations to

increase our chances, but when they didn't help we crossed them off the list one-by-one.

Just relax.
Elevate hips on pillow after sex.
Buy $30 ovulation pee sticks.
Buy $200 ovulation pee kit.
Semen analysis.
Read *Taking Charge of Your Fertility*.
Track basal body temperature.

Fertility pills or shots sounded too scary at that point in time, so I gave the ovulation pee kit another try. This time it worked. I discovered I was pregnant at age thirty-three over Thanksgiving weekend. For Christmas, my husband and I gave everyone presents with gift tags made out to their future roles: grandma, grandpa, uncle, uncle. Then, ten weeks in, I miscarried. Distraught and sad, I spent that winter crying in bed not only over the death of our unborn child but also because a follow-up ultrasound exam revealed a tumor on my right ovary.

"A *tumor*?" I asked my doctor, repeating his exact words. "Do I have cancer?"

"I won't know for sure until I do surgery," he said.

Turns out, I didn't have cancer. I had endometriosis.

"With endometriosis, the tissue of the uterus grows out of place," the doctor explained. "It can cause infertility."

I felt shell-shocked. I always believed I'd be a mother. The small Ohio neighborhood where I had grown up had been full of nuclear families where dads fired up the barbecue grill on the lawn and moms tended the flower garden or watched over their children running through the sprinkler. In church on Sunday mornings, I soaked up more lessons about motherhood. When I was in third grade, my Sunday school teacher taught us about Father Abraham and Sarah. She wrote the word *promise* on the chalkboard in bubble letters.

"God made two big promises to Abraham," she said. "One was that God would give Abraham land. The second was that God would give Abraham a son. Do you think God kept his promises?"

A few kids offered up a yes. Someone added that Abraham had a son in his old age.

"Good, that's right! Abraham and Sarah had to wait a long time for God to fulfill his promise. And it was hard for them to wait. God's timing isn't always the same as ours. We want things to happen right away."

Back then, I had no idea how much Sarah's story would come to mean to me, or that one day in the distant future, I'd be in similar straits. Barren.

When it came to a baby, was I simply supposed to wait for God's divine timing?

The same year of the Father Abraham story, a new family moved into our neighborhood. The family had a daughter my age, and when she saw me playing outside she walked over. She was as delicate as a butterfly—reddish-blonde hair, skinny, all knees and elbows. Her shorts and loose top fluttered on her body.

"Do you want to ride bikes?" she said.

An hour later, I had a best friend.

The butterfly girl's name was Terry. Terry had also grown up in the faith. One day, she showed me a small card she carried in her shorts pocket. It looked like a baseball card, except there wasn't a picture of a sports player on the front and it didn't come with a stick of bubble gum. Instead, the card had a picture of an old lady with a wrinkly face and a blue-and-white headscarf.

"Who's that?" I asked.

"Mother Teresa," Terry said.

"Mother Teresa?" I'd never heard of her.

"Aren't you Catholic like me?" Terry asked.

"I'm Christian," I said.

"So am I."

"You just said you were Catholic."

"Catholics are Christian," she said.

"Well, I'm Christian and I'm not Catholic," I said.

"Then what kind of Christian are you?"

I shrugged. "The regular kind."

Over the years, I would learn the differences between the Catholic faith and Protestant faith. And I would continue to hear lessons at church about how God works on a time frame different from mine and that God may have things in store for my life that I might not prefer or fully understand.

The night of my endometriosis diagnosis, I got into bed but couldn't sleep. My mind drifted to a different Sunday morning long ago. I'd just turned five,

and my mom had decided I was old enough to switch from the bathtub to the shower.

"Step inside." Mom nodded at the stall.

Water spurted from the nozzle. I submerged myself underneath it, squeezing my eyes shut. Mom followed behind me and closed the door. When I blinked open my eyes, I saw her holding a bottle of Johnson's No More Tangles shampoo. As I waited for her to lather my head with suds, I noticed something odd—a gigantic, purple bruise on her lower belly. It was jagged and ugly, with wiry stitches that stuck out from the center of the wound. She wouldn't let me touch it.

"It's a scar," my mom said. "I had an operation."

I pictured the board game Operation, the one where players used tweezers to remove plastic body parts from a patient. If you accidentally came in contact with the sides of the cavity opening, the patient's red nose lit up and buzzed.

"Did a doctor take out one of your bones?" I asked.

"Something like that," she said.

I wouldn't find out until years later that the doctor had removed one of my mom's fallopian tubes because of an ectopic pregnancy. I also wouldn't learn until later that this wasn't the first of my mom's reproductive troubles. It took her two years to conceive me—and she had to use a fertility drug. She had to use the drug again to conceive my brother Adam. Then the ectopic pregnancy happened. After that, she wasn't sure if she could have another child, but the following October my brother Greg was born.

Because my mom had three kids, I never thought of her as infertile. But the memory of that purple bruise from the shower seemed to be a clue to a different story in our family's history.

Suddenly I saw the broken limbs of infertility on our family tree. My only aunt never had any kids. She had been pregnant once but was diagnosed with an incompetent cervix. Her doctor performed an emergency procedure that involved stitching up her cervix and pulling it closed, like strings on a purse, but it didn't work. Her son had been stillborn.

By the time I recovered from my surgery (and before the India trip), I was thirty-four. At that point, we kicked up our efforts a notch and tried some of the less invasive fertility treatments. Once again, we racked up a list of failures to cross off a list.

Give up coffee.
Hysterosalpingogram.
Prayer.
Progesterone suppositories.
Pills to stimulate ovulation.
Insemination attempt #1.
Acupuncture.
Procreation vacation.
Insemination attempt #2.
Ask my period what it wants.
Prayer.
Fertility-friendly diet.
Yoga for fertility.
Fertility visualizations.
Acupuncture with different practitioner.
Focus energy on a life of abundance.

Now what?

I stood at a crossroads. I could plow straight ahead and try in vitro fertilization. I could veer left for a more gentle approach like Ayurveda, which would help me adjust my diet and lifestyle. I could turn right and try a combination of Eastern and Western medicine. Or I could turn around and embrace a child-free life. The last option was a legitimate one, but it was never discussed in the infertility support group I attended.

Not having my own biological children actually made me feel guilty. I suspected life was bound to be bittersweet either way, that I would experience joys and sorrows with or without kids. But I also felt an immense pressure to be a mom, a combination of self-imposed expectations and a sense that those I loved most (family and friends) would secretly disapprove of my choice to stop treatments, especially when it seemed like everyone else who struggled to get pregnant went to greater extremes.

And what about Ron? Would he resent me?

"I fell in love with *you*," he told me often.

His words comforted me. But I started to overthink, which only brought about more confusing and conflicted desires about whether or not to keep going.

Jenny Rough

After endless back and forth, I scheduled a consultation.

The doctor explained in vitro: I'd inject myself with a drug to force my body into the equivalent of early menopause in order to take control of my menstrual cycle. I'd inject a second set of shots to reboot my system and cause my ovaries to spit out eight to ten eggs (or more!) per cycle instead of a single one. I'd undergo surgery to remove the eggs so they could be mixed with Ron's sperm in a petri dish before being transferred back to my uterus. Then I'd take a third round of shots to make my body receptive to implantation. As I listened to the fertility specialist, I smiled and nodded politely while screaming *no way!* inside my head. The risks seemed too great. I don't even like to take cold medicine for the sniffles. I was afraid hormone drugs would make my body sicker than it already was.

A few months later, I read a blurb in a magazine about an Ayurveda health center in Kerala, India. The center promised to teach me how to use the gifts of Mother Earth—like plants, food, and herbs—to heal my body. I tore it out. Maybe Eastern medicine could provide a path to pregnancy without in vitro. According to Ayurveda, my body had become imbalanced from certain habits, like diet, irregular sleep patterns, a sedentary work environment, and nature deprivation. As a result, disease occurred. In Ayurveda-speak, my body had built up too much *ama* (toxins).

Deepak Chopra introduced Ayurveda to America, and the United States has its own centers. But traveling to a wildly different place would hopefully break me out of my rut. Also, I was still tied to the American church culture with its Mother's Day rose ceremonies, family picnics, and shame-filled admonishments to women who weren't towing the family line when it came to marriage and kids. I'd heard it preached often: "Be fruitful and multiply."

The spiritual vibe in India was strong but totally unfamiliar. The morning Manju pulled my hair, I had woken to chanting from the local Hindu temples. To start my treatment, Manju solemnly spoke a few words in Malayalam that sounded very pretty. Then she smashed a brown paste on my scalp.

"Hey!" I said, startled.

"Sandalwood," Manju said.

Sandalwood is a spice used to offer prayers to Hindu deities. And thus my initiation into Ayurveda began with sandalwood and hair yanking. Manju continued to go around every section on my head.

Twirl.

Yank.

"Ow!"

Twirl.

Yank.

"Ow!"

She then cracked all the knuckles in my fingers and toes. That hurt, too, and I began to second-guess my decision to seek out Ayurveda. Maybe I should have opted for cutting-edge Western medical treatments after all. Then I remembered my accountant. She went through so many rounds of in vitro, she couldn't find a single spot on her stomach that wasn't bruised from hormone injections. She got pregnant eventually—without medical intervention.

Manju motioned to me on the massage table.

"Down," she said.

I lay down on my back and stared at the thatched roof.

"Up," she said.

I sat up.

"No," she said.

I lay back down, a little frustrated.

"Up," Manju said.

What did she mean by *up*? Maybe . . . I raised my arms above my head while still reclined on my back, like a morning stretch in bed. This sent Manju into peals of laughter. I felt her grasp both of my wrists and pull so that my entire body slid along the table. Oh. She wanted me to scoot higher up *on the table*. Now I began to laugh, and Manju and I smiled at each other. We were both on the same page. Finally.

Once in my exact spot, another therapist, named Suda, joined Manju, and they began *abhyanga*. They slathered me with huge globs of warm oil from a pot until I was covered in a golden liquid. The oil slipped down my sides onto the slick table cover. The table had a slight slant that made it work like an aqueduct. The oil slowly ran to the bottom where it accumulated in a big puddle near my feet. Manju and Suda gathered the oil with their hands and applied it—again and again—all over my body. They worked in silence and perfect rhythm, like two synchronized swimmers. They rubbed oil into my arms, legs, torso, and joints, using a pattern to their application that reminded me of a figure eight, infinity.

I relaxed—for real this time—and my mind wandered to thoughts of preg-

nancy and babies and faith. I still believed in God but felt confused about my faith. My journal was filled with entries trying to sort out why I believed in God and what it meant.

Manju and Suda kneaded my lower abdominal area gently to break up the scar tissue caused by my endometriosis. By the end of the massage, I was soaked. Oil was in my belly button, between my toes, under my fingernails, and matted in my hair. The purpose of the therapy was to loosen my *ama*, sort of like softening up a dirty, dry sponge by running it under warm, soapy water to release the grit. The *ama*, once unstuck, would theoretically flow to my digestive tract and be eliminated, swept out of my body like a river releasing to an ocean.

The pinnacle of my therapy at the Ayurveda center came two weeks into my stay: Purgation Day. Purgation Day was exactly as it sounded: a purge. The time had come to get rid of my *ama*. For the first few days at the clinic, I assumed this meant elimination out of my back end. But after talking with the other patients, I realized I had been badly mistaken. I would receive a treatment called *vamana*, Sanskrit for "ejecting from the mouth." In other words, *vamana* would force me to barf—on purpose.

I *hate* to throw up. I hate it more than anything on the planet. If I come down with a stomach bug, I'll spend the night in misery, agonizing as I try to will the nausea away even though I know I'd feel better if I just let the stomach bug run its course. Most of my life, I'd had a weak stomach and tended to get sick at least once a year. When I reached my thirties, my stomach finally got stronger. I hadn't vomited in years, and I had no intention of breaking my record. How had I missed this? I thought I'd done thorough research.

"You don't have to do anything you don't want to do," the director of the clinic said. She was American and spoke English. "*Vamana* is gentle," she added. "You don't want to do the first steps of treatment without the purge. Otherwise, you would dislodge the toxins in your body and they would settle someplace else. They need to be eliminated."

"Out the back end," I emphasized.

"Yes, we'll move only your bowels," she promised.

No throwing up—that sounded good to me.

But that conversation had occurred two weeks before, and I wasn't sure my preferences had been communicated to the therapists.

The morning of Purgation Day, Suda handed me a stainless-steel cup that contained a laxative concoction—herbs mixed with castor oil.

"Medicine," Suda said.

"NO THROW UP," I said, as if speaking in a loud voice would improve our communication barrier. "I HATE TO PUKE."

"Medicine," Suda said, still holding the cup.

"I DON'T WANT TO BARF." I looked at Suda to see if she understood. "OKAY?"

Suda bobbed her head in a triangular motion that sort of looked like a yes but also sort of looked like a no.

Tentatively, I took a small sip. It didn't taste half bad, a little chalky but sweet. In fact, it tasted kind of good. I swallowed the rest.

At first I felt fine. Twenty minutes later, my stomach tightened. I hoped it was nerves, but it wasn't. I lurched for the bathroom and grabbed a bathing bucket. I was too sick to feel betrayed. I shuffled back to bed.

The next morning, I felt fantastic. I spent my last days at the clinic receiving rejuvenation therapies to build up my immune system. Rested, happy, and healthy, I left the clinic with a suitcase full of oils and herbs, recipes, and a bounty of cumin seeds, which I intended to dry-roast back in the States and then infuse the roasted seeds in hot water to create a tea called *jeera*. The Ayurveda doctor had included a written note confirming none of the powdered herbs in my suitcase were narcotics.

Before flying home, I spent two days in New Delhi. Although I doubted I would adopt a fully Ayurvedic lifestyle, I'd already noticed my menstrual cycle wasn't as irregular as usual. Only time would tell whether the improvement would be good enough for a natural pregnancy.

I never did get pregnant again after my miscarriage that had started me on the journey to Eastern medicine.

I never tried in vitro.

We decided not to adopt.

Eventually, because of complications from endometriosis, I had a hysterectomy.

Yet despite all those things, my life shifted from infertile to fertile.

It had begun in India.

My last two days there—the days in New Delhi—I explored the city. The dense population intimidated me, and the traffic was insane: Cars, vans, trucks, scooters, and rickshaws sped by as I walked. I ventured further into the mad traffic and honking horns. As I wound my way through the streets,

Jenny Rough

past heaps of trash, families warming themselves by firepits, and little kids urinating outside for lack of access to a toilet, I recalled a documentary I'd once watched on Mother Teresa. The film shared the story of how she had come to the slums of Calcutta to help the poorest of the poor—the orphaned, sick, dying, and forgotten. As she went about her work, she never seemed the least bit troubled by the traffic that made me so jittery.

In one of the most touching scenes in the documentary, Mother Teresa lifted a newborn girl from a crib. The baby looked listless and on the verge of death. I felt hopeless as I watched. But Mother Teresa caressed the baby and talked to her with a gentle voice. Unexpectedly, the baby smiled.

"See?" Mother Teresa said. "There's life in there."

As I replayed the scene in my head, I stopped in my tracks.

Mother Teresa.

*Mother* Teresa.

The mother who never had children.

The mother who never gave birth.

The mother who took a vow of celibacy.

That day years ago, when I was in grade school and my friend Terry showed me her pocket card, I hadn't made the connection that Mother Teresa was Terry's namesake. And until that moment in India, I hadn't noticed the parallels between Mother Teresa and Father Abraham. Just as Father Abraham left his relatives in Ur of the Chaldeans for a new land, Mother Teresa left Southeast Europe for India. Just as Father Abraham followed God's call to form a new nation, Mother Teresa followed God's call to care for those in distress. Abraham was known as Father not because of his son Isaac but because he became the father of faith. Mother Teresa was called Mother not because of her physical fertility but her spiritual one.

I'd always longed for intimacy with God, yet for much of my life it eluded me. When I returned home from India, my faith began to take root. The thin pages of my Bible fluttered in my hands day after day as I read its stories. Rebekah. Tamar. Hanna. Ruth. Jesus' entire lineage was riddled with stories of infertility. And God always used these times of difficulty and despair to help someone's faith blossom. I read more and more. The parable of the sower. The Garden of Eden. A land flowing with milk and honey. Every passage spoke of barrenness and fertility.

Now, I view the phrase "Be fruitful and multiply" in an entirely new light.

It can mean different things for different people and manifest in different ways. I wish I'd realized this sooner. Mother Teresa was already on her way to living a fruitful life by age eighteen. For me, my struggle with physical barrenness eventually helped me see my spiritual barrenness. And that led me to a life of faith that brought fulfillment. I was already in my mid-thirties. But then I read again the story of Abraham and Sarah and realized Abraham was one hundred when God called him; Sarah was ninety. If it wasn't too late for them, it wasn't too late for me.

# Bloodlines, Matryoshka

### *Raina Cowan*

I have a set of blank Russian nesting dolls, or *matryoshka*. I pondered them for years, trying to decide how to decorate them, before making this image in 2019. I realized how maternal they seem, one inside another, one carrying another. I started viewing them as an ancestral representation of bloodlines, which is their true symbolism.

With infertility, the loss of the ability to carry on the family bloodline can feel devastating. If considering adoption, one has to begin to grieve the loss of the "would be" child: the one with your eyes, Grandma's smile, and so on.

As an adoptive parent, I no longer dwell on my lost babies, but I do think a lot about my daughter's losses. By being placed for adoption, she lost her birthright to be raised by her birth family. She lost everyday interactions and reminders of her identity from people whom she not only resembles but who are also connected to her by blood and DNA. She lost racial mirrors and multicultural reflection by being adopted by a white couple. Transracial adoption, like these nested dolls, adds multiple layers to parenting and identity.

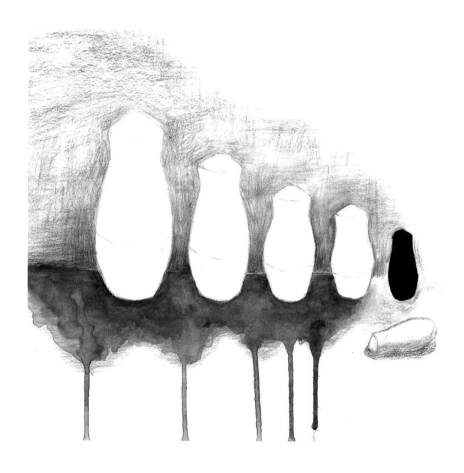

Raina Cowan, *Bloodlines, Matryoshka*, 2019, pencil and watercolor,
11" H × 14" W, collection of the artist, Chicago, Illinois

# S/m/othering: Cassatt

*Marissa McClure Sweeny*

As an artist, teacher, and researcher inspired by feminist artists and mother-scholars, I chose to create public art pieces, installations, and performances that confront my infertility experience. I called this process "s/m/othering": a play on words that not only describes the visceral and embodied way that I felt during the deepest valleys of my infertility journey but also the ways in which the absence of affirmations of the infertility experience in art functions as isolating and othering.

This image is from a series of works that I created when I visited the Dallas Museum of Art during a conference for art educators. I chose this Cassatt piece because her work had resonated with me since childhood: We were both born in Pittsburgh, Pennsylvania. In her work, she presents new feminist possibilities through her portrayal of the intimacy of mothering even though she had no biological children. Throughout the four-year s/m/othering project, I chose work at each museum / art exhibition that I visited to smother. I began by searching the museums' online collections using the keywords *mother*, *infant*, *baby*, and *child*. I then cut out the images of the babies and children, both physically in postcards and by using Photoshop to alter photographs in the images that I found most painful to see, leaving only the mothers/others and the empty space. This absence, then, was smothering. I reinserted my altered images into new spaces, in person and online, to encourage dialogue. I saved the cutout images of children from these pieces, and as I built my own family through ART, I invited my three children to use them and to reinsert them where the absences fill and remain unfilled in ways that represent my ongoing experience now parenting after infertility.

Marissa McClure Sweeny, *S/m/othering: Cassatt*, 2013, mixed media,
5" H × 3" W, collection of the artist, Indiana, Pennsylvania

# My List of True Facts

*Erika Meitner*

I am forty-three and I just drove to CVS at 9:30 p.m. on a Sunday
to buy a store-brand pregnancy test two sticks in a box
rung up by a clerk who looked like the human embodiment
of a Ken doll with his coiffed blond hair and red smock
even though I wished there were a tired older woman
at the register this once even though I am sure I am
not pregnant this missing my period is almost definitely
another trick of perimenopause along with the inexplicable
rage at all humans the insane sex drive and the blood that
when it comes overwhelms everything with two sons
already what would I do with a baby now even though
I spent four long years trying to have another I am done
have given away all the small clothes and plastic devices
that make noise just looking at toddlers leaves me exhausted
this would be a particularly cruel trick of nature the CVS
was empty there was no one in cosmetics or any aisle including
family planning which is mostly lube and condoms I didn't
know Naturalamb was a thing "real skin-to-skin intimacy"
there's just one small half of one shelf of pregnancy tests
and some say no/yes in case you don't think you can read
blue or pink lines appearing in a circle my grandmother
was a nurse-midwife during the war in the Sosnowiec ghetto
her brother ten years younger *a change-of-life child* she called him
when she told me finally she had a brother when the archivists
came around for her testimony years after her brother was gassed
alongside her mother in Auschwitz years after my grandmother
euthanized her own daughter whom I was named for because
the SS were tossing babies from the windows of cattle cars
*change-of-life child* the name for a baby born to an older mother
past forty I peed on so many sticks over so many years
gave myself scores of injections took pills went under anesthesia

and knives since there's an unspoken mandate to procreate
when all your people your family were actually slaughtered
I gave one son my grandmother's brother's name and
the other was called King Myson by his birth mother
on the page of notes we got that she filled out before she
gave him up it took me an hour of staring at the form
before I realized it was *my son* she was claiming him
before she let him go and I think the morning will bring
nothing just one blue line but right now it is still night
and I am sitting in my car under the parking lot lights
which are bright and static like me and beyond them
there's the clerk in the red smock locking the doors.

# An Open Letter to Our Sperm Donor

*Robin Silbergleid*

Our daughter looks like me
people say, the architecture
of her eyebrows and pointed stare.
But in the photograph of you
at thirteen months: our baby's
toothless grin after she's grabbed
the cat by the tail. Every child
you said needs a mother who reads
and each night I let her suck
thick cardboard illustrations,
*Big Red Barn* and *Goodnight Moon*,
while I balance her on my lap.
If you lived with us, you
would know this. Perhaps
you would bring me a cup of tea
while I nurse her on the couch,
a book of poems open nearby.
Sometimes I wonder if you wonder
about us, when you're at work
in the laboratory or when
you're feeding your new son a bottle.
The stories of our children
are woven together. The tapestry
couldn't be more beautiful, filled
with these widening holes.

# We Have No Room: A Study in the Ritual Practices of Infertility

*Amy Traylor*

In *We Have No Room: A Study in the Ritual Practices of Infertility*, I explore the ritual practices of a specific community of women experiencing infertility. The women are caught in the false dichotomy of logic and emotion, confronted with the heady scientific knowledge and medical invasiveness coupled with the absolute emotional devastation frequently experienced on the path to having a child.

The individual lamps represent the experiences of each member of the group: their hopes, desires, and many losses. The Flower of Life light projection is representative of the sixteen-cell division stage of the human embryo, the beginning of cell differentiation, frequently when embryos stop developing in the lab. The projection screen loops through the entire two weeks from egg fertilization to embryo division to the ritual of pink-dye pregnancy tests.

The bluish color of the lamps represents what an embryo might experience developing inside the embryologist's lab. What would the environmental context be, the lights, the sounds, the temperature? The golden lamp represents the Golden Egg, the end goal of every woman experiencing infertility. You need only one good egg to make a baby, the golden egg.

Each embryo was individually molded in coconut oil and sugar so they would melt into the skin when warmed. I wanted to provide visitors to the installation an opportunity to hold and possibly reincorporate the edible embryos as a way to become part of the physical cycle of infertility. Collectively, the installation provides a place of contemplation, waiting, and an opportunity for empathy.

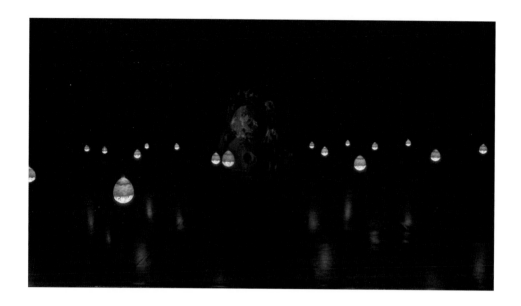

Amy Traylor, *We Have No Room: A Study in the Ritual Practices of Infertility*, 2020, multimedia, video projection, 15" H × 40" W, collection of the artist, Rio Rancho, New Mexico (continued on next page)

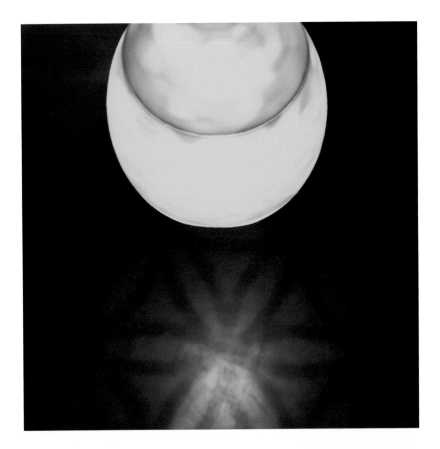

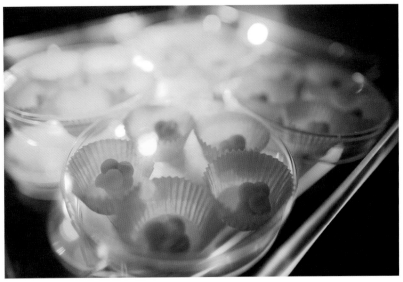

Traylor, *We Have No Room* (detail)

Amy Traylor

# Twelve Vessels

### Cole Askevold

After a failed in vitro fertilization (IVF), I asked my doctor about my chances for a second child. *Less than 10 percent*, she said, given the quality and quantity of my eggs. I counted our attempts at pregnancy through IVF and intrauterine insemination: eleven. (One resulted in our daughter, bracketed on both sides by failed attempts or miscarriages.) I urgently needed to memorialize the lineage of disappointment and success throughout the journey toward motherhood.

Vials of microscopic sperm are delivered to clinics in massive silver liquid nitrogen tanks. Eleven of these oversize vessels had been delivered to fertility clinics, and the sperm extracted and thawed for insemination in my uterus. One final vial was left at the sperm bank. I asked for it to be delivered to me at home.

The priority Fed-Ex shipment arrived in a bright blue corrugated plastic box with labels that read THIS SIDE UP and FRAGILE: HANDLE WITH CARE, echoing what I had been reminded to do when trying to conceive. I replicated the liquid nitrogen tank, making twelve sculptures from Hydrocal gypsum cement. Each one, though similar, revealed differences and irregularities that distinguished one from the other. In this way, the multiple attempts to become pregnant had parallels to the multiple variations of each of the eleven treatment cycles and the children that might have been. I embedded the final vial of sperm in resin and surrounded it with jagged chunks of concrete.

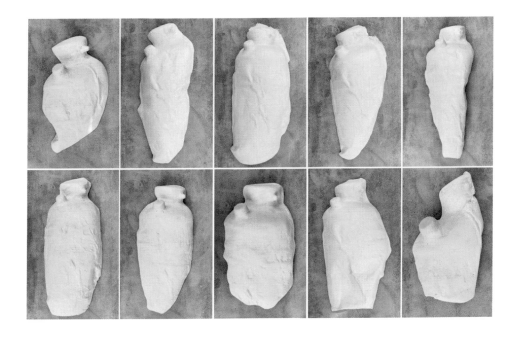

Cole Askevold, *Twelve Vessels*, 2022, Hydrocal gypsum cement,
20" H × 117" W × 8" D, private collection,
Port Townsend, Washington (continued on next page)

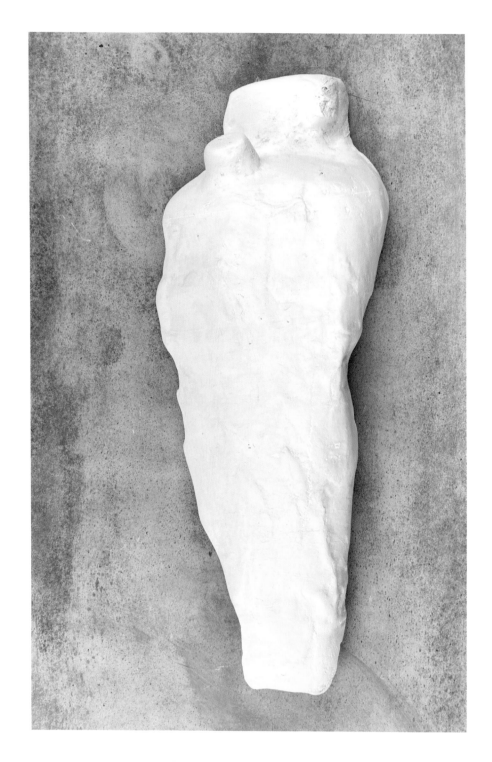

Askevold, *Twelve Vessels* (detail)

Cole Askevold

# Frozen Futures

*Krys Malcolm Belc*

Bills for the sperm sit and sit for months. They don't come addressed to me. They get shuffled like all our papers: from the table to the shelf, from the shelf to the counter, from the counter to the windowsill. They are in motion. They're addressed to Anna. She is the owner, the arbiter, the mother, even, of the sperm we keep stored. Is it *our* sperm? *Her* sperm? *Our donor's* sperm? It seems to be all these things; we call it *the sperm*, mostly. The sperm. It has been in storage at one of our reproductive endocrinologist's offices for nearly a decade.

I do not know what the containers it's in look like or even what reproductive endocrinology office—they have four in our state and an additional handful outside it—it's in. The bills don't say. I'm strangely uncurious about it, the frozen home.

We wait and wait to pay, not because we cannot but because we lack strong motivation to keep the sperm. We are ambivalent. We spend our days on job sites, Zillow. Our children know we are people who talk about moving. But nothing will happen to the sperm, even if we delay paying. We know the world loves the prospect of a child far too much to let any harm come to even the idea of one. And then, one day each year, we pay. Anna sends our checking account number into an online portal, and we hope the money gets to whomever it needs to get to and that the sperm is still frozen in space, waiting.

Wherever it is, it represents so much: our family's past, the conception of our three children. Our donor, with whom we're still in touch, frozen in time. Young, and a little bit handsome, and not yet a doctor, not even in medical school, long-haired and always riding that mountain bike around West Philadelphia.

Anna: pregnant, just about to start her first job as a nurse. So thin and freckled and energetic, on the cusp of a career's worth of jobs in hospitals all over the city, often two at a time. She bought her stethoscope, her first pair of clogs. Did she want the baby? She wanted to have children, and she wanted to have children with me, and I was in a rush, and so here we were. She glowed, ambivalently. At the same time she gestated this child, she finalized plans

to freeze our donor's sperm, forwarding me emails I would not read in their entirety until years later:

> Approximate cost of the program is $2500 to 3000, but can change if the State your fertility doctor practices in requires additional Donor screening tests. Please keep in mind that your specimens (once banked) may need further testing to be compliant with health regulations of another State if you change infertility doctors and your new physician is located in a different state other than originally planned. [. . .]

> When deciding how many DD [directed donor] specimens you will need to have banked, discuss with your physician the type of fertility procedure that will be used and the likelihood of wanting sibling pregnancies in the future.

And me: twenty-four years old. I was a teacher in the basement of an old high school. I stood in my school uniform—mine matched the students'—by the back door each morning and greeted them as they came off the buses. My wrinkled khakis and blue ties and my sweater vests. I looked like a baby. I was a baby. The only thing that kept other teachers from stopping me before going into the staff restrooms: I was white. Though I remember every one of my eleven students' names, when I try to remember the classroom, all I can recall is its walk-in closet, full of hazards; mice; and asbestos ceiling tiles. I loved the classroom best early in the morning, before any students had arrived. The black of early morning outside my window and the materials sitting at attention, waiting for my students. It was a long, hard year. I was waiting for a future that I thought I would be better. The thing that mitigated being a new visibly queer teacher on a hallway of older women teachers: the baby of my future. Everyone fawned over Anna, who has always, though it is not a role she chose or would have chosen, made me seem more normal.

For our first baby, our donor came to our apartment, went upstairs to my bedroom, left his sperm in a specimen cup on Anna's bedside table, then came downstairs to chat with me while I cooked the three of us dinner. Anna and I knew we wanted a number of children—four, we said then—and so we

were embarking on a relationship that could only last forever and only grow in intensity. And it was easy. I barely knew him, but I liked him. I loved that his contributions to our dinners were snacks he and I would eat while Anna laid with her ass propped up on pillows upstairs. Something about sperm and gravity. Something strangely intimate.

And then she was pregnant, and already it was time for him to store our future children, who were not children at all but rather an idea, more of a mere idea even than the baby growing inside her. He was still coming over for occasional dinners and loved to tell us the stories of the sperm bank. We had decided that after Anna had the first baby, we would quickly have a second. Since we didn't know where we would all be in a few years, banking sperm seemed like a good idea. We told him we wanted four children, but we had no idea, really. We didn't even have a first. Everything we decided about the bank was a projection of a possible future we could barely imagine.

Unlike the idea of wherever the sperm is now, the idea of the bank excited me then. I loved his tales of donating. The other men were impossibly tall and beautiful, but he was a "directed donor," just some regular guy giving sperm to a couple he knew. We laughed together at the cartoonish procedures for donation. He sheepishly downplayed the specialness of who he was to us. Before it was even late he would go outside, get on his bike, and go home.

We downplayed it, too, and still do. He has allowed us to make our family and also gave us the gift of possibility of a bigger, and different, family in whatever future we see fit. But in our twenties, we laughed together over the emails we received about his donations. How could we not?

Date: Wed, 11 Apr 2012 at 13:23

Subject: 4/9/12 Specimen

Hey Anna,

[_____'s] specimen looked really good from Monday. We were able to freeze 4 vials with 13.2 million motile cells per vial (this is a higher quality than what we sell)!

If you would like for [_____] to leave another specimen,

it would be ideal if he came in with the same amount of absti-nence hours.

Let me know if you have any questions.

Thanks!

I think of that time and I see mostly good. I think of the three of us sitting on my living-room floor drinking lemon seltzer and eating half a bag of pistachios our donor took home after a dorm party. I think of Anna's and my mismatched plates, how we owned only sneakers, the apartment with no closets, and how our donor fit right into all that. I was convinced he owned only the one T-shirt.

This is not a time of my life I would have chosen as the moment to freeze. I was so sure I was ready to be a parent, but in retrospect I was pushing down the things about myself that would come later: my own pregnancy, my medical transition. Before we had our children, I was not out to most people. I was not out to our donor. We never really talked out our family planning with anyone in our lives. I'm not sure why. I wasn't the teacher I wanted to be, the partner I wanted to be, and I didn't even realize any of that yet. The me I don't want to remember was eclipsed by one child, and then another, and then another, and I rarely think about him.

The other day I stood over Anna's shoulder at the counter as she paid for another year of storage. By paying this annual fee, we extend our family's pos-sibility into another year. We bring our uncertainty with us into another year. The possibility of our fourth child tethers us magnetically to the year I was twenty-three and waiting for Anna to come down to dinner, possibly pregnant this time. Every year we pay again to keep it. And we bring those moments of a past with our donor—standing at the counter chopping vegetables and lis-tening to him talk about his day, watching his back as he headed up the stairs to catapult us into our future—with us. Like us, he is nine years removed from those days. But the sperm we have, the letters we get, they are frozen in time. If we use the sperm, our sperm, if one of us becomes pregnant, we will have to access the selves we were, the selves he was too. In our family, there is no way to move forward without looking back.

Krys Malcolm Belc

# Cactus Middle Fingers, on My Way down the Mountain

*Annie Kuo*

I live in the Seattle area, but my attempts to freeze eggs here were not successful. My ovaries didn't respond well to the stimulation drugs, so the doctors canceled the egg retrieval procedures. I found a doctor in Arizona who was willing to retrieve however many eggs I produced. No matter how few, freezing eggs symbolized closure for me and empowerment that I could do something for myself in the context of a sunsetting marriage.

I was in Arizona for a last attempt at egg freezing when I took this picture hiking down Camelback Mountain, the highest summit in Phoenix. A nurse had called me on the way up to confirm that I had ovulated—something you don't want to happen before retrieving eggs (because it means there's nothing to retrieve)! I cried at the summit. I had climbed a mountain literally and figuratively but came away empty-handed except for the journey and the view. On the way down the mountain, I saw these cacti. At that moment, and even now, they appeared like middle fingers. *F\*&^ this*, I kept thinking to myself. *I'm done.*

After I was unexpectedly widowed in 2020, I grieved the loss of what would never be again. But I also realized there is so much we can't see or understand in the moment. Even if we think we are done with hope, the universe might not be done with us. There are many ways to build a family if we still have the desire.

Annie Kuo, *Cactus Middle Fingers, on My Way down the Mountain*, 2016, photography, 8" H × 10" W, collection of The ART of Infertility, Ann Arbor, Michigan

# Cousins

## Elizabeth Horn

This piece was created around a painful experience I had while my sister was visiting with her two youngest children. My four youngest nieces and nephews were having a sleepover at my parents' house. My mother bought them all matching pajamas, and they were wearing them, sitting in a row on my parents' couch. I was overwhelmed with sadness. I knew that if my twins, conceived after our first embryo transfer, had survived, they would be sitting in the middle of the lineup.

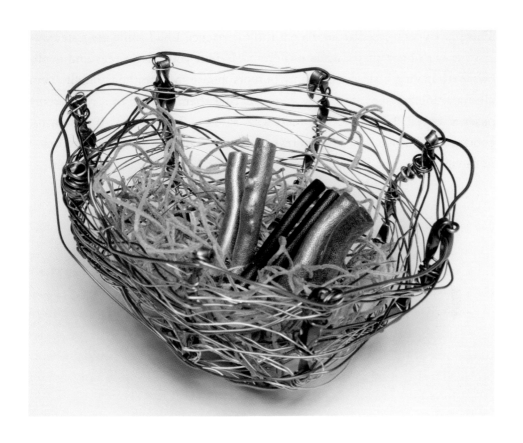

Elizabeth Horn, *Cousins*, 2016, mixed media, 3" H × 4.25" W × 4.25" D, collection of The ART of Infertility, Ann Arbor, Michigan

# Frozen

*Robin Silbergleid*

There is no other way to say this: I want another baby. I want another baby as I eye heavily pregnant women at the farmers' market and the women with bellies that may or may not be a "bump" or residual weight from the toddler whose hand she holds. I want another baby as women caress the rumps of their newborns through the cotton of Ergo and meh dais carriers; I want another baby as men adjust the sun visors on strollers with sleeping six-month-olds tucked inside. I want another baby in the way I wanted a baby more than a decade ago, when I hadn't yet experienced pregnancy and loss. I want a baby in that naive way that women who have sex and get pregnant want babies, with weekly reminders sent from BabyCenter and greedy registries at Babies "R" Us and Amazon.com.

I am unpartnered. I have the two children I always wanted. I have a chart three inches thick full of miscarriages and various infertility diagnoses. I had to use an egg donor (an egg donor!) to conceive my son in my thirties. I am now on the downside of forty-one. But I want to hop in bed with my sometimes lover at the right time of the month—the next few days would probably do—and feel a bit off in about two weeks and take a test and nine months later everything in the world would be right.

I have two embryos sitting in a cryotank an hour from home.

They are the remainders from my successful in vitro fertilization (IVF) cycle two years ago, a group of embryos that began as fourteen and by day 5 (transfer day) had whittled down to six. Two went into me, two went into the freezer, two were given another day to grow and then dismissed. These last two were less "pretty" as far as embryos go than the two that went into me. Like the estimated six hundred thousand frozen embryos in cryobanks across the country, they are, depending on one's perspective, clumps of cells or babies, or somewhere between. The paperwork sent from my doctor's office, reminding me that I have to pay to keep them there, gives me the choice to (a) use them within the next year, (b) pay to have them shipped elsewhere for long-term storage, (c) donate them for research, or (d) destroy them. None of

these options appeal. I go back and forth: They should be used; I don't want them to be used. If I want to donate them to another single woman or couple, I need to decide if they should be donated anonymously or not. All these options leave me with an icky feeling. Should they be transferred into a uterus and successfully implant, they have the potential to be my son's full-genetic siblings. His only full-genetic siblings.

Most of the time I don't really think about these embryos, and even after a three-year struggle with infertility and pregnancy loss, I have to say I don't think much on a day-to-day basis about the twin that didn't make it, or my son's origin, despite having a "baby picture" of him as a day 5 blastocyst, where he looks something like a pearl earring set in a blue jewelry box. Most of the time, I'm too busy chasing around a toddler, who calls me "Mama" when he wants to snuggle and nurse and "Mee-mee" when he's about to get into trouble. But when the paperwork shows up each year, I keep the envelope unopened on my desk for weeks.

Initially I didn't want to use them because they were my backup plan. Reading about women whose IVF cycles produced ten, even twenty, leftover embryos, I felt sick when the day after my embryo transfer the nurse called to say I was left with only two. What if I didn't get pregnant? Depending on the mechanism by which they are frozen, success rates for frozen embryo transfers can be much lower than initial IVF cycles. Two didn't leave a very large cushion— probably only one other transfer. They were insurance through high-risk pregnancy and infancy. I worried about sudden infant death syndrome. I worried that those worrying hormone levels in those first days of pregnancy meant something long term for him, that the 80–90 percent (yes, you read that right) chance of loss I was given in the first trimester somehow would stay with us. Worry dragged on through pregnancy, six markers for high risk in red at the top of my chart, the placenta possibly failing, my son's growth restricted. I sobbed through the physician-mandated C-section, sure that as soon as he was cut from my body his own would fail, that he'd never be able to take an independent breath.

Now that he's sixteen months, now that he's survived my "hostile uterus" and early infancy and moved into toddlerdom, I worry much less about spooky uncertainties in the dark. I think we will be okay. I think he might stick around for the long haul. I think I might get to keep him after all. And if

something happens to him—yes, I think in these terms, I have already lost babies—as much as I would ache for him, I will not start over. I will not replace him. Could never replace him.

I am done having babies. I know this.

When the phone rings with that familiar area code—my fertility specialist's office; it looks to be the extension that used to pop up on my phone as "More Bad News"—I know they must be calling about the embryos. They're still sitting there, waiting for me to make a decision. Yes, I hear myself say, yes, I would consider donating them under the right circumstances. Yes, I think I am ready to have that conversation. Yes, I think I might be able to sign those papers now.

And yet I am not sleeping at night. What is the right decision for those embryos? For me and my family?

I do not believe that embryos have rights. Contra to so-called pro-life rhetoric, they are not *children*. They are not even a guarantee of a pregnancy (much less a live birth), as, contrary to popular misconception on television and mainstream media, doctors do not *implant* embryos in women. This is an important distinction that anyone who has done—and failed—IVF can tell you. Embryos are *transferred* to a uterus by way of a catheter and, hopefully, are genetically healthy enough to thrive in a suitable uterine environment. Neither of those is a guarantee, which is why success rates for IVF, even at the best clinics in the world, don't go much over 50 percent.

I do not believe that embryos have rights. I do not believe that embryos are children.

But having been a long-term fertility patient, having wanted, desperately wanted, a healthy embryo to become a healthy child, I think that any woman who is willing to become a mother by way of embryo donation or adoption should be able to do so. I have been thinking hard about this, and if the end of my fertility journey is also the end of another woman's, well, that seems to me the only right way for this story to end.

I am frozen. Unable to make a decision. The embryos sit there. Waiting.

Robin Silbergleid

I wonder about family bonds, about what holds families together. It is certainly not DNA, as any adoptive parent will tell you. And yet I wonder if that will matter to my son, if he will want to know those potential donor siblings, if he will understand them as siblings in a way that I don't.

I think, too, about why it is that of those six blastocysts we reviewed that morning in the IVF clinic, he was the one of two my doctor and the embryologist chose to transfer, why he alone survived those first agonizing weeks of pregnancy and the other did not. Of those remaining two in deep storage, I wonder if they are male or female, if they would look like my son, if they would share any of his personality traits. I wonder how much of his identity is the result of his early experiences in utero, what scientists call epigenetics, how much, that is, that he got from me and not the two donors. How would he have been different, even, if he was the result of a traditional surrogacy arrangement, where the egg donor also carried him to term? Epigenetic research says that he would not be the same kid. My body began shaping him from the moment he entered my uterus and latched on tight.

These days, I think a lot about those embryos in their tank. About what I will say to my son when he asks why he doesn't look like me or his sibling. The picture book by Cory Silverberg, *What Makes a Baby*, talks about the many ways that families can come together. To make a baby, you need an egg and a sperm and a uterus.

I have no easy answers. I know it was important to me to try to get pregnant, even from another woman's egg, and I didn't want to adopt. I knew too many sad adoption stories, with bad outcomes. I wanted to mother my child from conception, to control the uterine environment he grew in. I know, for other women, their own DNA is so important that they will not consider donor egg, embryo donation, or adoption. If they can't have their "own" child, they don't want one. I know women who spend hundreds of thousands of dollars at world-renowned clinics, experience miscarriage after miscarriage, on the chance that it might eventually work. Sometimes it does. I know women who spend years trying to conceive, trying every possible alternative therapy and treatment, until they reach menopause and remain, unhappily, childless.

I suppose that sounds judgmental, although I do not mean it to be. There

is not one "right" way to build a family, just as there is no single cure for infertility. But as a friend (another donor egg mama) said to me, why choose infertility and loss instead of the best possibility of joy? I chose joy. I chose donor eggs.

And this is the best reason I can think of to donate my remaining embryos to someone who wants them, someone who has come to terms—more or less—with being a recipient. Because while I do not believe that embryos have rights, infertile women do. And what an amazing gift to be able to share the gift that was given to me.

I chose anonymous donors for a reason. I did not want to become entangled in someone else's life when I chose to have my family as a single mother. The kinds of scenarios you find in films like *The Kids Are Alright* and ones I witnessed on a listserv for single mothers by choice—in which kids grow up and find donors who then become a part of a family, sometimes even becoming their mother's lover—do not appeal to me. My children have an aunt and an uncle, cousins, a grandmother who dotes on them, a great-grandmother who watches them grow from afar. They have our "chosen" family of close friends who come to dinner and hang out with us on the weekends.

So, while I know they both have other genetic half-siblings out there, I do not know who and where they are. I have not taken any steps to find out. If and when my children ask, I will certainly help them make connections. But making the decision that might lead to the production of more genetic siblings I find troubling, to say the least.

I decide that it's time to donate the embryos, when my son is eighteen months; my doctor sends me a contract. She's working with an agency, as legal issues with embryos are tricky, but it's an understatement to say I find the arrangement objectionable. This agency would earn money from my embryos. This agency would vet prospective parents, as if they were becoming foster or adoptive parents to living children. This agency would not have let me, as a single Jewish woman, become a mother. I deliberate for a day or two, then tell my doctor I still want to donate but just can't do it this way. I am struck, again, about how anyone who can have sex and is fertile can have a baby but somehow those who already struggle with infertility, those who want desperately to have a baby, warrant home studies and regulations, as if they weren't stig-

Robin Silbergleid

matized, traumatized, enough already. I think anyone who wants a baby that much probably isn't the one who needs a home study.

I am done having babies. Although I don't begrudge other women's desires to have babies through their forties and even fifties, that's not something I want for me (if life worked the way I planned, I would have been done having children at thirty-five). It is harrying enough to have two children (they outnumber me!), and I fully believe my family is complete.

And yet when I read that one of the friends I met online, one who failed multiple IVF cycles and did a donor egg cycle around the same time I did, no less, is pregnant just from having sex with her husband, it is like a knife to the belly. If that happened to me, certainly I would not choose to abort. So: Am I really done having children?

When my doctor's personal cell phone number shows up on my caller ID, it takes me almost a week to listen to the message. Whatever she has to say, I am not ready to hear it. I had been ready to donate but not anymore.

Maybe it's the fact of weaning my son. Maybe it's the fact that the difficulties of sleep deprivation and new baby–ness are largely over. With an almost two-year-old, I can be nostalgic now for those newborn days. I want to be able to donate these embryos, don't want them to just sit there in long-term storage. But I can't imagine a situation in which anyone else is their mother.

I email my doctor, tell her I'm not ready.

*No worries*, she writes back. *Just enjoy your babies!*

I am, and yet why is this so fucking hard?

Now, at twenty-three months, my son has strawberry-blond hair and, depending on the light, blue or hazel eyes. Sometimes strangers ask—in that stupid way that strangers do—if he "got those" from his father. And I reply, honestly, though it is not really the answer the stranger is seeking, that there are light eyes on both sides of the family. Like me, both egg and sperm donors have brown eyes and brown hair. It takes recessive genes on both sides in order to produce a light-eyed child from two dark-eyed parents. My eyes, I have been told, are coffee-brown and my hair, these days, almost black.

What does the stranger really want to know, and why does it matter?

When I was in the thick of infertility and pregnancy loss, when friends and family knew I was struggling, they would ask (all with good intentions) if I wanted another child *enough* that I would adopt. The language puzzled me, as if there were a sliding scale of wanting children and the most wanted ones were adopted. Perhaps to a point that's true; I have no doubt that adopted children are very much wanted, in many cases the result of their parents/mothers wanting their "own" biological children, though in others chosen simply for themselves. And also true that in many cases biological children, if not unwanted, are not always deliberately chosen, with something like half of all pregnancies in the United States "unplanned." It did not occur to any of my friends that egg donation (or even surrogacy) was a possibility I might consider. I wanted this child, my child, a great deal. Although I said at the time I had no interest in pursuing adoption as a method of becoming a mother, I also know that had egg donation not worked for me, I probably would have. Maybe that sliding scale after all.

Three years after the IVF cycle that led to my son, there is an unopened envelope on my desk from the fertility clinic that houses my embryos. I know what is in it without opening it, a reminder that the embryos need to be shipped elsewhere, paperwork I have already filled out. I have chosen not to make a decision, chosen to keep my decision-making process literally on ice. I resent these reminders. Would like to go about my days not thinking of the embryos, not getting occasional calls or letters from the clinic. I still think of those days more than I care to admit.

In the early morning hours: a dream I'm in a waiting room at the clinic. It does not look like the clinic when I was a patient, with its hushed green and purples, its tiny fountain and new-agey music, designed to promote calm. I am there with a friend, who is wearing only panties and bra, and her children but not mine. A patient is having a problem. I don't think she can speak. My doctor comes out and talks to me; she's wearing a white-and-black suit like one I used to have, maybe in 1993, but she has a new haircut, with bangs. When I wake from the dream, I know what it means: that envelope, the embryos, my son.

Robin Silbergleid

—

What makes a mother? I am teaching a class on motherhood; this question comes up from time to time. Is a woman who has an abortion a mother? No, I don't think so; she is a woman who had an abortion. Is a fertility patient who has a miscarriage a mother? No, I think she desperately wants to be a mother but is not one yet. I do not think being pregnant is the same thing as being a mother. Mothering is a verb, I think, more than it is a noun. Perhaps motherhood is not a permanent state of being. You can be a "genetic" mother, a "biological" mother, a "social" mother. These qualifiers are not meant to be exclusionary; I just think they are different. There is no question that I am a mother to my son; he does not share my genes, but he grew in my body, I nursed him, I have raised him from the time he was a day 5 blastocyst and he was wanted long before that. The egg donor is not his mother; we signed papers saying as much. She has never seen him. Will never. She has never changed his diaper or cleaned up his vomit from the car seat. But he shares her DNA, and those of the children she gave birth to. Someday that genetic connection might be important to him.

I imagine I am in my therapist's office. I am sitting on that 1990s floral upholstered couch. She is in her chair across from me, chewing her gum or taking a sip of water. She is generally doing something with her mouth. She has her notepad, always, but she never writes. She asks me, when I start to cry, what it is about, put words to it, and we go through this perfunctory dance of me saying I don't know, but I really do. I don't want to think about where my son came from, those long months leading up to the decision, all those awful days and nights and waiting for phone calls, and yes, maybe this is something we call posttraumatic stress disorder. Maybe an envelope with the name of that place on it is enough.

I decide to let the embryos go, finally, when I am forty-two and my son is three. I offer them to a woman I know, who is rapidly becoming a friend. The surety hits me like a spark while I am in the frozen-food section of the grocery store (the irony is not lost on me), and by the end of the day I have sent her an email. She writes back yes. There is paperwork, bureaucracy. We still have not seen the lawyer and officially transferred "custody" between us. I sign the

paper releasing the embryos from the care of one clinic to another; my friend's name is listed as the "recipient." I find myself in a new state of uncertainty and desire. The baby lust still comes in waves, though less physical than conceptual. I think about giving my friend the crib in the basement. The boxes of cloth diapers. I think about holiday meals shared between our families. One summer day we take my son to a park. We sit together on the wooden play structure he has declared a boat. She helps him on and off. We make a sandcastle with a big moat. It occurs to me that she, more than I, looks like his mother. He runs ahead; we follow him into the future.

# Round and Round the Merry-Go-Round

*Noah Moskin and Maya Grobel*

For years we spun in circles trying to figure out how we were going to build a family. After nearly five years and countless treatments, we landed on anonymous embryo donation and now have the most incredible little girl. This photo is from her fourth birthday, and the moment at the carousel brought me back to the feeling of going around and around in our search for her. Yet while our infertility story may be over, her story is just beginning. As a parent of a donor-conceived child, I think often about what it means or might mean to her to be anonymously conceived. I think about what obligations I have to her as a parent to try to find answers—connections to her genetics, links to her identity. I wonder how it may impact her and how I can do everything in my power to support her. Going through a journey to conceive means I have some baggage; I'm just trying to sort out what might be my own and what she might now have as a result. And then I come back to thinking about her. How much we love her. How lucky we are to be a family. I ground myself in the confidence that whatever she needs, however she feels about the unique way she came into the world, we will navigate the experience with her.

Noah Moskin (photographer) and Maya Grobel (narrative),
*Round and Round the Merry-Go-Round*, 2019, digital photography,
25" H × 33" W, collection of the artists, Bainbridge Island, Washington

# Until Her Last Breath, This First Breath

*Ryan Ferrante*

The one thing my wife wanted the most could not be given to her without condition: She wanted to have a family. There were years of disappointment. An immeasurable number of needles. Thousands of miles traveled. Daunting financial obligations. An intimidating legal landscape. Five cycles of in vitro fertilization. Crushing medical opinions. But there was hope. And the incredible fortune of coverage for infertility through private insurance and, eventually, the grace of a heroic surrogate. My wife's refusal to accept a devastating reality was matched in intensity only by the support she received from medical professionals, her family, her employer, and her friends.

This photo was taken the moment she watched our son take his first breath. Her tears were the spontaneous joy of welcoming her child into the world and also a release of gratitude for everyone who helped her experience the wonder of her own family.

Ryan Ferrante, *Until Her Last Breath, This First Breath*, photography,
11" H × 8.5" W, collection of the artist, Chicago, Illinois

# Fingerprints

*Michele Wolf*

When I was applying to become a mother,
the police kept scrutinizing my fingertips,
by ink and by computer—inspected them
four times. Social workers grilled me
about my childhood, judged my parenting
philosophy. My dossier ran fifty-eight pages long.

The whorls wear off if, day after day, you are
sawing and sandpapering—smoothing out
defects—or you're a musician plucking
strings, a teller flicking through stacks
of twenties, or an editor focused on
fine-tuning stories, fast-tapping a keyboard.

I no longer had fingerprints. With the passage
of years, they had worn off onto the warm
back of my husband while I was
trying—so many times, repatching my
heart so many times—to become a mom.

# Begin

## Carla Davis

I lived with infertility from the age of twenty to the age of thirty-seven. I had a total of five diagnosed pregnancies that could not go to term. Often extremely painful, and even life-threatening, these experiences were sad and frightening. During this time, I asked myself, *What if I decide to stop trying to have children?* As a wife who could no longer bear children, did I feel that I had the right to earn money at work, or to stay at home, and either way feel free from judgment? My answer was ultimately yes. I decided I had worth as an individual, a person who had a right to live and contribute in our society in other creative ways besides motherhood. I express this sense of independence in my art.

Bird images are very calming to me. They remind me of nature walks or just relaxing outside. But they also symbolize the changing seasons and the cycle of life. In spring, they symbolize rebirth and fertility; in summer, growth and prosperity; in the fall, harvesting and gathering for the nest; and in the winter, fortitude, faith, and patience. As in *Begin*, I have created a lot of art with only one bird in a composition. As an artist, the lone bird symbolizes independence, but it also symbolizes isolation.

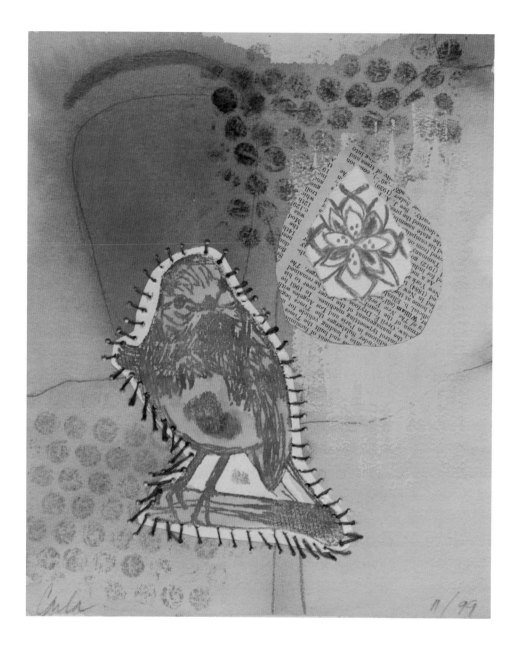

Carla Davis, *Begin*, 2015, watercolor on paper with fiber thread,
10" H × 8" W, collection of The ART of Infertility, Ann Arbor, Michigan

# Sun Showers

*Brit Ellis*

Infertility is hard. There's no softening that. It will change you. If you're not careful, it will consume you.

I was actively trying to conceive for six years. I had two unmedicated intrauterine inseminations, multiple cycles with an anonymous sperm donor, and one expensive and exhausting round of in vitro fertilization, none of which ever resulted in a pregnancy.

Examining the ways in which I mother already—my role in community and family, and in cultural and clinical therapy—have greatly helped me in healing from my experiences with infertility (IF). To focus on growth and feeling good. To blossom as an individual, to be spontaneous, to allow the Creator to direct me, to listen.

My experiences influenced many elements intentionally included in this piece. The sunflower opens and faces the sun, representing optimism and hope. Like our sister corn, the sunflower's stalk grows tall and strong, resilient against the weathering storm. The sunflower grows from three hearts—past, present, and future ancestors—nestled safely in our first mother, the land. I've beaded them one bead at a time with a striped bead to represent seeds. Two small flowers are sprouting from the lower stalk. But we see when they bloom, their centers are skulls. These are representative of pregnancy loss.

I've also included blueberries and strawberries, significant medicines that also carry role and responsibility teachings. They represent healing through community connection. And a butterfly: messenger and pollinator. Like a flutter of butterflies, my prayers were ever present in the air around us. All colors of the rainbow are present in this piece in reference to the common IF term, *rainbow baby*: A rainbow (baby) comes after a storm (IF).

There was a long time that I could not imagine my life without raising children of my own. Now my future may not feel as clear, but I'm better at enjoying the present moment, and my future definitely feels bright and full of love.

Brit Ellis, *Sun Showers*, 2020, beadwork,
15" H × 6" W, private collection

# The House—Part II

*Maria Novotny*

The sun shines through the leaded glass windows and creates a glare on my laptop screen. I adjust my chair and attempt to close the blue drapes, leaving enough sunlight so that I can keep the lamp off. Rolling my neck, I readjust my posture and take a deep breath, when I am caught in a memory.

I think of the house that never became home for the baby. That house where my husband and I made many difficult decisions, not knowing what would result from them. Would I stay married to my husband? Would we ever be happy? Would we become parents? Those questions lurked throughout the five years that we lived in that house. It was only when we moved that answers to those questions began to emerge. We stayed married. We found happiness. And we became parents.

Today, I sit in this new house in the room that used to be the nursery. The baby we adopted and brought home from the hospital is now nearly two years old. As she has gotten bigger, we have had to reassign rooms in this bungalow-style house. The upstairs has three-bedrooms. One small one that overlooks the main street and has low, sloped ceilings; this room is my husband's home office. The room down the hall is the largest bedroom upstairs and is more square in shape. The ceilings don't slope in this room, and when we moved to this house, over a year ago, our first thought was to use this room as the master bedroom. But for the first year, as we adjusted to life with a one-year-old and lived in the COVID-19 pandemic, we never made the big leap to move in. Instead, the room served as a makeshift office for my sister as she worked remotely while she escaped from New York City during the pandemic's surge. Later, when my sister left, the room became an ad hoc playroom where toddler toys slowly found a home. Farther down from that room, at the top of the stairs is a small rectangular room with a sloped ceiling on the north wall. When we first moved in, we put the crib against the wall as it sat just below the slope. The changing table was tucked next to the crib, and two dressers, one with a bookshelf, sat opposite of the crib. Now that room is my office. The two-year-old has moved into the big room upstairs, which allows her to arrange her stuffed animals and spread books out all around the floor.

The house feels big, bigger than the house we owned before. That "bigness," though, is more than just the space we have. The bigness is in our hearts. My husband and I find ourselves chatting—in between our meetings when our toddler is at day care—in the hallway outside of her room about what our life once was and how we got to this point. We remark on a felt sense of resilience. So many challenges and hurdles we had to encounter to get to this point, to feel big, to feel love.

Sitting with these memories, I notice the sun getting higher; it warms up the room and my heart feels full. This time the house is different. This time this house is a home.

# Letting Go

## *Denise Callen*

Every plan I imagined revolved around a fairy-tale view of how life was to play out. I married a wonderful man; we bought the perfect house with room for 2.5 children, and then the dream took us down a very dark, unexpected path. We spent years trying to conceive and experienced recurrent miscarriages. I reached a point when it was time to stop crying, injecting, treating, and pouring money into a dream that wasn't to be. I needed to let go of the fantasy and find a new dream. This piece uses *kintsugi*, which translates from Japanese as "broken seams." My version of *kintsugi* emphasizes the ravages of time and destruction on the ware as well as a rebirth. While still beautiful and holding parts of the past, it is very different from the original plan. Patched together, it, and I, will never be the same.

Denise Callen, *Letting Go*, 2014, mixed media, 21" H × 24" W × 2" D,
collection of The ART of Infertility, Ann Arbor, Michigan

# Crib with Medication Boxes

*Elizabeth Horn*

These are the remnants of approximately $10,000 worth of medications, needles and syringes I used while undergoing one in vitro cycle and two subsequent frozen embryo transfers. What could have resulted in my child, or children, instead resulted in a pile of boxes, bottles, and sharps disposal containers that I find hard to discard because they help represent my treatment journey. I began creating art in part because I wanted a historical record of my experience with infertility for the day it no longer plagued me. Now, I realize that infertility is always there. I've become accustomed to life with it, and it doesn't necessarily hold the same power it once did, but it has forever changed me.

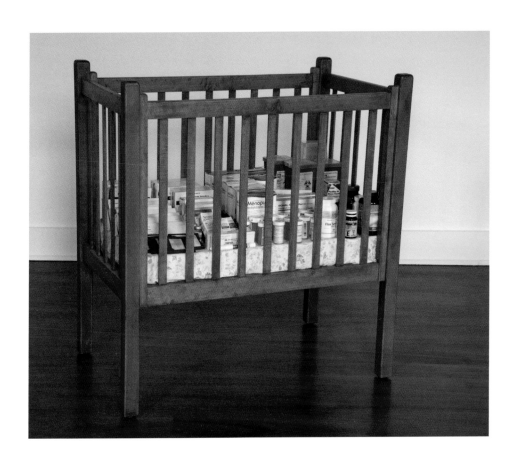

Elizabeth Horn, *Crib with Medication Boxes*, 2014,
mixed media, 36" H × 36" W × 22" D, collection of
The ART of Infertility, Ann Arbor, Michigan

# APPENDIX I
## Thematic Table of Contents

### ADOPTION
Cowan, *Bloodlines, Matryoshka*
Dayal, *El Camino* (The Journey)
Grunberger, Inheritances
McClure Sweeny, *S/m/othering: Cassatt*
Meitner, My List of True Facts
Novotny, M., The House—Part II
Wolf, Fingerprints

### AGE
Grunberger, Inheritances
Meitner, My List of True Facts
Novotny, M., The House
Novotny, M., *Seventy-Two Red Tears: Undeniable Proof*
Rough, A Mother by Any Other Name
Silbergleid, Frozen

### ALTERNATIVE MEDICINE
Ellis, *Sun Showers*
Mason, Incantations for Fertility
Rough, A Mother by Any Other Name

### AMBIVALENCE
Belc, Frozen Futures
Bradley, Downer
Davis, *Begin*
Rough, A Mother by Any Other Name
Silbergleid, Frozen

## BIRTH AFTER INFERTILITY
Ferrante, *Until Her Last Breath, This First Breath*
Lyons, Birth ~~Plan~~ Warning
MacClure, *The Wound*

## CANCER
Klein, The Tribe of Broken Plans
Rough, A Mother by Any Other Name
Sameth, Mother's Day
Schloss, *Infertility Study—Objects*

## CHILD-FREE
Callen, *Letting Go*
Glen, *Baby Ladies and Dog Lady II*
Maddox, A Dog Is Not a Baby. Or It Is.
Mason, Incantations for Fertility
Rough, A Mother by Any Other Name

## COVID-19
Novotny, M., The House—Part II
Peterson, *Everyone Knows*

## DIMINISHED OVARIAN RESERVE
C., Jo, *Excision*
Figueroa-Vásquez, Grief to the Bone
Silbergleid, Frozen

## DONOR GAMETES (EGG AND/OR SPERM)
Askevold, *Twelve Vessels*
Belc, Frozen Futures
Berney, She's Not My Mother: Fertility, Queerness, and Invisibility
Ellis, *Sun Showers*
Nye, *Imitor Virgo Fructuarius, Mulieres Offerunt Maternitam*, and
*Familia Adduco Mundum*
Silbergleid, Frozen
Silbergleid, An Open Letter to Our Sperm Donor

EGGS AND EGG RETRIEVALS

Dayal, *El Camino* (The Journey)

Dietz-Bieske, *Lady in Waiting*

Doyle, On Ovaries

Kuo, *Cactus Middle Fingers, on My Way down the Mountain*

Traylor, *We Have No Room: A Study in the Ritual Practices of Infertility*

EMBRYOS AND EMBRYO DONATION

Horn, *Cousins*

Jenkins, *Disbelief*

Moffat, *Tainted*

Moskin and Grobel, *Round and Round the Merry-Go-Round*

Traylor, *We Have No Room: A Study in the Ritual Practices of Infertility*

Silbergleid, Frozen

ENDOMETRIOSIS

Douglas, Matthews, and Herrick, *From Hatred to Hope*

Jenkins, *Disbelief*

Rough, A Mother by Any Other Name

Seemel, *It is Easier for a Camel to Pass through the Eye of a Needle than for a Fertile Woman to Understand Infertility*

Wiesblott, *The Seeds Were Sown*

FIBROIDS

Muntadas, *What the Fibrous Tissue of Your Love Has Created*

Wiesblott, *The Seeds Were Sown*

GENETICS

Cowan, *Bloodlines, Matryoshka*

Moskin and Grobel, *Round and Round the Merry-Go-Round*

Nye, *Imitor Virgo Fructuarius, Mulieres Offerunt Maternitam*, and *Familia Adduco Mundum*

Silbergleid, Frozen

GESTATIONAL SURROGACY
Douglas, Matthews, and Herrick, *From Hatred to Hope*
Ferrante, *Until Her Last Breath, This First Breath*

INTRAUTERINE INSEMINATION
Askevold, *Twelve Vessels*
Berney, She's Not My Mother: Fertility, Queerness, and Invisibility
Bradley, Downer
Ellis, *Sun Showers*
Jenkins, *Disbelief*
Silbergleid, Infertility Sestina

IN VITRO FERTILIZATION
Arliss and Lane, What IF
Blicher, *In My Heart*
Bradley, Downer
Butcher, *Hair Piece II*
Clark Davis, *Box: What Remains Hidden in IVF*
Davis, *Begin*
Dayal, *El Camino* (The Journey)
Douglas, Matthews, and Herrick, *From Hatred to Hope*
Ellis, *Sun Showers*
Ferrante, *Until Her Last Breath, This First Breath*
Horn, *Crib with Medication Boxes*
Jenkins, *Disbelief*
Kuo, *Cactus Middle Fingers, on My Way down the Mountain*
Lyons, Cycle #2
McClure Sweeny, *S/m/othering: Cassatt*
Nye, *Imitor Virgo Fructuarius, Mulieres Offerunt Maternitam*, and
*Familia Adduco Mundum*
Peterson, *Waiting on Wanda* and *Everyone Knows*
Schloss, *Infertility Study—Objects*
Silbergleid, Frozen

ISOLATION
Davis, *Begin*
Glen, *Baby Ladies and Dog Lady II*
Moffat, *Tainted*
Peterson, *Waiting on Wanda* and *Everyone Knows*

LGBTQ+ PERSPECTIVE
Askevold, *Twelve Vessels*
Belc, Frozen Futures
Berney, She's Not My Mother: Fertility, Queerness, and Invisibility
Klein, The Tribe of Broken Plans
Sameth, Mother's Day

MALE FACTOR INFERTILITY
C., Jo, *Excision*

MALE PERSPECTIVE
Ferrante, *Until Her Last Breath, This First Breath*
Foster, *Pain Will Not Have the Last Word*
Jordan, *Staying Mobile*
Kearney, The Miscarriage: A Sunday Funny
Quarterman, Baby Land

MEDICAL PROCEDURES
C., Jo, *Excision*
Figueroa-Vásquez, Grief to the Bone
Hadar, *HSG*
Novotny, S., *One Pill, Two Pill, Red Pill, Blue Pill*
Peterson, *Waiting on Wanda*
Wiesblott, *The Seeds Were Sown*

MENSTRUATION
Berney, She's Not My Mother: Fertility, Queerness, and Invisibility
Doyle, Poem of the Body and Mozart Effect
Novotny, M., *Seventy-Two Red Tears: Undeniable Proof*

MENTAL HEALTH AND TRAUMA
Arliss and Lane, What IF
Clark Davis, *Box: What Remains Hidden in IVF*
Figueroa-Vásquez, Grief to the Bone
Foster, *Pain Will Not Have the Last Word*
Jenkins, *Disbelief*
Jordan, *Staying Mobile*
Miyasaki, *Anyway, Here's Wonderwall*
Silbergleid, Frozen

MISCARRIAGE/LOSS
Berney, She's Not My Mother: Fertility, Queerness, and Invisibility
Blicher, *In My Heart*
Butcher, *Hair Piece II*
Davis, *Begin*
Figueroa-Vásquez, Grief to the Bone
Foster, *Pain Will Not Have the Last Word*
Gutiérrez, *Two Futures: A Portrait of Infertility*
Horn, *Cousins*
Jenkins, *Disbelief*
Kearney, The Miscarriage: A Sunday Funny
MacClure, *The Loss*
McClure Sweeny, *S/m/othering: Cassatt*
McKellar, *Challenger*
Moffat, *Tainted*
Parag, *A Mother's Embrace*
Sameth, Mother's Day
Schloss, *Infertility Study—Objects*
Silbergleid, Infertility Sestina and Fertility Patient
Turisch, *Collecting Seeds*
Zechmeister-Smith, *That Time We Had Fleas*

POLYCYSTIC OVARY SYNDROME (PCOS)
Benson, *Stone Womb Fetuses*
Doyle, Poem of the Body, The Mozart Effect, and On Ovaries
Figueroa-Vásquez, Grief to the Bone
Muntadas, *What the Fibrous Tissue of Your Love Has Created*

RACE AND RACIAL EXPERIENCES
Cowan, *Bloodlines, Matryoshka*
Douglas, Matthews, and Herrick, *From Hatred to Hope*
Ellis, *Sun Showers*
Figueroa-Vásquez, Grief to the Bone
Gutiérrez, *Two Futures: A Portrait of Infertility*
Sameth, Mother's Day

RELATIONSHIPS
Blicher, *In My Heart*
Douglas, Matthews, and Herrick, *From Hatred to Hope*
Horn, *Cousins*
Klein, The Tribe of Broken Plans
McDonough, *A Game of Twenty Questions*
Novotny, M., The House
Sameth, Mother's Day
Schuetz, *Connection*

RELIGION AND SPIRITUALITY
Ellis, *Sun Showers*
Figueroa-Vásquez, Grief to the Bone
Grunberger, Inheritances
Gutiérrez, *Two Futures: A Portrait of Infertility*
Novotny, M., *Seventy-Two Red Tears: Undeniable Proof*
Nye, *Imitor Virgo Fructuarius, Mulieres Offerunt Maternitam*, and
*Familia Adduco Mundum*
Rough, A Mother by Any Other Name

## SECONDARY INFERTILITY / INFERTILITY WHILE PARENTING
Bradley, Downer
Foster, *Pain Will Not Have the Last Word*
Jenkins, *Disbelief*
Meitner, My List of True Facts
Novotny, S., *One Pill, Two Pill, Red Pill, Blue Pill*

## SINGLE PARENTHOOD
Kuo, *Cactus Middle Fingers, on My Way down the Mountain*
Sameth, Mother's Day
Silbergleid, Infertility Sestina and An Open Letter
to Our Sperm Donor

## SPERM
Askevold, *Twelve Vessels*
Belc, Frozen Futures
Berney, A Mother by Any Other Name
Ellis, *Sun Showers*
McDonough, *A Game of Twenty Questions*

## UTERINE MALFORMATION
Muntadas, *What the Fibrous Tissue of Your Love Has Created*
Wiesblott, *The Seeds Were Sown*

## WAITING
Dietz-Bieske, *Lady in Waiting*
Horn, *Crib with Medication Boxes*
Peterson, *Waiting on Wanda*

# APPENDIX II
## Art-Making around Infertility

Since 2014, we have hosted workshops in art galleries, fertility clinics, university classrooms, and other spaces. We have found writing and art-making around infertility to be productive and healing for us. Some of our workshops are geared toward specific experiences with infertility and reproductive loss, while others situate infertility within the context of reproductive health and choice; sometimes we make visual art, sometimes we write, sometimes we incorporate both visual and verbal elements in our work. We invite you to join us in undertaking the following prompts on your own or in a group setting; no previous experience in art or writing is required, and you may work with whatever materials you have on hand. The instructions provided are meant to provide a starting point and framework for exploration; feel free to diverge from them if you are inspired to do so. We recognize that making art around infertility and reproductive experiences might be triggering for some; following these prompts, we offer a note from one of our contributors, Raina Cowan, who is a trained art therapist with suggestions for further resources.

### PROMPT 1: BLACKOUT POETRY

*Blackout poetry can be an accessible form of art-making for those who may feel they lack "artistic" abilities. Additionally, it uniquely combines art with writing and what often results is a reminder of how embracing small creative practices can bring healing and newfound perspectives.*

1. Begin by selecting a medical consent form or other found document to work with.
2. If you want to shape your piece, as Elizabeth does (below), select a stencil. (When we work with groups, we provide stencils of uteruses and fallopian tubes, penises, brains, babies/children [scan the QR code to download stencils].)
3. If you are working with a stencil, trace it on the medical consent form.
4. Use a pencil to circle ten to twelve words on the document, within

the boundaries of the form, which stand out to you. Blackout poetry intentionally invites arbitrariness. Therefore, words should be circled in terms of what immediately "pops up" from the page.

5. Take time to review and reconsider. We encourage you to jot down the poem that is emerging on a piece of scrap paper. You are free to remove words to craft your poem, or add any back in.
6. When you determine which words will remain in your poem, circle them with a Sharpie.
7. Proceed in blacking out the remainder of the sheet.

### AN EXAMPLE OF BLACKOUT POETRY

*Working Mother* (right) is an example of a completed blackout poetry piece created by Elizabeth Horn. The poem reads:

> Committed, worthy, successful, non-mother.
> Shouldn't have to win acceptance.
> My own positive impact.

### *Working Mother* by Elizabeth Horn

The mailbox can be a dangerous place for those dealing with infertility. Receiving a baby shower invitation or a baby announcement can feel like a knife in the heart or a punch in the gut. At least you usually have some idea they are headed your way. It's the other random pieces of baby, child, and mom mail that give me the most trouble. One in particular. My blood pressure rises each time I open the mailbox to find an issue of *Working Mother* magazine. If it weren't for infertility, I would be a working mother now. When I pictured parenthood, I always saw myself balancing my children and my career. Sure, it would be a challenge, but I was up for it. I'm not sure how I got on their list. I tried for a while to have my name taken off. An email to the publishing company, a comment on their Facebook page. When that didn't work I just started giving them to my working mother friends. Recently, I decided to reframe my relationship with the magazine by using it to make blackout poetry.

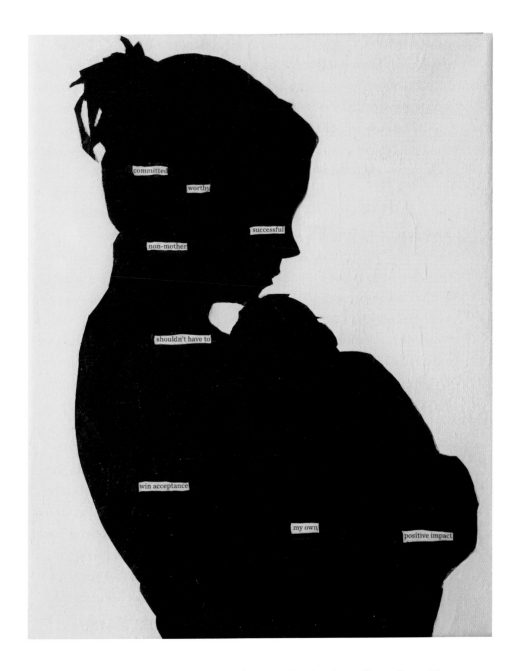

Elizabeth Horn, *Working Mother*, 2016, mixed media, 10" H × 8" W,
collection of The ART of Infertility, Ann Arbor, Michigan

# PROMPT 2: REPRODUCTIVE WRITES

*This prompt invites participants to grapple with the emotional, physical, familial, and political challenges surrounding reproductive care for those who experience infertility, as well as the general public. This prompt directs participants to explore their own relationships to the reproductive body and care and reflect on how writing about the body can foster more astute awareness about the body's resilience. The prompt can be used to facilitate discussions about the power of writing for legislative change.*

1. Prewrite. What does the term *reproductive rights* mean to you?
2. Reflect on a significant experience you've had involving reproductive choice and/or reproductive health or loss. Perhaps a major event or decision, such as the onset of menstruation, the first purchasing of birth control, the day you received an infertility diagnosis or underwent reproductive surgery, the result of a pregnancy test, the choice to have an abortion or make an adoption plan for your child. These are only a few ideas.
3. To get started, write a list of concrete images—those that appeal to each of the five senses—drawn from this experience. For example, a single pink line on a pregnancy test is a concrete image.
4. Drawing on your list of images, write a short piece in the form of a letter engaging reproductive health, choice, and/or loss. This might take any number of forms: A note to your body or body part. A letter to a past (or future) version of yourself. A note to honor a miscarriage or stillbirth. A rant to a doctor, medical professional, or congressional representative. A thank-you to an egg donor, gestational carrier, or birth mother; the friend who took you to a procedure; the nurse who always took care. These are only a few suggestions. Let the letter be the outlet for the emotions you want to recognize today.

## OPTIONAL QUESTIONS FOR DISCUSSION

* What was the experience of writing on this topic like? How did it feel in your body?
* In reflecting and writing on this topic, what questions or memories emerged about your reproductive experiences?
* Can you imagine how writing about these experiences may help guide

future action—whether that is personal action/choice or larger forms of advocacy/resistance?

## PROMPT 3: FAMILY TREE

*The family tree is a common visual appearing as an assignment in elementary school to household displays noting the genealogical history of a family. Infertility and recurrent reproductive loss can often disrupt normative representations of "family." This prompt invites a critical reexamination of how and what we claim in our own family tree. The prompt aims to empower and redefine what counts as family.*

1. Think of a family tree. What does yours look like right now? Who sits at the roots? Who is included on the branches? Has this image changed over the course of your life? How might it change in the future? If you are struggling with infertility or have chosen to live child-free, how might you represent that experience? Similarly, if you have built your family through adoption or third-party reproduction, how do you represent that on a tree (or is another metaphor more appropriate)?

2. Draw your family tree freehand or using a stencil.

3. Then add color, with watercolor, colored pencils, markers, or whatever materials you have on hand.

4. When your tree is finished, take some time to free-write. When you look at your tree, how do you feel? Is it a tree that represents hope? A tree that has strong roots? What is the season that the tree represents—winter, fall, spring, summer? Why did you select that season? What does this tree represent about your family and/or your fertility journey? What story are you telling? In what ways might your tree offer a counternarrative to dominant stories about family building?

Note: The prompts listed above can be done independently, in support groups, or with the assistance of trained art therapists, or other clinicians, as needed. Art therapists are either master's- or doctorate-level clinicians who have completed education in individual, group, and family art therapy methods, techniques, art media, psychological theories, and psychotherapy methods and modalities. Registered and/or board-certified art therapists in the United States can be found by contacting local state art therapy chap-

ters, the American Art Therapy Association, or the Art Therapy Credentials Board. Other countries have their own art therapy organizations.

—Raina Cowan, LCPC, ATR, PMH-C

If you have questions or would like more information about The ART of Infertility programming, please feel free to consult our website and send inquiries to info@artofinfertility.org.

# RESOURCES

The following resources largely pertain to infertility from an American context.

## GENERAL INFORMATION AND HISTORY

American Society for Reproductive Medicine. www.asrm.org.

Boggs, Belle. 2016. *The Art of Waiting: On Fertility, Medicine, and Motherhood*. Minneapolis: Graywolf Press.

Casey, Ellen Weir. 2022. *Unstoppable: Forging the Path to Motherhood in the Early Days of IVF: A Memoir*. Austin, TX: River Grove Books.

Glaser, Gabrielle. 2022. *American Baby: A Mother, a Child, and the Secret History of Adoption*. London: Penguin.

Jensen, Robin E. 2016. *Infertility: Tracing the History of a Transformative Term*. University Park: Pennsylvania State University Press.

Katkin, Elizabeth L. 2019. *Conceivability: What I Learned Exploring the Frontiers of Fertility*. New York: Simon & Schuster.

Klitzman, Robert. 2020. *Designing Babies: How Technology Is Changing the Ways We Create Children*. New York: Oxford University Press.

Layne, Linda L. 2003. *Motherhood Lost: A Feminist Account of Pregnancy Loss in America*. New York: Routledge.

Marsh, Margaret S., and Wanda Ronner. 1996. *The Empty Cradle: Infertility in America from Colonial Times to the Present*. Baltimore: Johns Hopkins University Press.

Silverman, Rachel E., and Jay Baglia. 2015. *Communicating Pregnancy Loss: Narrative as a Method for Change*. New York: Peter Lang.

## ADVOCACY

Men Having Babies. www.menhavingbabies.org.

National Council for Adoption. www.adoptioncouncil.org.

RESOLVE: The National Infertility Association. www.resolve.org.

Single Parent Advocate. www.singleparentadvocate.org.

## ART THERAPY

Hogan, Susan. 2021. *Therapeutic Arts in Pregnancy, Birth and New Parenthood*. London: Routledge.

Seftel, Laura. 2006. *Grief Unseen: Healing Pregnancy Loss through the Arts*. London: J. Kingsley.

Shockley, Sarah. 2020. *Infertility Coloring Book: Relaxation and Stress Relief*. Independently published.

Swan-Foster, Nora. 2021. *Art Therapy and Childbearing Issues: Birth, Death, and Rebirth*. New York: Routledge.

Van Styvendale, Nancy, J. D. McDougall, Robert Henry, and Robert Alexander Innes. 2021. *The Arts of Indigenous Health and Well-Being*. Winnipeg: University of Manitoba Press.

## CHILD-FREE

Broad, Tessa. 2017. *Dear You: A Letter to My Unborn Children*. West Sussex, UK: RedDoor Press.

Day, Elizabeth. 2020. *How to Fail: Everything I've Ever Learned from Things Going Wrong*. London: 4th Estate.

Froelker, Justine. 2015. *Ever Upward: Overcoming the Lifelong Losses of Infertility to Define Your Own Happy Ending*. N.p.: Morgan James.

Gateway Women. www.gateway-women.com.

Kaufmann, Kate. 2019. *Do You Have Kids? Life When the Answer Is No*. Berkeley, CA: She Writes Press.

Tonkin, Lois, and Jody Day. 2019. *Motherhood Missed: Stories of Loss and Living from Women Who Are Childless by Circumstance*. Philadelphia: Jessica Kingsley.

## FAMILY BUILDING

Creating a Family. www.creatingafamily.org.

Goldberg, Abbie E. 2019. *Open Adoption and Diverse Families: Complex Relationships in the Digital Age*. New York: Oxford University Press.

Golombok, Susan. 2020. *We Are Family: The Modern Transformation of Parents and Children*. New York: Hachette.

Tober, Diane. 2019. *Romancing the Sperm: Shifting Biopolitics and the Making of Modern Families*. New Brunswick, NJ: Rutgers University Press.

## LGBTQ+

Craven, Christa. 2019. *Reproductive Losses: Challenges to LGBTQ Family-Making.* New York: Routledge.

Epstein-Fine, Sadie, and Makeda Zook. 2018. *Spawning Generations: Rants and Reflections on Growing up with LGBTQ+ Parents.* Bradford, ON: Demeter Press.

Gibson, Margaret. 2014. *Queering Motherhood: Narrative and Theoretical Perspectives.* Bradford, ON: Demeter Press.

Mamo, Laura. 2007. *Queering Reproduction: Achieving Pregnancy in the Age of Technoscience.* Durham, NC: Duke University Press.

Park, Shelley M. 2013. *Mothering Queerly, Queering Motherhood: Resisting Monomaternalism in Adoptive, Lesbian, Blended, and Polygamous Families.* Albany: State University of New York Press.

Patton-Imani, Sandra. 2020. *Queering Family Trees: Race, Reproductive Justice, and Lesbian Motherhood.* New York: New York University Press.

## MALE EXPERIENCES

Barnes, Liberty Walther. 2014. *Conceiving Masculinity: Male Infertility, Medicine, and Identity.* Philadelphia: Temple University Press.

*Dr. [Paul] Turek's Blog.* www.theturekclinic.com/dr-tureks-blog.

Waldman, Jon. 2021. *Swimming Aimlessly One Man's Journey through Infertility and What We Can All Learn from It.* New York: Simon & Schuster.

## REPRODUCTIVE RIGHTS AND JUSTICE

Center for Reproductive Rights. www.reproductiverights.org.

Gurr, Barbara Anne. 2015. *Reproductive Justice: The Politics of Health Care for Native American Women. New Brunswick, NJ:* Rutgers University Press.

Ross, Loretta, Lynn Roberts, Erika Derkas, Whitney Peoples, and Pamela Bridgewater Toure. 2017. *Radical Reproductive Justice: Foundations, Theory, Practice, Critique.* New York: The Feminist Press.

SisterSong. www.sistersong.net.

## SUPPORT NETWORKS

American Adoptions. www.americanadoptions.com.

Broken Brown Egg. www.thebrokenbrownegg.org.

Donor Conceived Community. https://donorconceivedcommunity.org.

Fertility for Colored Girls. www.fertilityforcoloredgirls.org.

Men Having Babies. www.menhavingbabies.org.

RESOLVE: The National Infertility Association. www.resolve.org.

Single Mothers by Choice. https://www.singlemothersbychoice.org.

Yesh Tikvah. www.yeshtikvah.org.

## THE ART OF INFERTILITY PROJECT

Novotny, Maria. 2019. "The ART of Infertility: Finding Friendship & Healing after Reproductive Loss." *Survive & Thrive: A Journal for Medical Humanities and Narrative as Medicine 4 (1)*. repository.stcloudstate.edu/survive_thrive/vol4/iss1/19.

Novotny, Maria. 2021. "Rhetorical Curation of Patient Art: How Community Literacy Scholars Can Contribute to Healthcare Professions." *Community Literacy Journal 15 (2): 84–96*, https://digitalcommons.fiu.edu/communityliteracy/vol15/iss2/8/.

Novotny, Maria, and Elizabeth Horn-Walker. 2020. "Art-i-facts: A Methodology for Circulating Infertility Counternarratives." In *Interrogating Gendered Pathologies*, edited by Michelle Eble and Erin Frost, 43–66. Louisville, CO: Utah State University Press, an imprint of University Press of Colorado.

*The ART of Infertility.* www.artofinfertility.org.

## THIRD-PARTY DONATION

Bergman, Kim. 2019. *Your Future Family: The Essential Guide to Assisted Reproduction. Newburyport, MA: Conari Press.*

EM•POWER with Moxi. www.empowerwithmoxi.com.

Parents via Egg Donation. www.pved.org.

We Are Donor Conceived. www.wearedonorconceived.org.

## TRAUMA

Domar, Alice D., and Alice Lesch Kelly. 2004. *Conquering Infertility: Dr. Alice Domar's Guide to Enhancing Fertility and Coping with Infertility.* New York: Penguin.

Flemons, Joanna. 2018. *Infertility and PTSD: The Uncharted Storm.* CreativeSpace.

Jaffe, Janet, and Martha Ourieff Diamond. 2011. *Reproductive Trauma Psychotherapy with Infertility and Pregnancy Loss Clients*. Washington, DC: American Psychological Association.

Methot, Suzanne. 2019. *Legacy: Trauma, Story and Indigenous Healing*. Toronto: ECW Press.

Van der Kolk, Bessel A. 2015. *The Body Keeps the Score: Mind, Brain and Body in the Transformation of Trauma*. New York: Penguin.

## WRITING TO HEAL

Cacciatore, Joanne. 2021. *Grieving Is Loving: Compassionate Words for Bearing the Unbearable*. Somerville, MA: Wisdom.

DeSalvo, Louise A. 2000. *Writing as a Way of Healing: How Telling Our Stories Transforms Our Lives*. Boston: Beacon Press.

Febos, Melissa. 2022. *Body Work: The Radical Power of Personal Narrative*. New York: Catapult.

Gibney, Shannon, and Kao Kalia Yang. 2019. *What God Is Honored Here? Writings on Miscarriage and Infant Loss by and for Native Women and Women of Color*. Minneapolis: University of Minnesota Press.

Hooper, Kim, Meredith Resnick, and Huong Diep. 2021. *All the Love: Healing Your Heart and Finding Meaning after Pregnancy Loss*. Nashville, TN: Turner.

Lind, Emily, and Angie Deveau. 2017. *Interrogating Pregnancy Loss: Feminist Writings on Abortion, Miscarriage, and Stillbirth*. Bradford, ON: Demeter Press.

# ACKNOWLEDGMENTS

This book emerged from the friendships and community fostered by The ART of Infertility. We would like to thank the many individuals who have shared and entrusted us with their stories and their artwork. To those who have invited us into their communities and have been champions of artistic storytelling as a creative outlet and form of advocacy, we are indebted to your support. We want to recognize those who contributed their art and writing and shared their stories with The ART of Infertility over the years. While we could not include everyone who has participated in this project, they have shaped the creation of this book and we are deeply grateful. We would especially like to recognize Betsy Campbell, Barbara Collura, Dr. April Gago, Camille Hawkins, Annie Kuo, Steven Mavros, Jennifer Neeley, Dr. Paul Turek, Imogen Weatherhead, Rabbi Zalman Wircberg, A/NT Gallery, Ella Sharp Museum of Art and History, and Donald and Judy Horn. While we cannot list everyone who has helped us in our mission, we are grateful to all who have offered space, time, resources, and expertise, including Kate Novotny Angeles, Julie Berman, Gerry Blanchard, Raina Cowan, Jesse Fiest, Ames Hawkins, Cindy Flynn, Risa Levine, Sara Rector, Krissy Clark Rock, Trixie Smith, and Candace Wohl. Additionally, this book would not have been possible without the support of grants from Michigan State University and the University of Wisconsin–Milwaukee. We want to thank the student interns who have worked with us: Danielle Bucco, Elena Castro, Maggie Chesbrough, Kyra Connors, Lauren Gaynor, Juliette Givhan, Kristen Mahan, and Jalen Smith. We are grateful to Marie Sweetman, Carrie Teefey, and Jude Grant for their assistance in bringing this book to fruition. Finally, as a book about the desire to have a family, we want to acknowledge our families who have supported us throughout the life of this project: Kevin and Nina Jordan, Josh and Hayden Silbergleid, Scott Walker, Sarah and Jeff Powell, and Bobby, Zoe, and Jazelle Streng.

We are also grateful to be able to reprint the following poems and essays, sometimes in slightly different forms:

"What IF," by Barrie Arliss and Dan Louis Lane, is excerpted from *What IF: An Infertile Graphic Novel*, independently published in 2019 and used with permission of the artist and author.

"She's Not My Mother: Fertility, Queerness, and Invisibility," by Jennifer Berney, is adapted from the author's essays "She's Not My Mother" and "Screw Fate," in *The Other Mothers: Two Women's Journey to Find the Family That Was Always Theirs* (Naperville, IL: Sourcebooks, 2021).

"The Mozart Effect," by Betty Doyle, was first published in the author's collection *Girl Parts* (Birmingham, UK: Verve Poetry Press, 2022).

Douglas Kearney, "The Miscarriage: A Sunday Funny" from *Patter*. Copyright © 2014 by Douglas Kearney. Reprinted with the permission of The Permissions Company, LLC on behalf of Red Hen Press, redhen.org.

"The Tribe of Broken Plans," by Cheryl E. Klein, was originally published by *MUTHA*, October 9, 2013.

"A Dog Is Not a Baby. Or It Is.," by Marjorie Maddox, was originally published in *The Penn Review* and republished in the author's book *Begin with a Question: Poems* (Brewster, MA: Paraclete, 2022). Reprinted with permission of the author.

"My List of True Facts," by Erika Meitner, was originally published by *The Believer* and republished in the author's book *Useful Junk* (Rochester, NY: BOA, 2022).

"The House," by Maria Novotny, appeared in "The ART of Infertility: Finding Healing & Friendship after Reproductive Loss," *Survive and Thrive: A Journal for Medical Humanities and Narrative as Medicine* 4, no. 1 (2019).

"Mother's Day," by Carla Rachel Sameth, was originally published in the author's book, *One Day on the Gold Line* (Black Rose Writing, 2019). Reissued in 2022 by Golden Foothills Press.

Robin Silbergleid, "The Fertility Patient," "Infertility Sestina," and "An Open Letter to Our Sperm Donor" from *The Baby Book*. Copyright © 2015 by Robin Silbergleid. Reprinted with the permission of The Permissions Company, LLC on behalf of CavanKerry Press, Ltd., www.cavankerry.org.

# CONTRIBUTORS

Elizabeth Horn is the cofounder and codirector of The ART of Infertility for which she has curated thirty exhibits since its inception in 2014. A graduate of the Art Institute of Pittsburgh's photography program, she turned to mixed media after being diagnosed with infertility in 2010. She also began documenting the lives of others with infertility through portraits and interviews to share those stories with medical practitioners and legislators. She has worked as a health care communicator for more than twenty years and lives with her family in Ann Arbor, Michigan.

Maria Novotny is an assistant professor of English at the University of Wisconsin–Milwaukee, where she teaches in the Rhetoric, Professional Writing, and Community Engagement graduate program. Her research considers how reproductive health patients advocate for health care. This work has been published in *Computers & Composition*, *Community Literacy Journal*, *Peitho*, *Present Tense*, *Reflections*, *Rhetoric of Health & Medicine*, and *Technical Communication Quarterly*. She holds a PhD in writing and rhetoric and MA in critical studies in literacy and pedagogy, both from Michigan State University. She serves as the codirector of The ART of Infertility and lives in Wisconsin with her husband, adopted daughter, and two dogs.

Robin Silbergleid is a professor of English at Michigan State University. She is coeditor of *Reading and Writing Experimental Texts: Critical Innovations* (Palgrave, 2017) and the author of several books that address the experiences of infertility, reproductive loss, and single motherhood, including the chapbook *In the Cubiculum Nocturnum* (Dancing Girl Press, 2019), *The Baby Book: Poems* (CavanKerry Press, 2015), and the memoir *Texas Girl* (Demeter Press, 2014). Since 2014, she has collaborated with The ART of Infertility on writing and art workshops, as well as undergraduate research on infertility. Born and raised in the Midwest, she currently lives in East Lansing, Michigan, with her two children.

———

Barrie Arliss has been reading graphic novels practically since birth. She's your garden-variety adult, with your average baggage. She mends holes, forages for mushrooms, and can barely stay awake past 10 p.m. She's a mama, a wife, a copywriter, a daughter, and a million other things. She's constantly pinching herself, grateful that she gets to do this whole living thing with the rest of y'all. She's always looking for the next big adventure. You can find her work-life stuff at agirlnamedbarrie.com.

Cole Askevold is an artist working on a multimedia project in relation to her journey through infertility. An examination of elapsed time, expressed through meticulously encoded painted calendars, sculptures, photography, and writing detail an experience of loss and perseverance. Askevold received an MFA/MA from the San Francisco Art Institute (2012) and later taught as an adjunct professor at the University of Alaska Anchorage. She currently resides and works in Port Townsend, Washington, with her wife and daughter. Her works in progress can be viewed at www.coleaskevold.com.

Krys Malcolm Belc is the author of the memoir *The Natural Mother of the Child* (Counterpoint, 2021) and the flash nonfiction chapbook *In Transit* (Cupboard Pamphlet, 2018). Krys is the memoir editor of *Split Lip Magazine* and lives in Philadelphia with his partner and their young children.

Katie Benson graduated from Brigham Young University in 2019 with a BFA in studio art. Katie works predominantly in oil paint but often branches out into mixed media and new genres. She pays particular attention to issues that we don't talk about openly enough, such as illness and marginalization.

Jennifer Berney is a mother, writer, and teacher. She is a contributing blogger at *Brain, Child*, and her writing has been featured in the *Washington Post*, the *New York Times*, *Mutha*, *Tin House*, *Brevity*, *The Offing*, and elsewhere. Her memoir of queer family building is titled *The Other Mothers: Two Women's Journey to Find the Family that Was Always Theirs* (Sourcebooks, 2021). She lives in the Pacific Northwest with her partner and two sons.

Jamie Kushner Blicher, a self-taught artist, started creating mixed-media pieces in high school and continued to do so throughout her college years at

New York City's Fashion Institute of Technology. Today, Jamie's main medium is ink on paper. Since 2016, Jamie has been using her art to help bring calm and happiness to others who have gone through or are still going through their infertility journeys. When Jamie is not painting, she works as a lifestyle buyer and lives with her husband, her twin boys, and their labradoodle named Gem in their very noisy house in Rockville, Maryland.

Kate Bradley is a writer and professor. She earned her English PhD from the State University of New York at Albany in 2019 and is currently working on a novel based on events surrounding the birth of her daughter, who was conceived through in vitro fertilization. Her work has been published in journals, including *Controlled Burn, Colonnades*, and *Ruminate*. She lives in Wilmington, Delaware, with her husband and children.

Sally Butcher is an artist, lecturer, and researcher in Birmingham, UK. Her interdisciplinary practice engages with discourse on female subjectivity and embodiment across spheres of the domestic, maternal, and erotic. She has recently completed her Arts Council England–funded project, "(Re)conceive: Infertility in the Maternal Visual Arts," and is now conducting a practice-based PhD titled "(In)fertile Embodiment between the Medical and the Maternal," funded by the Arts and Humanities Research Council. Her work has been featured in such publications as *Elephant* magazine, the *Mothers Who Make* platform, and on the *Artist/Mother* podcast network. She has been shortlisted for the Brixton Art Prize and Jerwood Photoworks Award. Read more about her work at www.sallybutcher.com.

Jo C. lives in the Pacific Northwest and works in legal services in the tech space. She and her husband underwent ART for several years, including seven intrauterine inseminations and nine failed in vitro fertilization cycles due to male factor infertility and diminished ovarian reserve. They are now living as childless not by choice and use their creative pursuits of art and music, respectively, for their healing process.

Denise Callen and her husband, Dave, had decided to live child-free after many years of treatment. The universe had other plans and blessed them with two beautiful children. Denise sold her successful paint-your-own-pottery stu-

dio to focus on being a mom. Five years after the birth of their daughter and ten years after starting treatment, the couple finally received an explanation for Denise's infertility. She continues to paint murals (and almost anything that stands still) to bring joy to her community in Reno, Nevada. More of her work can be seen at www.denisecallen.com.

Sarah Clark Davis is an artist, art educator, and mother of three boys who lives in northern Virginia. During her five-year infertility journey, she found art-making to be a source of solace and hope. It is her sincere wish that sharing her work can help someone on their journey and she thanks The ART of Infertility for giving her and many others the transformative platform it is, to share and be less alone on the infertility journey.

Raina Cowan is a licensed clinical professional counselor, an artist, and a registered art therapist with an MA from the School of the Art Institute of Chicago. She is also certified in perinatal mental health. Currently in private practice, she worked in various community mental health settings for more than eighteen years. Her focus areas include reproductive challenges, recurrent pregnancy loss, transracial adoption, postpartum concerns, and parenting. Her specialty is using art therapy and art-based methods to assist people. She lives in Chicago with her family and four rescue cats. To learn more about her work, visit www.rainacowanarttherapist.com/.

Carla Davis is a multimedia fine artist who originally studied and received a BFA in oil painting from the University of Washington. Listening to music continues to be a source of inspiration and therapy and is part of her creative process. She lives with her family in Seattle.

Molina B. Dayal, MD, is an in vitro fertilization and infertility specialist with her own personal experience with infertility. After having multiple miscarriages followed by secondary infertility, she completed her family through international adoption. Dr. Dayal continues to take care of patients in the midst of their fertility journeys at STL Fertility, of which she is the cofounder and medical director. Originally from the Washington, DC, area, she and her adopted daughter call St. Louis their home.

Jessie Dietz-Bieske utilizes her BFA in sculpture to express her personal experience with infertility and womanhood. Her work predominantly reflects the disparities and inequities women face privately and, conversely, in the public eye. Jessie prefers to work with mixed media to underpin social stratification. She is a pharmaceutical professional, artist, and mother. She currently resides in Michigan with her family.

La-Anna Douglas is a fashion model, influencer, writer, women's advocate, and a motivational speaker. La-Anna has shared her experiences with fertility struggles, including being born with a didelphys uterus (double uterus and a double cervix), one kidney, endometriosis, fibroids, and polycystic ovary syndrome. She has created a movement through her public speaking on several podcasts, radio broadcasts, and conferences to include Endo Black's Our Table conference, the White Dress Project's *Dialogue with the Doctors*, Womb Prep, Phenomenal Women conference, and HerStory Women's Symposium. La-Anna has been published and featured on the covers of magazines, including *Afro News*, *NJOY* magazine, *Full Bloom Magazine*, and *Empowering Boss Life* magazine.

Betty Doyle is a poet from Liverpool, UK. Her work has been published in *Poetry Wales*, *Butcher's Dog*, *Agenda*, and *The North* and most recently placed second in *Brag* magazine's inaugural poetry prize. She is currently studying for a PhD in creative writing at Manchester Metropolitan University, researching infertility poetics. Her debut poetry pamphlet, *Girl Parts*, is published by Verve Poetry Press. She tweets as @betty_poet.

Brit Ellis (Blu Hummingbird) is a multidisciplinary artist specializing in beadwork and tattooing, with an educational background in community work and counseling. She creates intricate, one-of-a-kind pieces that inspire conversation and connection. Influenced by her love of pop culture and bold tattoo design, Brit aims to create a variety of works that speak to the complexity of contemporary Indigenous identities and experiences on Turtle Island. Blu's work has been featured in *Flare*, *Luxe*, *The Walrus*, *Fashion*, and *Native American Art* magazines, on TVO, and on CBC radio programs. Brit is a Haudenosaunee woman of mixed ancestry currently living in Tkaronto with her dog, Morty.

Ryan Ferrante is an assisted reproduction attorney and husband who confronted infertility with his wife but not without the unending support of countless friends and family. After years of holding out hope, collaborative reproduction made him a father. Originally from Cleveland, Ryan has made Chicago home with his family.

Yomaira Figueroa-Vásquez is an Afro–Puerto Rican writer, teacher, and scholar from Hoboken, New Jersey. She earned her MA and PhD in comparative ethnic studies at the University of California, Berkeley and her BA at Rutgers University. She is an associate professor of Afro-diaspora studies at Michigan State University and the author of *Decolonizing Diasporas: Radical Mappings of Afro-Atlantic Literature* (Northwestern, 2020). She is a founder of the MSU Womxn of Color Initiative, #ProyectoPalabrasPR, Taller Electric Marronage, and is the principal investigator of the Mellon Diaspora Solidarities Lab. She has been a Duke University Summer Institute on Tenure and Professional Advancement Fellow, a Ford Foundation Postdoctoral Fellow, and a Cornell University Society for the Humanities Fellow.

Foz Foster is an artist who is fascinated by the ordinary. The everyday inspires him, whether that be through HIV awareness, personal and family relationships or sexual fetish, miscarriage or mental health issues. His visual work forges a link between abstract mark making and graphic communication with strong content underlying the aesthetics. His practice is about playing with intent, where he discovers his thoughts and one of his closest friends. He is an award-winning artist and educator and was awarded an Honorary Fellowship for his contribution to the arts.

Faye Glen channels her infertility through sculptural work and abstract paintings. Her work confronts the raw emotions of the pain and loneliness of infertility. Accepting and embracing life without her own children, she now finds fulfillment through being an aunt to her nieces. She lives in Broadstairs, South East England, with husband, Ian, and Monty, the Jack Russell.

Maya Grobel is a psychotherapist in private practice, where she specializes in supporting individuals and couples struggling to conceive or building their family in alternative ways. Maya and her TV producer husband, Noah, made

a feature-length film documenting their tumultuous journey to parenthood, which ended with the birth of their daughter via embryo donation in 2015. The film, called *One More Shot*, debuted on Netflix in January 2018 and is now available on Vimeo on Demand. Maya is also a cofounder of EM•POWER with Moxi, an educational company focused on empowering choice in embryo donation.

Lisa Grunberger is a Pushcart nominee and Temple University English professor. Her play, *Almost Pregnant* (2018), is about infertility, motherhood, and assisted reproductive technologies. Lisa teaches yoga and infertility workshops throughout the country. Her award-winning poetry books, *I Am Dirty* (Moonstone, 2019) and *Born Knowing* (Finishing Line Press, 2012), are lyrical reflections on life as a woman, a mother, and a daughter of Holocaust survivors. She is currently adapting her book *Yiddish Yoga: Ruthie's Adventures in Love, Loss and the Lotus Position* (Newmarket Press, 2009) as a musical—*Yiddish Yoga: The Musical*. Her poems have been translated into Hebrew, Slovenian, Russian, Spanish, and Yiddish. To learn more, visit www.Lisa-Grunberger.com.

Cha Gutiérrez is a visual artist who lives and works in Phoenix. Primarily a figurative painter, she blends expressive portraiture with elements of nature. Using bold color and surreal imagery, her paintings aim to capture the complexity of human beings, particularly women. She strives to depict their strength, grace, growth, weaknesses, and battles in the mediums of oil and acrylic. She is most inspired by stories of ancestry, family folklore, and the ways in which healing journeys can be represented visually. She studied fine art at both the School of Visual Arts in New York and Arizona State University.

Adi Hadar is human resources specialist for a start-up. She holds an MA in labor and human resources management studies and a BA in social work. Adi lives in Israel with her husband and five-year-old son, who was born after a long journey with infertility. She has liked art from the time she can remember.

Cynthia Herrick has been a visual designer in the Baltimore area since 1986. Her creatives include photography, graphic design, award-winning publication design, exhibit design, illustration, and branding. As a commercial designer, she embraces the challenges of integrating digital technology with creative visual

art, producing strong conceptual materials for marketing. As a photographer, her intimate portraits of people, nature, and wildlife bring you up close and personal to see the world from her perspective and give you an insight into her vision. Her award-winning photographs have been recognized and published by *National Geographic*.

Roxy Jenkins is a St. Louis–based artist who has been honoring her journey through infertility by painting embryos under Dear Coco Design business for the past several years. High school teacher by day, painter by night, she has dedicated her life to educating others. Her passion is to create unique, one-of-a-kind embryo watercolor paintings that represent the beauty and pain of creating life.

Kevin Jordan was born and raised in Wisconsin. He received his BS from Marquette University in mechanical engineering and received his MS in radiological physics at Wayne State University School of Medicine. He works as a global product director in the radiology sector. His art draws on his engineering and scientific background to capture the embodied tension of the infertility journey as a man. He documents the intersections of his work on his website, kevintjordan.com. He is a proud parent of an adopted daughter.

Douglas Kearney is a poet, interdisciplinary writer, and performer. He is the author of seven books, including *Sho* (Wave Books, 2021), a National Book Award, Pen American, and Minnesota Book Award finalist; *Buck Studies* (Fence Books, 2016), the winner of the Theodore Roethke Memorial Poetry Award, the CLMP Firecracker Award for Poetry, and silver medalist for the California Book Award (Poetry); *Patter* (Red Hen Press, 2014); and *The Black Automaton* (Fence, 2009), winner of the National Poetry Series. A Howard University and CalArts alum, he teaches at the University of Minnesota, Twin Cities, where he is a McKnight Presidential Fellow. Born in Brooklyn, raised in Altadena, California, he now lives in St. Paul with his family.

Cheryl E. Klein is the author of *Crybaby* (Brown Paper Press, 2022), a memoir about wanting a baby and getting cancer instead. She also wrote a story collection, *The Commuters* (City Works Press, 2006), and a novel, *Lilac Mines* (Manic D Press, 2009). A senior editor and monthly columnist for *MUTHA*

*Magazine,* her stories and essays have also appeared in *Blunderbuss*, the *Normal School*, *Razorcake*, and several anthologies. She blogs about the intersection of art, life, and carbohydrates at breadandbread.blogspot.com. She can be found on Twitter as @cherylekleinla and on Instagram as @cherylekleinstories.

Annie Kuo is an Asian American journalist and longtime advocate for men's health and family-building legislation. Her experiences of infertility and pregnancy loss have taught her invaluable survival lessons about the importance of finding resilience, community, and self-compassion in uncertain times. Grateful for a miracle daughter conceived independent from fertility treatment, Annie hosted RESOLVE infertility support groups for many years and brought *The ART of IF* to Seattle in 2015. She now organizes the Club Wid Seattle Meetup group, a social club for widowed people who are Gen X and younger. She dabbles in mixed media and photography. For more, go to www.anniekuo.com.

Dan Louis Lane is a loose collection of atoms that formed in order to illustrate the comic *What IF?* He is now floating somewhere over the eastern blight of Washington state, until he precipitates once again.

Siobhan Lyons was born and raised in Pennsylvania. She holds an MFA in creative writing and a PhD in creativity studies. She lives in St. Thomas with her husband and son, where she is an assistant professor of English at the University of the Virgin Islands. The works included in this anthology are her first published texts. She is currently weaving a hybrid writing project with reflections on infertility, immigration, motherhood, storytelling, and violence.

Ashley MacLure explores motherhood, grief, mental illness, and trauma through her work. She identifies as a mixed-media artist who works with charcoal, drawing, collage, and painting; she is trained in traditional and digital two-dimensional illustration methods. She graduated with a BFA in illustration from Rhode Island School of Design in 2009 and holds a postbaccalaureate in visual arts education from Framingham State University. She is currently teaching high school while working toward her MA in education with a concentration in visual arts at Framingham State University.

Marjorie Maddox is a professor of English and creative writing at Pennsylvania's Lock Haven University. She has published fourteen collections of poetry, including *Begin with a Question* (Paraclete, 2022), *Transplant, Transport, Transubstantiation* (Wipf & Stock, 2018), and the ekphrastic collections *In the Museum of My Daughter's Mind* (with artist Anna Lee Hafer and others; Shanti Arts, forthcoming), and *Heart Speaks, Is Spoken For* (with photographer Karen Elias; Shanti Arts, 2022). She also has published four children's books and a short-story collection, and she is coeditor (with Jerry Wemple) of the anthology *Common Wealth* (Pennsylvania State University Press, 2005). She lives with her husband and two children in Williamsport, Pennsylvania, birthplace of Little League and home of the Little League World Series.

Margaret A. Mason is the university archivist at Syracuse University. She has a BA from Hartwick College and MAs in history and library and information services from the University of Maryland. She lives with her husband in Syracuse, New York.

Sarah Matthews has an MA in art and the book from the Corcoran College of Arts and Design at George Washington University. She received an MBA with a marketing concentration in 2005 and a BS in sociology in 2000 from Bowie State University in Maryland. Her work has been exhibited and is a part of the permanent collections of Yale's Beinecke Rare Book and Manuscript Library, George Washington University's Gelman Library, University of Puget Sound, and Samford University. Sarah is also a wife to Khari and the mother of four girls.

Christine McDonough received her BFA from Syracuse University, where she studied illustration. It wasn't until almost a decade later that she was inspired to use her illustrative background as a way of coping with and confronting her own infertility. Christine is based in Washington, DC, with her husband, their son born from IVF, and their dog.

Sharon McKellar is a librarian who lives in the San Francisco Bay Area with her husband and their seven-year-old twins whose existence is the culmination of many years of needles, medications, mood swings, cycles of hope and of

hopelessness, and so much screaming into the void. Sharon survived, in part, because of writing and photography.

Erika Meitner is the author of six books of poems, including *Useful Junk* (BOA, 2022) and *Holy Moly Carry Me* (BOA, 2018), the winner of the 2018 National Jewish Book Award in poetry and a finalist for the National Book Critics Circle Award in poetry. She sometimes writes about her experiences with unexplained secondary infertility, reproductive endocrinology and technology, and the adoption process. Her poems have been published most recently in the *New Yorker, Orion*, the *New Republic, Virginia Quarterly Review, The Believer*, and elsewhere. Meitner is currently a professor of English at the University of Wisconsin–Madison, where she also directs the MFA program in creative writing.

Annamarie Torpey Miyasaki was raised in the LGBTQ+ community of San Francisco at the flashpoint of the AIDS epidemic. "Silence = Death" has been a lifelong mantra, and art is where she found her voice. With symbols and images pulled from Catholicism, mythology, and tarot she explores identity, trauma, and recovery through mixed media self-portraiture. Her work is fundamentally Elder Millennial in spirit, inspired and influenced by zines, nineties music, and pop culture. It is visual prayer, spell-work, and a therapy journal. Her twins, Matilda and Samuel, were born one year after this piece was completed.

Christine Moffat earned her BS from Brigham Young University but is lucky enough to have her dream job of being a mother. She loves to garden and be creative by making stained-glass projects. She and her husband, Andrew, have two boys, eight years apart; with another miracle IVF baby girl on the way. Their IVF babies are the product of years and years of trying, heartbreak, miscarriages, and pain. But they are miracles of science and a blessing from God.

Noah Moskin is a television producer based in Los Angeles. From his cable access show in high school, to his early films at the University of California, Berkeley, to producing unscripted shows for a multitude of networks, Noah has always looked for projects that have a different point of view or something new to say. His work has taken him across the globe for comedy and into intimate settings for access to award-winning musical artists. He finds creative value in all genres. *One More Shot* (Netflix, 2018) is his first feature film.

Montserrat Duran Muntadas is a Catalan artist living in Canada. In 2007 and 2010, she graduated from the Centro Nacional del Vidrio in Segovia and received a fine arts degree from the University of Barcelona. She has had ten solo exhibitions and has several more planned for the next few years. She is the laureate of several awards including the 2017 RBC Award for Glass. Her works are part of many collections, including the City of Montreal. She brings together diverse materials with traditional glass-worked pieces that visually eradicate the historical barriers between visual arts and crafts.

Shannon Novotny is an artist and gardener whose work centers around the interplay of art and science. She earned her BFA in painting from Central Michigan University and her MFA in painting from the University of Cincinnati. Finding patterns and making meaningful connections through art inside the complex world of secondary infertility gave her the ability to successfully navigate through years of loss and unanswered questions. She currently lives outside of Chicago with her family.

Eva Nye was born and raised in Sweden. In 1992, she moved to Chicago to study Fashion Design at Ray College of Design. In 1998, she started her own company and has since made her living making wearable art. Her specialty is hats and hand-printed shirts. During the years of struggling with infertility she created three seven-foot-tall pieces using needles, syringes, and medical packaging used for in vitro fertilization. Today, she and her husband are busy taking care of their two sons who were conceived through egg donation. Art, photography, yoga, and writing are still part of her everyday life.

Poonam Parag, a former supply-chain specialist at Apple, now mother of two babies, struggled with repeated pregnancy loss for seven years. During that period, art was a medium through which she found comfort. Her paintings depict the pain, anxiety, and fear she endured in those years. While working through her emotions, she grew in her belief that every human is born with an innate wisdom, an inner compass. And hers was telling her that her journey had not ended. South African born, Poonam now lives in California with her growing family. Her latest passion is creating themed sensory kits for children through BlossomBloomKids.com.

Jaimie Peterson is an artist, art therapist, counselor, and educator in Texas. She received her BFA in painting from the Kansas City Art Institute and her MA in art therapy from the School of the Art Institute of Chicago. She is passionate about how the creative process can provide healing and a sense of self during life's most difficult challenges. She has presented and published works nationally and internationally regarding the use of art to reduce stigma and build community in mental health. She loves to write and tell stories about her life experiences. Her artwork aims to reflect a quiet narrative of her struggles, grief, and personal growth.

Matt Quarterman grew up as an expatriate in Portugal and Ukraine. He studied literature and music in Mississippi and Massachusetts and has settled in the Pacific Northwest. His writing credits include the *Penwood Review* and *Zymbol*; more of his creative work can be found at mattquarterman.com.

Jenny Rough is a writer and a lawyer. She earned her JD from Pepperdine University School of Law and practiced higher education law before switching to journalism. She is the cohost of the podcast *Legal Docket* and a regular contributor to WORLD News Group. She also writes a quarterly newsletter, *Rough Draft*. She and her husband, Ron, live in Virginia and Colorado. Find her at www.jennyrough.com.

Carla Rachel Sameth was recently selected as the 2022–24 co–poet laureate for Altadena, California. Her chapbook, *What Is Left* (Dancing Girl Press), was published December 2021. Carla's award-winning memoir, *One Day on the Gold Line*, originally published by Black Rose Writing in 2019, was reissued by Golden Foothills Press in 2022. Her writing on blended/unblended, queer, multiracial, and single-parent families appears in a variety of literary journals and anthologies. Carla's work has been twice named as Notable Essays of the Year in *Best American Essays*. A former PEN teaching artist, Carla teaches creative writing to high school and university students and has taught incarcerated youth.

Lauree Jane (Sundberg) Schloss battled infertility for eight years—undergoing three intrauterine inseminations, three in vitro fertilization cycles, eight embryo transfers, thousands of injections, and multiple miscarriages. She and her hus-

254                                                                Contributors

band were finally blessed with three miracles: two sons and a daughter. Her entire infertility journey can be found here: justrelaxanditwillhappen.blogspot.com.

Leanne Schuetz started making art as a way to create a new life after dealing with infertility. She has been married to her husband for eighteen years; they have one daughter and live in the Phoenix area.

Gwenn Seemel's polka-dot cubist painting style has been delighting art lovers and inspiring artists for two decades—so much so that in 2017 a tech company named one of their photo filters "the Seemel." This unusual recognition of her contribution to the look of the new millennium struck her as both a compliment and a cheeky challenge from our future AI overlords to keep making original art that matters. For her, that means joyfully feminist figurative paintings that refuse to let us forget how interconnected we all are.

Marissa McClure Sweeny, as an artist, educator and scholar, is committed to reconceptualizing images of historically marginalized groups of young children and to centering difference through collaborative scholarship, pedagogy and mentoring, and multimedia art-making. She currently serves as professor of art education and women's and gender studies affiliate faculty at Indiana University of Pennsylvania. In 2017, she founded SQUAD Art Studio, a community-based program dedicated to negotiated arts experiences with young children, and the Scribble Squad, an international research collaborative for caregivers of young children and academic motherscholars.

Amy Traylor is a computational artist who develops custom software integrating textiles, sound, traditional art materials, and new media. Through her generative practice, she creates opportunities for new rituals and resonant objects, particularly surrounding family, habitus, grief, and the body. She holds an MA in art education, an MFA in experimental art and technology, and is currently pursuing a PhD in computational education, exploring the connections among computer science, art, design, and craft. She lives with her husband, four children, and two old dogs in Rio Rancho, New Mexico.

Crystal Tursich often draws on memory and emotion to create diaristic photographs that hover between staged self-portraits and constructed memories.

Her work has been included in many exhibitions, with recent solo exhibitions in Columbus, Defiance, and Dayton, Ohio. In 2019, she was the recipient of the EMERGE Fellowship Award from Midwest Center of Photography. She holds an MFA from Columbus College of Art and Design and BFA from Adrian College. Crystal is based in Columbus, where she serves as Fine Arts Department chair at Columbus Academy.

Monica Wiesblott is an internationally award-winning printmaker who currently exhibits her photography and printmaking both in the United States and abroad. Born in Los Angeles, by the age of seven she was handed a 110 camera and so began the journey into image making. Monica has studied studio art and art history in Europe and Asia and completed a round-the-world trip beginning in Nepal. When she is not making art, you will find her planting flowers in her neighbor's yard or feeding the local birds. Monica currently lives in Southern California with her husband. You can find her work at www.monicawiesblott.com.

Michele Wolf is the author of two books—*Immersion* (Word Works, 2011) and *Conversations during Sleep* (Anhinga, 1997), winner of the Anhinga Prize for Poetry—and a chapbook, *The Keeper of Light* (Painted Bride Quarterly, 1995). Her work has appeared in *Poetry*, the *Hudson Review*, the *Southern Review*, *North American Review*, and many other journals and anthologies, as well as on the Poetry Daily, Verse Daily, and the Poetry Foundation websites. Among her honors is a 2022 literary arts Independent Artist Award from the Maryland State Arts Council. She teaches at the Writer's Center in Bethesda, Maryland. Her website is http://michelewolf.com. Her daughter recently turned twenty.

Kelly Zechmeister-Smith is an educator and illustrator who spent four years in a profound struggle with unexplained infertility (UI). She hopes to invoke a playful spirit through her work, combining simple lines with deeper concepts like UI and pregnancy loss. She and her husband now have two children and spend their days adventuring around Ann Arbor, Michigan.